INFINITE
COSMOS

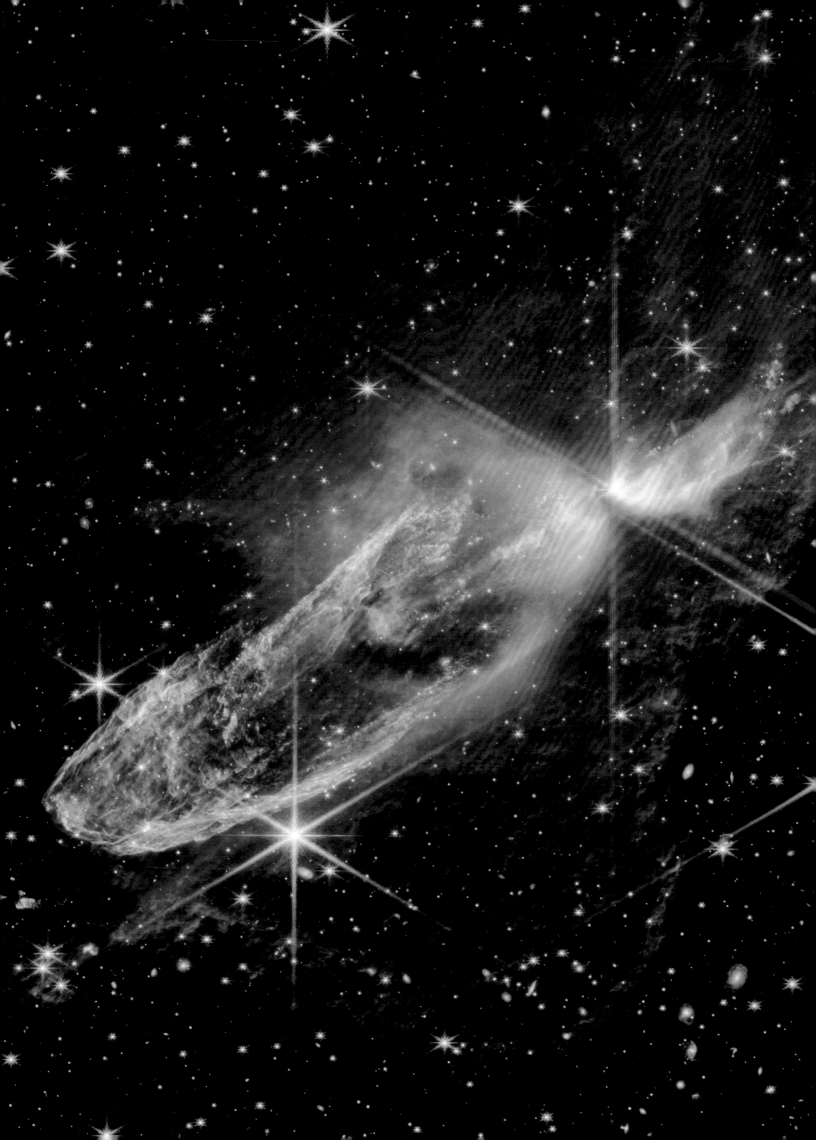

INFINITE
COSMOS

Visions From the
James Webb Space Telescope

Introduction by Brian Greene

ETHAN SIEGEL

NATIONAL GEOGRAPHIC

WASHINGTON, D.C.

CONTENTS

13 → 25
26 → 79
80 → 121
122 → 215

The James Webb Space Telescope's first six (out of 18) mirror segments prior to cryogenic testing in 2011

(previous) A young cluster of new stars, with one particularly active member. Thousands of galaxies glitter in the distant background.

To human eyes, the center of the Milky Way looks dark, since thick lanes of light-blocking dust obscure our views. But through instruments sensitive to infrared light, that dust is transparent, enabling views of our galaxy's center. The blue features on the left represent ionized hydrogen, with needlelike structures pointing toward a cluster of new protostars—a novel discovery. The dark region above is so dust-rich that even NIRCam struggles to see through it. On the right, rich clusters of new stars shine brilliantly. An estimated 500,000 stars shine in this image from JWST: Witness the wonders of our universe anew.

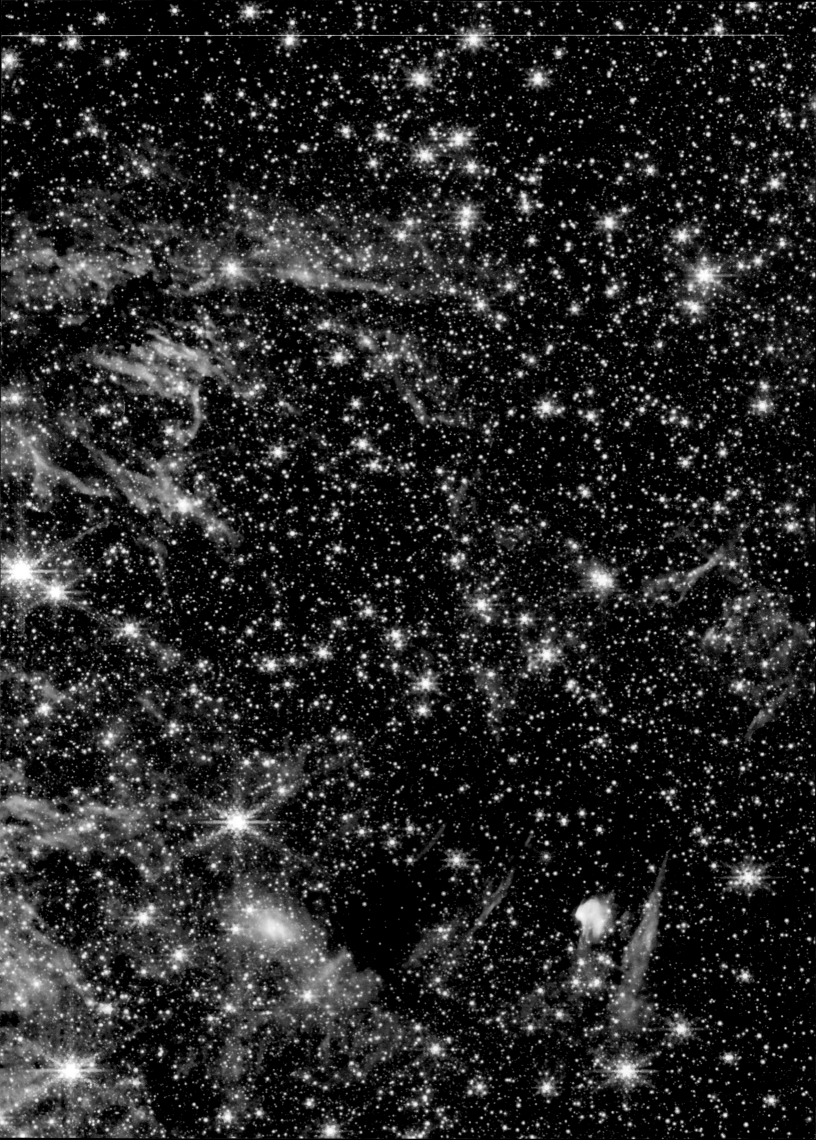

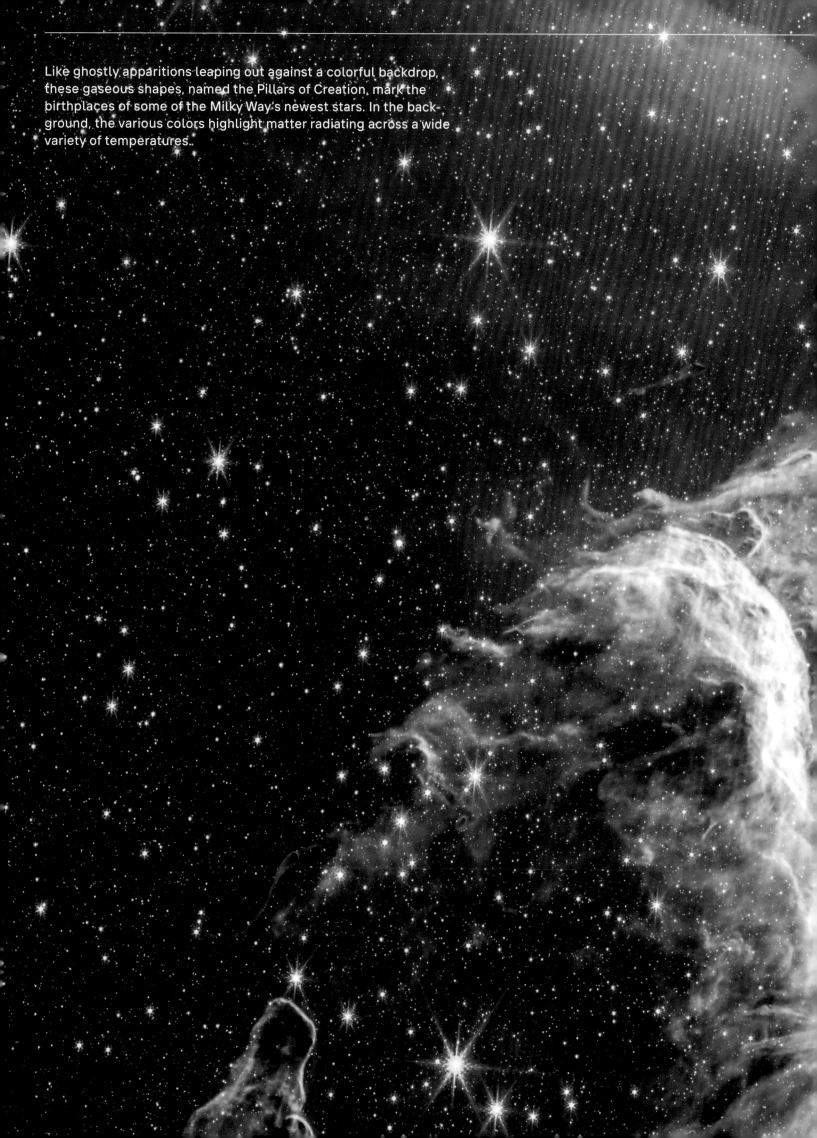

Like ghostly apparitions leaping out against a colorful backdrop, these gaseous shapes, named the Pillars of Creation, mark the birthplaces of some of the Milky Way's newest stars. In the background, the various colors highlight matter radiating across a wide variety of temperatures.

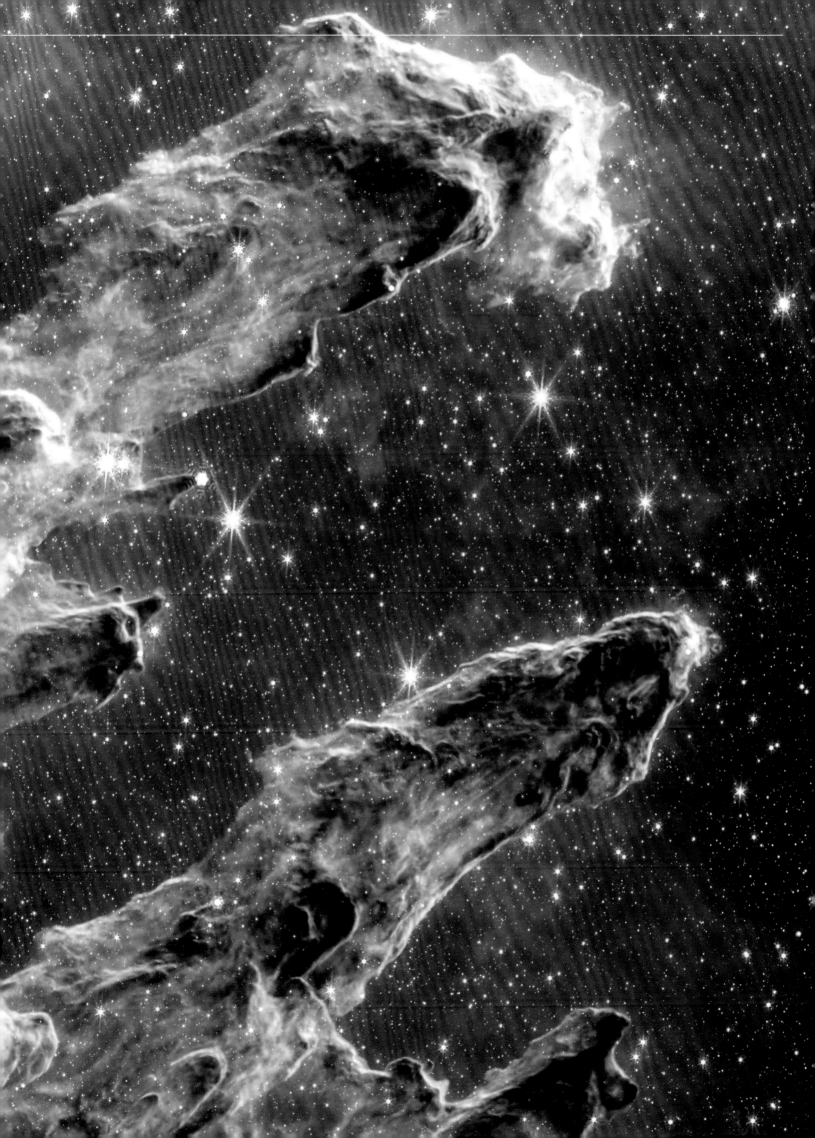

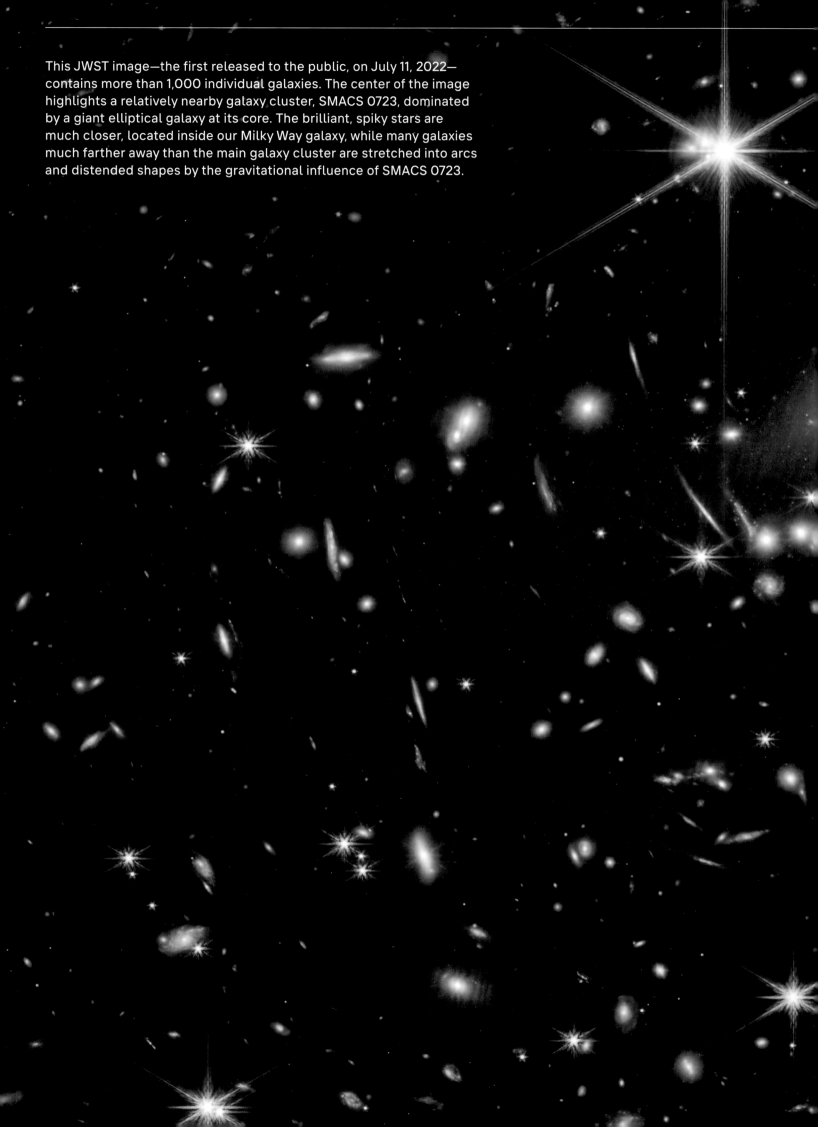

This JWST image—the first released to the public, on July 11, 2022—contains more than 1,000 individual galaxies. The center of the image highlights a relatively nearby galaxy cluster, SMACS 0723, dominated by a giant elliptical galaxy at its core. The brilliant, spiky stars are much closer, located inside our Milky Way galaxy, while many galaxies much farther away than the main galaxy cluster are stretched into arcs and distended shapes by the gravitational influence of SMACS 0723.

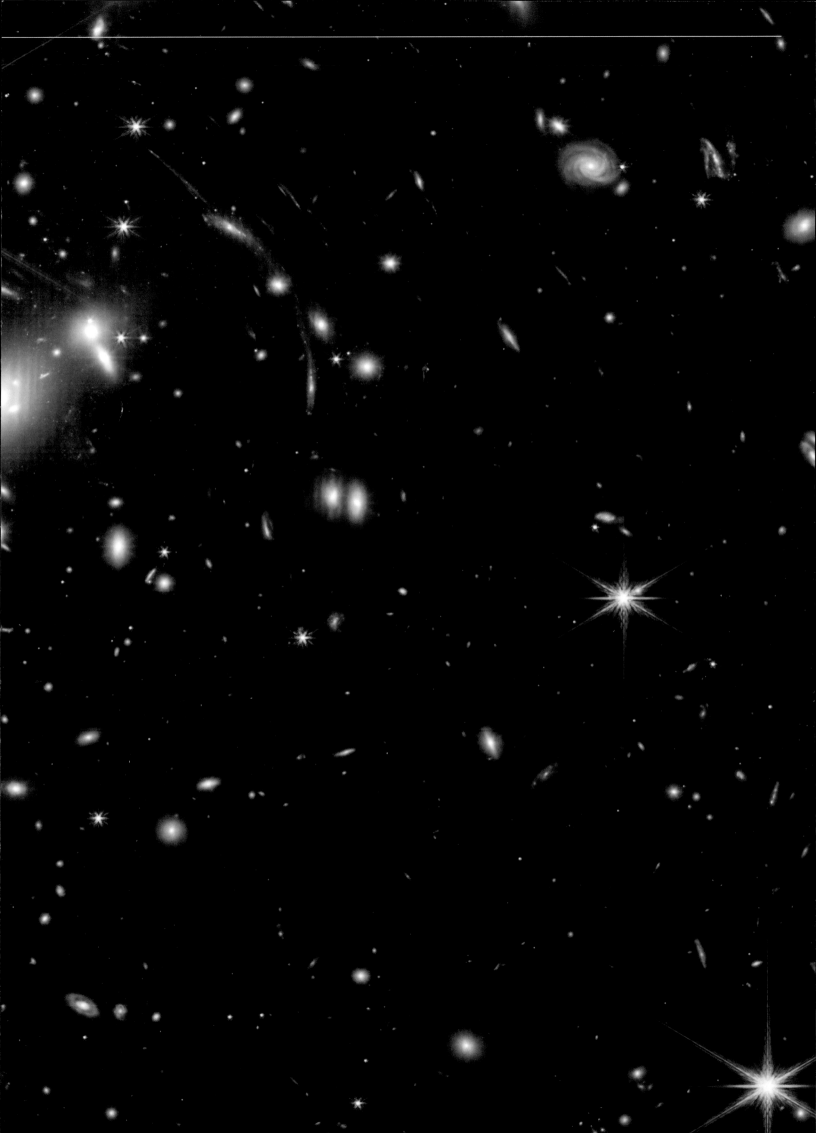

Introduction

Seeing Farther
Than Ever Before

Brian Greene

In the balmy June of 2010, beneath the shimmering embrace of New York City's skyline, I stood mesmerized by a behemoth of human ingenuity. As the sun cast its golden glow upon Battery Park, I was transfixed by a full-scale model of the James Webb Space Telescope. The occasion was the World Science Festival, a magnet for inquisitive minds and celestial enthusiasts eager to probe the very edge of human understanding. I was gently startled by a young student: "Is this how we'll figure out why we are here?" I smiled, momentarily taken aback by the uninhibited display of a connection I know so well: between awe and science. As the student could sense, the Webb telescope, at that time still more than a decade from launch, promised not just to peer into the distant reaches of space but also, as with all ambitious challenges, to hold up a mirror to our very nature, revealing the depth and scale of our commitment to know ourselves and our reality.

A few years later, I was a guest at the Goddard Space Flight Center in Greenbelt, Maryland, where the Webb telescope was being assembled. I watched as the team gingerly moved a couple of the telescope's gold-plated hexagonal mirrors, readying the instrument for a barrage of diagnostic tests. Among the most memorable was sealing the telescope in a giant anechoic chamber and subjecting it to sound vibrations so powerful they can be lethal, ensuring that the telescope would survive its launch into space unscathed. I am a theorist, so the only physical challenges my work presents are an infrequent broken pencil or a mild

case of carpal tunnel syndrome. To design an instrument with heaps of moving parts and carefully assemble them into one of the most powerful telescopes in history, all with the intention of mounting it on a fiery rocket that will thrust the delicate contraption on a million-mile journey where it is supposed to deploy and properly function—well, the fortitude to take on such a mission is nothing short of heroic.

Such heroism, led by senior project scientist and Nobel laureate John Mather and channeled through the hands of thousands of skilled scientists, engineers, technicians, project managers, and outreach personnel, was put to its first real-world test on Christmas Day, 2021. With the telescope carefully packed within an Ariane 5 rocket standing tall on its launchpad in Kourou, French Guiana, team members from around the world held their breath as 25 years of preparation ceded to a 10-second countdown. The engines roared, the rocket lifted, and with that picture-perfect launch, the James Webb Space Telescope carried skyward the hopes and dreams of two generations of astronomers.

The worldwide audience let out a sigh of relief. Those in the know then quickly inhaled. By design, the next six months would be chock-full of anxiety. How much fuel would the telescope need to correct imprecisions in the Ariane 5's launch trajectory? Would the tennis-court-size solar shade, folded origami style into the Ariane 5's loading bay, unfurl without a snag? Would the telescope properly acclimate to frigid conditions only lightly touched by sunlight? Would the communication channels function as planned? These are just a few of the many ways the telescope might fail.

A composite of a JWST image of the Orion Nebula and a portrait of author Brian Greene

So, how did it do?

While there are always unexpected glitches, the telescope came through its commissioning process with the highest of marks, readying it to look farther into space and further back in time than ever before.

The Telescope

The velocity of light is enormous, fast enough to circumnavigate Earth more than seven times in a single second. Even so, because the expanse of space is enormous too, the light we receive from the most distant astronomical objects began its journey billions of years ago. Consequently, when we capture and analyze such light, we are directly examining conditions not just far away but also long ago. Such is the wonder of light, and the power of instruments like the James Webb Space Telescope (JWST).

The light produced or reflected by an object, whether terrestrial or distant, travels outward in all available directions. To use the language of quantum physics, a great many photons—little packets of light—disperse from each point on the object. The more photons a telescope intercepts, the brighter each point of the object will appear, which is why telescope designers place a premium on collecting as many photons as possible. The method for doing so is immediate: The larger the telescope's lens, the greater the number of photons its optics will bring to a focus. Equivalently, for telescopes like JWST that use a mirror to collect photons, the larger the mirror, the greater the number of photons.

The mirror on the Hubble Space Telescope is 2.4 meters (7.8 ft) across, providing a collecting surface of about 4.5 square meters (48 sq ft). Each of the hexagonal mirrors on JWST is 1.3 meters (4.2 ft) across, and there are 18 of them, yielding a total collection surface of about 25 square meters (270 sq ft)—roughly six times the collection area of Hubble. This means that after their long journey across space, some 85 percent of the photons JWST captures have trajectories that would speed just outside the rim of the Hubble telescope's smaller mirror, giving a feel for why JWST is so much more powerful.

Ground-based telescopes, immune from the challenges of being launched into space, can be far larger, but their observations are subject to distortions and degradations because photons must pass through Earth's relatively warm and turbulent atmosphere. This is especially true for the variety of light that JWST is designed to detect and explains why the telescope is operating far out in space, well beyond the distance to the moon. Let me explain.

While the speed of light is constant, its vibrational properties are not. Light is an undulating wave, and as scientists realized as far back as the 1800s, the slower the undulations, the redder the light's color. In keeping with light's constant speed, slower undulations go hand in hand with longer wavelengths (the distance light covers per undulation), and so the longer the wavelength, the redder the color too. Human eyes can detect light in only a limited range of wavelengths—from red to violet—and it is no coincidence that these are the very wavelengths of light that the sun emits most strongly. Over the course of millions of years of evolutionary history, eyes sensitive to the wavelengths most abundant

during waking hours were eyes that prevailed in the relentless battle for survival.

But eyes attuned for earthbound survival are not eyes optimized for examining structures in the cosmos. The wide range of astrophysical sources emit and reflect light with wavelengths that can be well outside the range of human sensitivity. JWST was designed to detect wavelengths of light in the infrared (longer wavelengths than red light, and thus light the human eye cannot see) that are particularly relevant for studying the early universe as well as distant star-forming regions. Moreover, the suite of instruments on JWST not only constructs images of distant objects but, like a prism, also separates the incoming light into its component wavelengths—its spectra—which is vital for analyzing the detailed composition of the light's source.

Specifically, JWST comprises four main detectors: NIRCam, which is an imager sensitive to light in the near infrared (with wavelengths just beyond those of visible red light); NIRSpec, which also operates in the near infrared but decomposes the light into its spectrum; FGS/NIRISS, which is the fine guidance system used to align the telescope and which also has the capacity to image and take spectra in the near infrared; and finally, MIRI, which is the telescope's imager and spectrometer that is sensitive to light in the middle of the infrared range.

We often associate infrared light with heat, the invisible radiation emitted by a warm object, and that connection raises an essential design consideration. To avoid interfering with its own measurements, JWST needs to be kept extremely cold. How to ensure this? The design team implemented two complementary methods. First, they equipped the telescope with an enormous parasol, a five-layer metallicized plastic sunshield that both reflects incoming sunlight and facilitates the release of intrinsic heat from the telescope. Second, the designers chose to place the telescope in a very particular orbit, first identified mathematically through the works of 18th-century mathematicians Leonhard Euler and Joseph-Louis Lagrange, that keeps the telescope in stable, nearly unchanging environmental conditions. I won't subject you to the equations (although a good high school student could work out the details), but in two sentences here's the idea pared down to the basics: For a relatively small object like a telescope, there are a handful of special orbits along which the combined gravitational pulls of the sun and Earth provide exactly the force necessary to keep the object in orbit. Consequently, for such orbital trajectories, an object feels no net push or pull and so remains in an unchanging position relative to both the sun and Earth. One of these positions, called the second Lagrange point, or L2 for short, is 1.5 million kilometers (about 932,000 mi) from Earth and is where JWST is now parked.

A touch more precisely, JWST is not located at the L2 point but is orbiting the L2 point. This trajectory keeps the telescope just beyond the shadows of Earth and the moon, allowing its solar panels to feed on constant sunlight while its enormous sunshield keeps the sensitive instruments at a constant but frigid temperature. The stable environmental conditions are essential for the telescope to function properly, and with the sun's and Earth's gravity guiding all the

motion, the telescope uses very little fuel, extending its life.

There is also a downside to the telescope's location. If anything should go wrong, JWST is too distant for a practical servicing mission. You may recall that shortly after Hubble was launched, astronomers realized that there was a problem with the telescope's main mirror (the mirror's shape was off by about 1/50 the thickness of a human hair), which would have severely compromised the images it produced. In 1993, the crew of the space shuttle *Endeavour* was able to rendezvous with the telescope and correct the optics. But servicing a telescope orbiting Earth at 525 kilometers (326 mi) is, to say the least, a different proposition from servicing one orbiting at nearly 1.5 million kilometers away. If challenges arise, troubleshooting from Earth will be the only option.

JWST's orbit is also too distant for refueling. Thankfully, all indications are that this won't present an issue for quite some time. Before launch, scientists estimated that the telescope could be carrying enough fuel to operate for roughly 10 years, a projection directly influenced by the amount of fuel actually needed to steer JWST to its home in orbit around the second Lagrange point. Wonderfully, the Ariane 5 rocket was so precise in its launch and trajectory that far less of the reserve fuel was used than expected, and so scientists now predict that JWST may operate productively for some 20 years or more.

Over such long time spans, the most revolutionary contributions of new scientific instruments are sometimes ones that scientists could not anticipate at the outset. Many astronomers expect this will likely happen with JWST, as each new discovery will have the capacity to shift the very questions scientists will use the telescope to subsequently investigate. But in designing JWST, astronomers focused on four main areas of investigation: exoplanets, star and planetary formation, the evolution of galaxies, and the early universe. Let's take a look at each.

Exoplanets

Nicolaus Copernicus, a Polish polymath who lived some 500 years ago, is credited with overturning the prevailing wisdom that Earth was the center of the universe. A mathematician and astronomer, Copernicus unwittingly followed the nearly 2,000-year-old footsteps of Aristarchus of Samos, a Greek astronomer who is the first on record to propose that the sun, not Earth, is the center of it all. But it was Copernicus's version that gained prominence, spawning an intellectual revolution that bears his name and pushing Earth off its false pedestal. Through centuries of subsequent astronomical advances, the Copernican revolution continued to reverberate as our supposed specialness was diminished by the realization that the sun is but one of hundreds of billions of stars in the Milky Way galaxy, and that our galaxy is but one of hundreds of billions that populate the observable universe.

Through it all, we could still hang on to the hope that our solar system was exceptional, because across all these advances, science had not mustered convincing evidence for any planets beyond those orbiting the sun. In the 1990s, that changed. The first extrasolar planets (or exoplanets) were confirmed, setting off an avalanche of further discovery that has now identified over

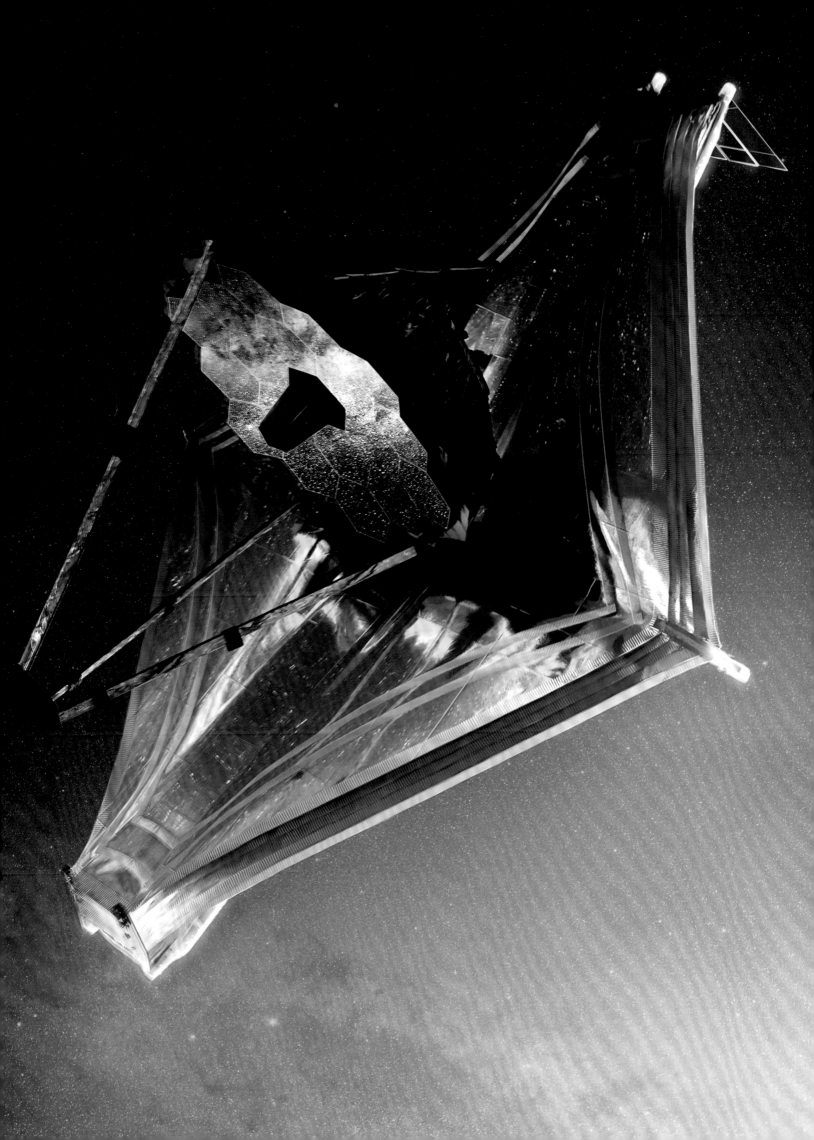

5,000 exoplanets. The data have convinced astronomers that stars hosting planets is the norm, not the exception, which means that our galaxy alone is likely home to many hundreds of billions, if not trillions, of planets—other worlds awaiting exploration.

The James Webb Space Telescope will provide a monumental leap in the ability of astronomers to mount in-depth studies of exoplanets, seeking to understand their compositions, determine whether they have atmospheres, and perhaps even find signatures of life.

Because they are relatively dim, compared to the stars they orbit, exoplanets have primarily been detected indirectly. As an exoplanet's orbit travels across its host star, the planet blocks out some of the star's light, and that dip in brightness is the planet's telltale signature. The dip is not by much. After all, planets are small compared to stars, and so they typically block as little as 1/10,000 of their host star's output. That slight dimming has been detected by earlier observational missions, and JWST is employing the same technique. But JWST is also going much further.

If an exoplanet has an atmosphere, light from the host star that streams through it carries a treasure trove of information. Different molecules in the planet's atmosphere will absorb different wavelengths of the starlight, and so when JWST decomposes the light it collects into its spectral components, the missing wavelengths will delineate the atmosphere's chemical composition. Many of the spectral features of the anticipated molecules lie in the infrared, explaining why JWST's instruments were designed to be sensitive to these very wavelengths.

The pièce de résistance would be finding an Earthlike planet with an Earthlike atmosphere, taking us a step closer to establishing that we're not the only life in the cosmos. But that's far from the only goal. Astronomers want to know whether our planet and our solar system are run-of-the-mill or special. They want to compile planetary demographics, cataloging the range of planetary sizes and masses and distances from their host stars. They want to determine the fraction of planets that have atmospheres and, among those that do, their range of chemical compositions. And so, even without detecting atmospheric biomarkers, these pursuits are poised to transform exoplanetary science.

Star and Planetary Formation

The question of how stars and planets form has long captured the imaginations of astronomers. Understandably so. While seeking to determine how the universe was created might seem to be an abstract, even quixotic pursuit, the sheer ubiquity and abundance of stars suggest that they arise from a commonplace astrophysical process that scientists should be able to unravel. Indeed, we have significant insight already. We know that stars are born within vast clouds of gas and dust through a kind of gravitational snowball effect: Slightly denser regions of the cloud exert a slightly stronger gravitational pull, which attracts surrounding material, thus becoming denser still and driving the process to repeat continuously and with ever greater gravitational vigor. As the ball of gas grows larger and denser, the temperature at its core climbs ever higher, ultimately igniting nuclear processes, and the star lights up.

Surrounding these young stars are remnants of gas and dust that can similarly fall together under the pull of gravity into smaller clumps from which planets eventually emerge.

This is an origin story that science has been telling for some time and that is, in broad strokes, a respectable summary. Nevertheless, many details of the processes remain elusive. Within the intricate interplay between gravity, radiation, magnetic fields, and turbulent motion in these stellar nurseries are numerous mysteries, particularly regarding the earliest stages in the birth of stars and planets.

The Hubble telescope has provided dramatic images of stellar nurseries, thick with sculpted plumes of gas and dust, but with Hubble's optics, the clouds are opaque. Here's where JWST's sweet spot in the infrared makes all the difference. Infrared light can pierce through the thick, dusty veils of stellar nurseries, providing a direct window on star and planetary formation. Moreover, by analyzing the spectra of the infrared light emitted within the gas clouds, astronomers will determine the detailed molecular ingredients and interactions that power the formation processes.

These studies will shed light on a number of basic and important questions. Why do stars often form in binary or multiple groups? What is the detailed trigger that initiates the gravitational snowball for stellar formation? How do supermassive stars form, some weighing in at tens of thousands times the mass of the sun? And on the planetary front: Within the disk of material that swirls around a young star, where do planets of various sizes and compositions first form? Do planets undergo significant migrations before settling into

their final orbits? Closer to home: What is the origin of Earth's water? Was it delivered through bombardments of asteroids or comets, or was water part of the planetary-formation process, during which it was stored as ice within Earth's rocky structure, later to be released through outgassing?

Through the coming years of research, astronomers will use JWST to rework today's broad-brush summary of stellar and planetary formation into a full and quantitative narrative.

The Evolution of Galaxies

Spiral galaxies, with their regal arms reaching out from a central core, are among the majestic wonders of the cosmos. Comprising billions of suns, galaxies are a primary structure organizing matter on the large scales. Ever since the pioneering observations in the early decades of the 20th century revealed a universe populated with galaxies, ever more refined telescopes have provided ever more refined imagery. From the standpoint of science, this is wonderful; from the standpoint of cosmological aesthetics, less so. As we've looked further back in time, we find that early galaxies were for the most part a motley, clumpy crew, riddled with knots of gas and dust from which new stars were born. While decades of research have provided many insights, scientists still lack a full understanding of the developmental steps from this earlier stage to today's galactic population.

And it is not that today's galaxies are all stately spirals. Surveys reveal enormous elliptical galaxies as well as an array of galaxies whose irregular shapes don't conform to a useful categorization. Astronomers will use JWST to better understand the detailed processes by which

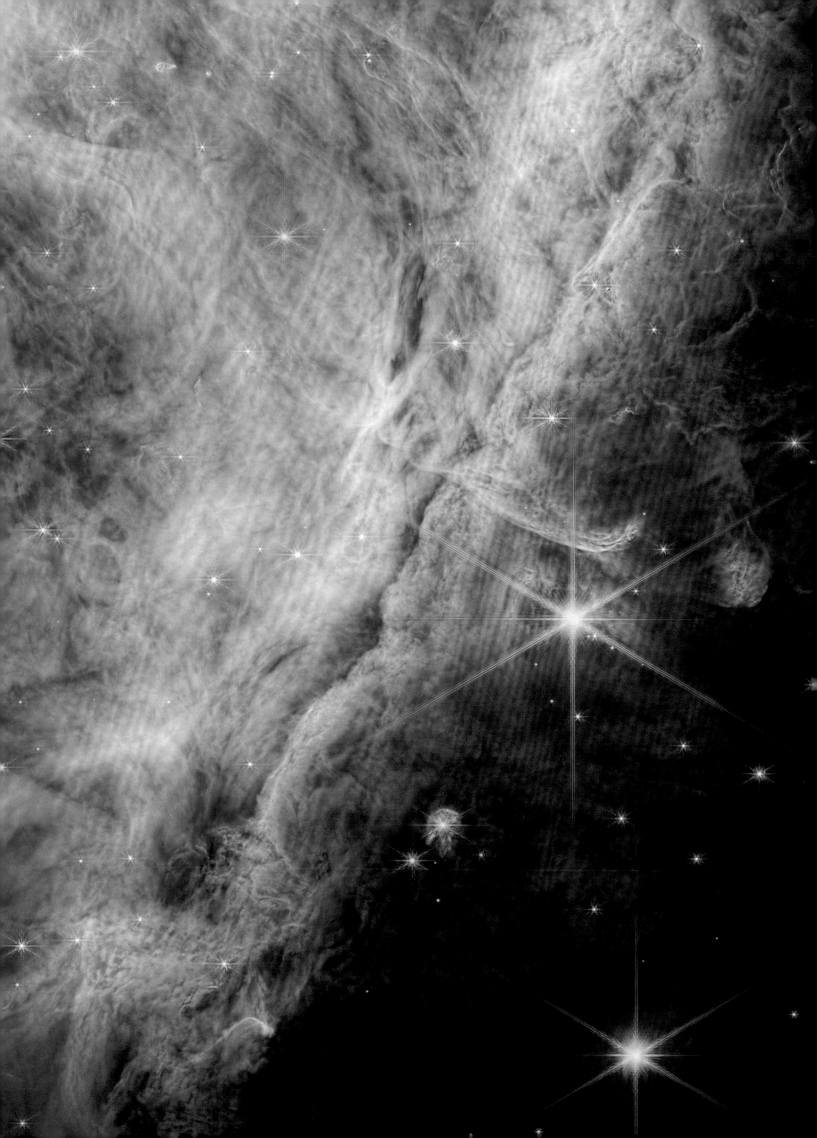

This view inside the great Orion Nebula demonstrates how, unlike optical telescopes sensitive to emitted and reflected starlight, JWST has infrared instruments that are better able to sense gas and dust. The spiky points of light are stars within the nebula, some of which appear to be blowing gas bubbles into their surroundings. As ultraviolet radiation from these newborn stars collides with the surrounding neutral matter, that material heats up and eventually evaporates, leading to the complex structure revealed here.

galaxies initially form and develop, and how their shapes evolve over cosmological time. Vital to this goal is enhanced insight into the roles of dark matter and black holes, which JWST is primed to provide.

Observations going back to the early decades of the 20th century have convinced most astronomers and physicists that in addition to the matter we can see (e.g., stars and planets and nebulae), the universe contains a great deal of matter that's invisible. Such "dark matter" doesn't give off or reflect light, and interacts with familiar matter only through the force of gravity. Although no one has detected dark matter directly and no one knows its composition, mathematical calculations have shown that only by including the gravitational influence of dark matter can we understand the formation and stability of galaxies. These mathematical studies and computer simulations have established that dark matter is essential for generating the gravitational pull that attracts ordinary matter to gather into large astronomical structures. And so, by studying galaxies at ever earlier times, JWST promises to shed new light on the detailed nature of dark matter. Indeed, some early JWST studies have already suggested that the telescope has detected stars composed not of ordinary matter but rather of dark matter. The results are preliminary and so should be approached with a skeptical eye, but if true, this would be an impressive step forward.

Scientists have identified a large black hole at the center of most galaxies. In our own Milky Way galaxy, that black hole has a mass about four million times the mass of the sun. The nearby M87 galaxy hosts a central black hole whose mass is

about six billion times the mass of the sun. In a universe replete with mind-boggling features, a six-billion-solar-mass black hole—a black hole large enough that the entire solar system could comfortably fit inside—is breathtaking, but raises deep questions. What is the origin of these supermassive black holes? How do they influence the development of their surrounding galaxies? Which comes first, the black hole or its host galaxy? Scientists are at an early stage in these investigations, and the new data from JWST will be vital in guiding research toward answers.

Indeed, early data from JWST has already raised eyebrows. Using its infrared capabilities, the telescope has peered all the way back to a few hundred million years after the big bang, revealing an unexpected galactic population. Infrared sensitivity is essential here, because through billions of years of cosmic expansion, the wavelength of light traveling from early galaxies has been elongated into infrared wavelengths, which JWST welcomes with open arms. The surprise is that the galaxies JWST has found are more structurally mature for their young age than current theories would suggest is possible. These nascent galaxies are too big and too bright to fit the conventional developmental paradigm. It is too early to determine whether refinements in calibration and analysis will bring the data more in line with expectations, and if not, what this all means for galactic formation.

But no doubt the surprises are just beginning.

The Early Universe

Less than a century ago, Albert Einstein resisted the implication derived from his own general-relativistic

equations that the universe should be expanding or contracting but not holding still. Einstein was steeped in the philosophical prejudices of the time, which were biased against a dynamic universe that might have had a beginning, noting the uncomfortable resonance, albeit superficial, with theological accounts. Observations made by Edwin Hubble using the telescope at Mount Wilson Observatory changed Einstein's mind. The data revealed that space is indeed expanding. And by using the equations to wind the cosmic unfolding in reverse, scientists were led to a creation-like event billions of years ago in which a tiny, dense morsel rapidly swelled into the expanse of space we can now observe. In broad outline, this is the paradigm of big bang cosmology.

In the intervening decades, scientists have sought to fill in the broad outline with rigorous detail. What sparked the initial outward swelling of space? Was there a "before" the big bang? How did the initial matter filling space arise? These are just a few of the many questions that continue to transfix cosmologists, but I want to focus on one related question, more pedestrian in its phrasing but potentially revolutionary through its resolving. It is the very question that cosmologists are now using JWST to study, and is simply this: How fast is the universe expanding?

The question is far from new, but the wrinkle cosmologists now face surely is. For decades, astronomers argued over a range of answers for the expansion rate that differed by as much as a factor of two. Some of the observations concluded that for every additional megaparsec of separation in space (about 3.26 light-years), the expansion speed increases by about 50 kilome-

ters per second per megaparsec (km/s/Mpc), while others found it to increase by as much as 100 km/s/Mpc. The answer matters because, much as a faster car can get from New York to Los Angeles in less time, a faster expansion rate for space means that the cosmos would need less time from the big bang to reach its current configuration. That is, the faster the expansion rate, or what astronomers call the Hubble constant, the younger the universe.

As observations refined, so did astronomers' measurements of the Hubble constant, ultimately yielding consensus that the actual expansion rate was intermediate between the low and high values previously found—roughly 70 km/s/Mpc. Within the margin of error of most observations, this became the consensus value, settling decades of arguments. Having achieved détente, we perhaps would have been wise to leave well enough alone.

But now, using JWST, we can refine the observations further. And as we do, trouble brews anew. Indeed, a different strain of trouble has bubbled up, one that scientists call the Hubble tension, because two different approaches for measuring the expansion rate are finding two different answers.

In one approach, astronomers carefully measure the cosmic microwave background radiation—residual heat in the early universe, left over as space expanded after the big bang—and on the basis of how the temperature of the radiation varies across space, they can determine how fast space must have been expanding. The astronomers then invoke our understanding of how the cosmos has evolved since that early time to determine how fast the universe must be

expanding today. With the most refined data gathered by JWST, astronomers invoking this approach have converged on an expansion rate of about 67 km/s/Mpc.

The second approach is more direct. Astronomers measure the distance to comparatively nearby astrophysical beacons—pulsating stars and supernovae—and they also measure the speeds at which these objects are rushing away. Such measurements, significantly refined by JWST, are converging on an expansion rate of about 73 km/s/Mpc.

The difference in these expansion rates is the Hubble tension. But unlike the arguments decades ago about the expansion rate, these two answers arise from two different approaches: one from direct measurements of the expansion rate, and the other via extrapolation from measurements of the early universe. And so it could well be that this difference is pointing to new physics that we are failing to account for in our extrapolation from the early universe to today.

Researchers have no shortage of ideas for what the new physics might be, and here's one example. In 1998, we learned from observations of distant supernovae that for billions of years, space has likely been permeated by a uniform and diffuse substance called dark energy, which provides an outward push that contributes to the expansion rate of space. The new proposal hypothesizes an additional and far earlier phase of dark energy that increases the expansion rate, thus bringing the extrapolated expansion rate today in line with the expansion rate found from direct measurements. This is but one of numerous proposals for easing the Hubble tension, and it is far too early to crown the most compelling of the contenders. JWST will surely be an essential tool in sorting this out, and in the process will deepen our understanding of how the universe has evolved since the big bang.

The Future

It might seem premature to think about tomorrow's telescopes, especially in a book celebrating the most powerful one we have today. But it's important to realize that when it comes to telescopes, it's not an either-or proposition. Telescopes are designed to have what Nobel laureate Adam Riess calls their own "superpowers," and so the wisest approach is for astronomers to combine such superpowers by using cutting-edge telescopes in tandem. So, let's conclude by taking a brief look at what new telescopic superpowers are hovering on the horizon.

The next space-based observatory will be NASA's Nancy Grace Roman Space Telescope. The Roman telescope will have a primary mirror whose size is on par with Hubble's but whose field of view is about a hundred times larger. This will allow the telescope to undertake exhaustive surveys of supernovae explosions, giving new and far more detailed insight on the nature of dark energy. The Roman telescope will also measure the matter, luminous and dark, contained in hundreds of millions of galaxies, giving the most refined picture thus far of large-scale matter distribution in the cosmos. And, rounding out its charge, the Roman telescope will search for exoplanets using a technique called microlensing, in which a planet's gravitational field slightly focuses passing light, which is expected to reveal rocky worlds in temperate regions that would allow for liquid water.

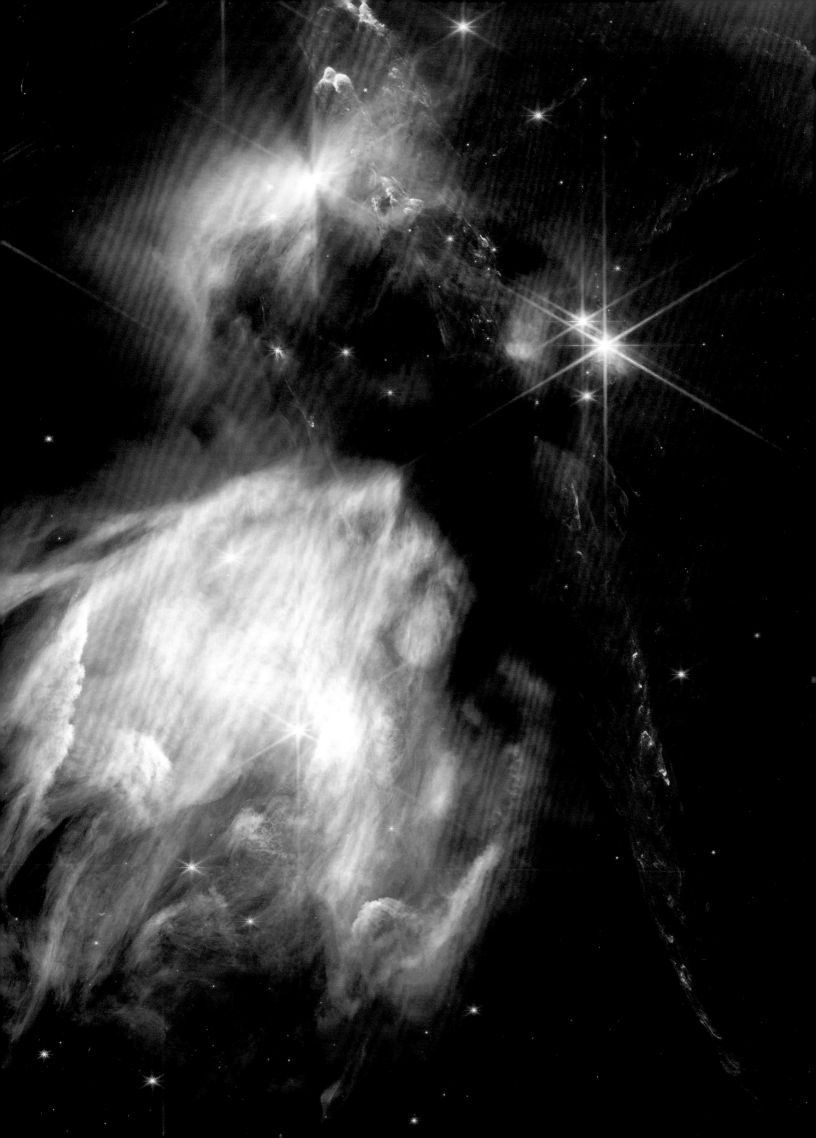

This relatively small, low-mass cloud of gas is actively forming new stars just 390 light-years away. Known as the Rho Ophiuchi cloud complex, it is actually the closest star-forming region to Earth. At the lower left, newborn stars light up the main gas cloud; at the upper right, neutral matter still blocks the direct starlight. The eight-spike pattern attached to each star is a telltale imprint of JWST's optical systems.

On the ground, one of the most exciting new observatories will house the Giant Magellan Telescope in Chile's Atacama Desert. Scientists project that the telescope's seven mirrors, giving a collection area of nearly 370 square meters (4,000 sq ft), will have four times the resolving capacity of JWST. Since it is ground based, though, the Magellan will be compromised in the infrared, the very wavelengths at which JWST excels, making the telescopes ripe for fruitful collaboration.

Finally, I'll mention one more space-based operation that's in the works: the Laser Interferometer Space Antenna (LISA), which will measure gravitational waves instead of light waves. Comprising three spacecraft that will be positioned at the vertices of a large equilateral triangle whose sides are about 2.5 million kilometers (1.5 million mi) long, the instrument will carefully monitor changes in those separations to detect the passing of gravitational waves. LISA will be a rich source of information for understanding the mergers of black holes in galactic centers, the inward spiraling of smaller objects into massive black holes, and signatures of various transitions that may have occurred in the early universe.

As these new instruments come online, they will join JWST in its ongoing mission to reveal aspects of the cosmos that have so far eluded us. I have little doubt that, a couple of decades from now, analyses based on the new data collected will rewrite the details of today's understanding, perhaps even replacing entire areas of explanation. It's exciting to imagine what a scientist will write to introduce a book celebrating the 25th anniversary of JWST's operation.

Will these observations and analyses answer the student's question I recounted at the outset, the question of why we are here? No one knows, of course, but my guess is they will not. Scientists have different perspectives, but my decades of immersion have convinced me that in pursuing that question, we need to focus our attention not outward but rather inward. Even so, that inward journey, during which we each seek our own individual basis for meaning and motivation, needs context. The journey needs to be informed by the deepest and most complete understanding of reality we can attain. The James Webb Space Telescope will be a vital part of achieving that understanding and, in so doing, affirms our species' continued commitment to grasp our place in the cosmic order.

Chapter 1 Design & Construction

To achieve its science goals and surpass the limits of prior observatories, the James Webb Space Telescope (JWST) had to be designed to be larger, colder, more precise, and outfitted with superior instrumentation than all the other space-based telescopes. A larger primary mirror can not only gather more light but also achieve superior resolution, and JWST engineers ambitiously conceived a segmented mirror design that could fold up geometrically and fit inside a smaller rocket. The plan was to launch it to the L2 Lagrange point—a gravitational balance point located on the opposite side of Earth from the sun, 1.5 million kilometers (932,000 mi) away from the pollutive influence of Earth's heat signatures. A novel five-layer, tennis-court-size system known as a sunshield was designed to passively cool the telescope and its instruments once they were positioned in space.

Simultaneously, a complex instrument suite was planned to make the most of every photon collected over an enormous range of wavelengths, from visible light all the way through the mid-infrared. By observing the cosmos with more gathered light, at higher resolution, and with superior instrumentation, JWST was designed to reveal unprecedented cosmic details that promised to teach us how stars, planets, and galaxies are birthed in our universe.

(previous) Prepping the mirrors

Work ongoing in 2010 on the first primary mirror segments, composed of beryllium, a material that is light, strong, and able to hold its shape across a wide range of temperatures. The hexagonal shape allowed these mirrors to be tiled together. Ultimately, all 18 segments operated in a synchronized fashion as a single mirrored surface. The marks on the surface were polished away, and the final surface was coated with gold.

Perfecting the mirrors, step by step

Each of JWST's 18 mirror segments visited 11 different locations across the United States to complete the manufacturing process. As the mirror segments underwent cryogenic temperatures of 37 kelvin (nearly −400°F) at NASA's Marshall Space Flight Center's X-ray and Cryogenic Facility, their shapes changed slightly, with each change recorded using laser technology and corrected by polishing. Next, each segment received a thin coating of gold. Here, mirror segments in various stages of completion—pre-polishing, post-polishing, and after gold coatings are applied—can be seen.

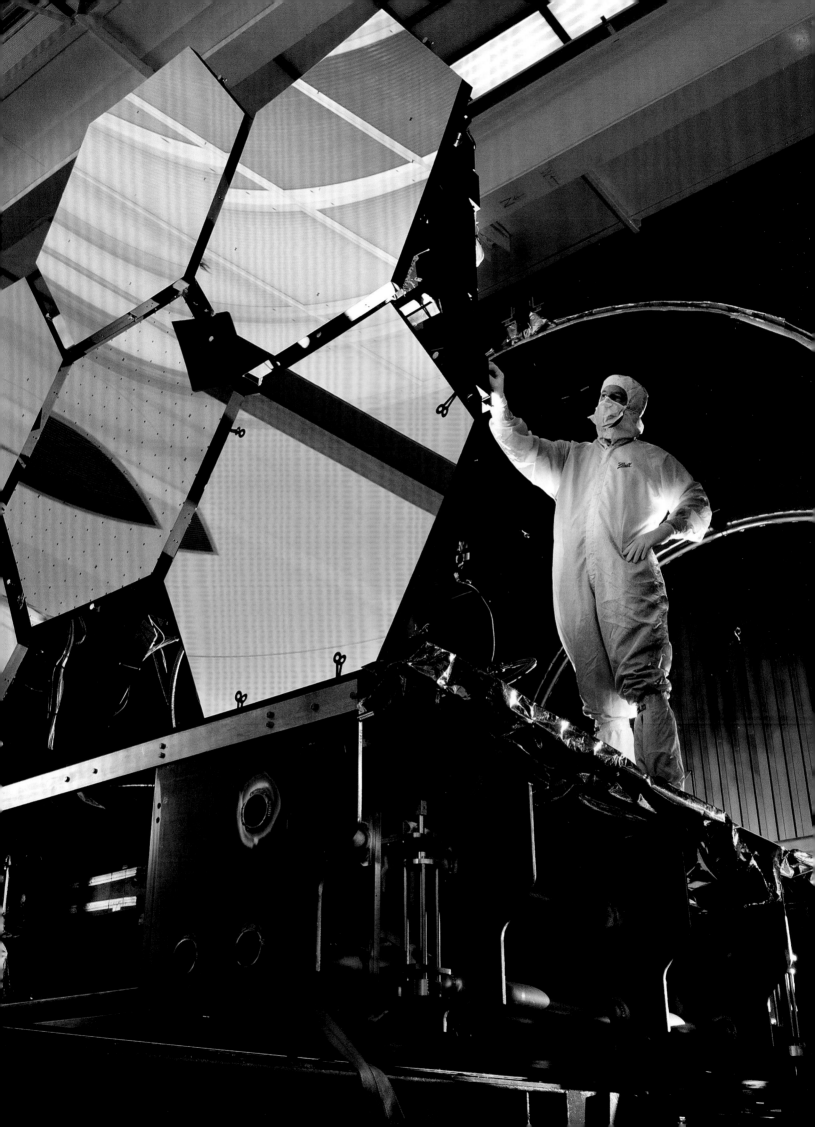

C1.1

Unprecedented precision

The major components of JWST, including the mirrors, the sunshield, and the instruments within the Integrated Science Instrument Module (ISIM), all needed to be individually engineered to precise specifications and then fitted together into a fully functional observatory: the most precise space telescope ever created.

① The first deployment and tensioning of JWST's sunshield in the same configuration it would reach once in space

② Harnesses within the ISIM are checked to ensure that the electronics compartment will operate correctly.

③ The science-instruments installation team gathers in a clean room at NASA's Goddard Space Flight Center to discuss upcoming work.

④ JWST's ISIM at the conclusion of a months-long test at extremely low temperatures in the Space Environment Simulator

⑤ An optical engineer examines two mirror segments, confirming they are ready to be assembled onto the final flight structure.

⑥ A clean tent is lowered over JWST's optical assembly to protect it from dust and dirt during transport from the clean room to the vibration and acoustic testing areas.

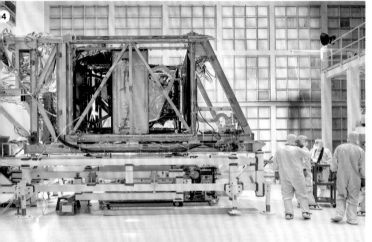

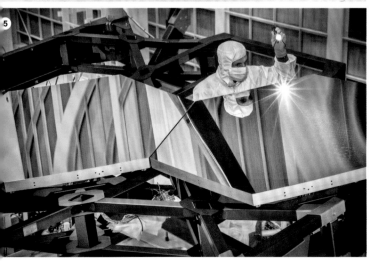

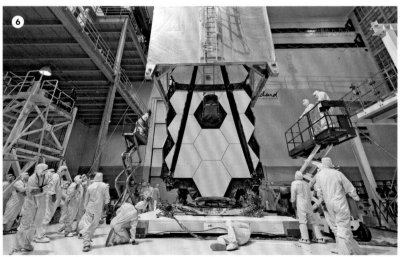

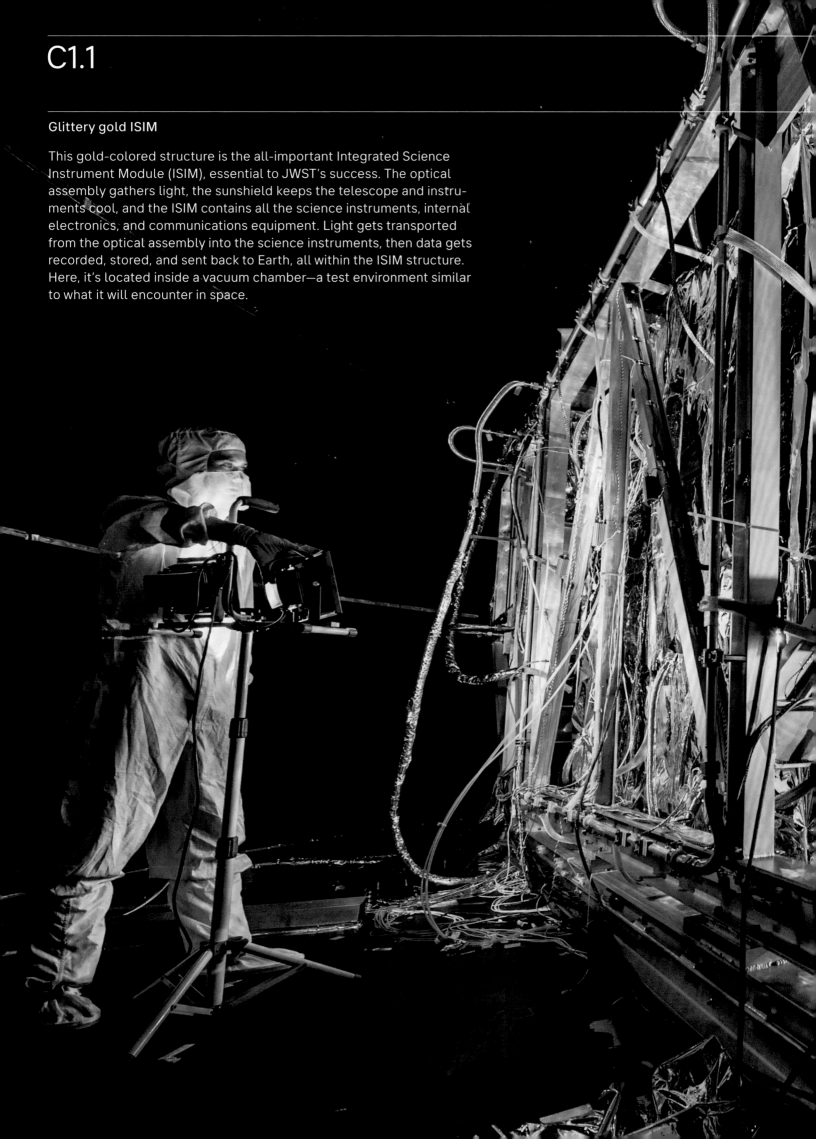

Glittery gold ISIM

This gold-colored structure is the all-important Integrated Science Instrument Module (ISIM), essential to JWST's success. The optical assembly gathers light, the sunshield keeps the telescope and instruments cool, and the ISIM contains all the science instruments, internal electronics, and communications equipment. Light gets transported from the optical assembly into the science instruments, then data gets recorded, stored, and sent back to Earth, all within the ISIM structure. Here, it's located inside a vacuum chamber—a test environment similar to what it will encounter in space.

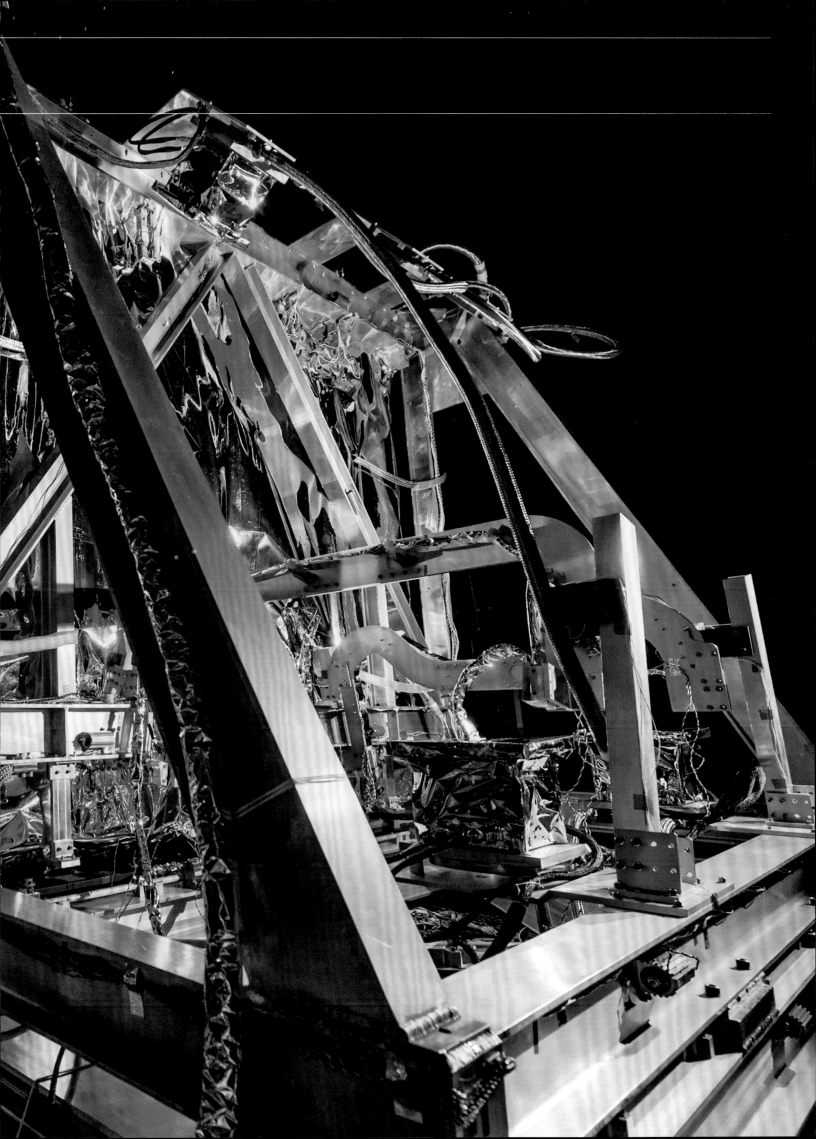

● **Expectations**

Owing to its novel instrument suite and large primary mirror optimized for infrared wavelengths, the accomplishments of the James Webb Space Telescope were expected to far surpass anything the Hubble Space Telescope, the Spitzer Space Telescope, or any other space-based telescope can teach us. Whereas Hubble can see only a little bit into the infrared—to a little over 2,000 nanometers in wavelength, about three times the maximum wavelength of visible light—JWST is sensitive to wavelengths up to 28,000 nanometers long, about 40 times the maximum wavelength of visible light. The larger diameter of its primary mirror—6.5 meters (21.3 ft)—not only gathers more than seven times the light that Hubble does but also achieves resolutions nearly three times as sharp.

Designed to be more sensitive to colder phenomena than the Hubble telescope is, JWST can reveal details in planet-forming disks, gas-rich galaxies, and star-forming regions that Hubble cannot access. Moreover, its long-wavelength sensitivity enables it to image fainter, more distant, more severely obscured objects than Hubble could ever reach. Finally, its spectroscopic capabilities perceive atomic and molecular signatures across greater cosmic distances than any other observatory can measure. All these design details contributed to the ultimate goal of the James Webb Space Telescope: a deeper, richer view of our universe than ever seen before.

A golden eye

The heart of JWST is its iconic golden primary mirror, composed of 18 hexagonal segments tiled together to create one uniform surface of curvature. The light from cosmic objects reflects off this surface to strike JWST's secondary mirror (connected to the folded-up struts that extend up above the top of this image), where it is then directed through the central opening of the primary mirror and into JWST's various instruments, yielding unprecedented scientific riches.

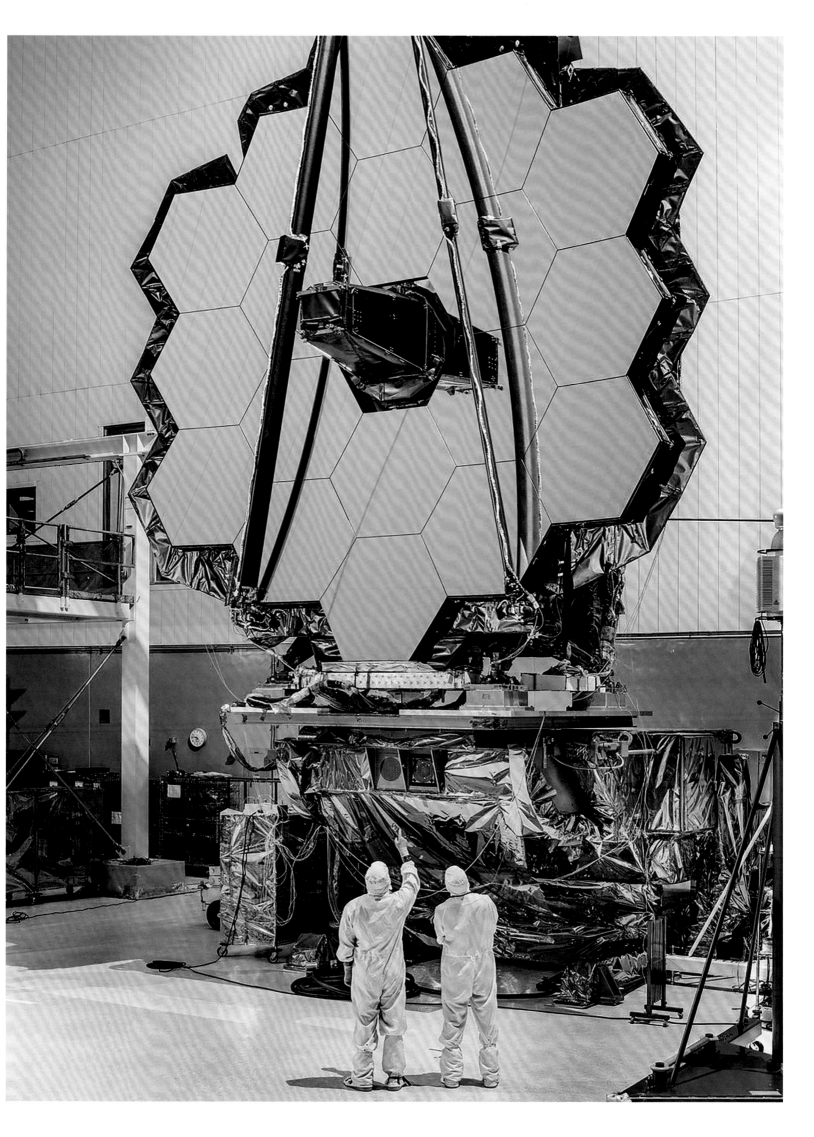

C1.2

Launch date: December 25, 2021

6.5 m (21.4 ft) tall

Primary mirror diameter:
6.5 meters (21.3 ft)

Size: Sunshield dimensions, 21.197 m x 14.162 m
(69.5 ft x 46.5 ft), comparable to a tennis court

Weight at launch:
Approx. 6,200 kg (13,700 lb)

Wavelength coverage:
0.6 to 28.5 microns

Distance from Earth: 1.5 million km (932,057 mi) at the L2 Lagrange po

Comparing three space telescopes

The Hubble and Spitzer Space Telescopes represent the first generation of NASA's Great Observatories, launched in 1990 and 2003, respectively. The next-generation James Webb Space Telescope, launched in 2021, is larger, more powerful, and capable of higher-resolution images—all features that enable it to gather information about the universe that was simply inaccessible to its predecessors.

2.4 m (7.9 ft) tall at small end	0.85 m (2.8 ft) tall at small end
Primary mirror diameter: 2.4 meters (7.9 feet)	Primary mirror diameter: 0.85 meter (2.8 feet)
Size: 13.2 m x 4.3 m (43.5 ft x 14 ft)	Size: 4 m x 85 cm (13 ft x 33.5 in)
Weight at launch: Approx. 10,800 kg (24,000 lb) Weight after servicing mission #4: Approx. 12,200 kg (27,000 lb)	Weight at launch: 950 kg (2,094 lb)
Wavelength coverage: 0.09–2.5 microns	Wavelength coverage: 3.6 to 160 microns
Distance from Earth: 525 km (326 mi) in low-Earth orbit	Distance from Earth: 210 million km (130 million mi) in Earth-trailing orbit

The early universe

JWST's unparalleled high-resolution and infrared-sensitive eyes are revealing the earliest galaxies, quasars, and black holes. The cosmic story of how the universe went from a pristine, star-free mix of hydrogen and helium to the rich collection of stars and galaxies we have today began only a few hundred million years after the big bang. JWST is giving us glimpses of earlier, more detailed views of the universe than ever before.

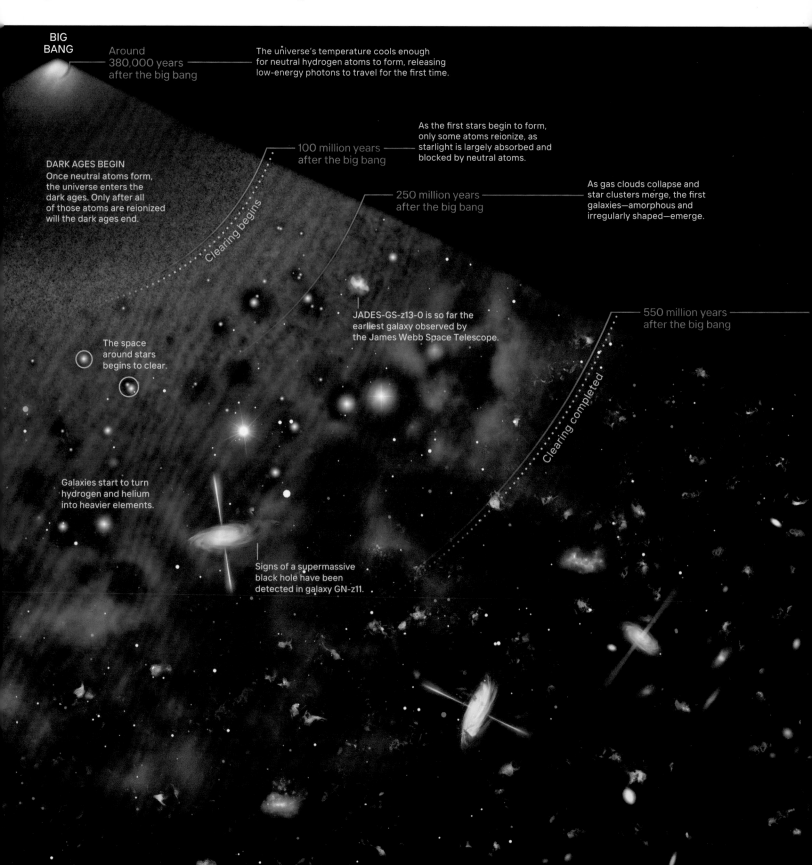

BIG BANG

Around 380,000 years after the big bang — The universe's temperature cools enough for neutral hydrogen atoms to form, releasing low-energy photons to travel for the first time.

100 million years after the big bang — As the first stars begin to form, only some atoms reionize, as starlight is largely absorbed and blocked by neutral atoms.

DARK AGES BEGIN
Once neutral atoms form, the universe enters the dark ages. Only after all of those atoms are reionized will the dark ages end.

250 million years after the big bang — As gas clouds collapse and star clusters merge, the first galaxies—amorphous and irregularly shaped—emerge.

Clearing begins

The space around stars begins to clear.

JADES-GS-z13-0 is so far the earliest galaxy observed by the James Webb Space Telescope.

550 million years after the big bang

Clearing completed

Galaxies start to turn hydrogen and helium into heavier elements.

Signs of a supermassive black hole have been detected in galaxy GN-z11.

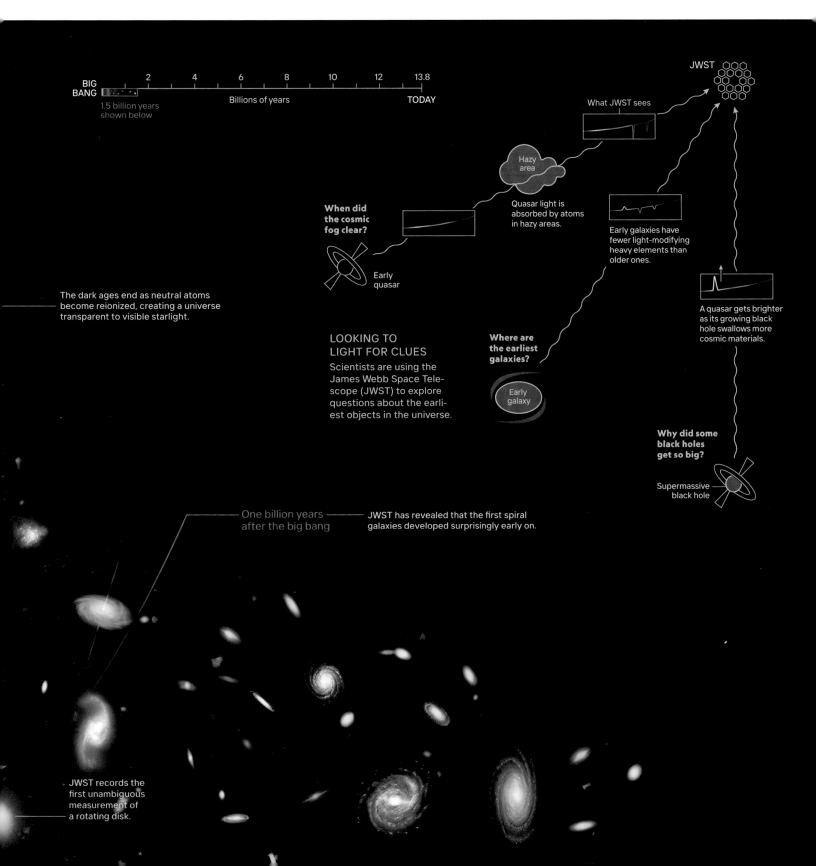

BIG BANG

2 4 6 8 10 12 13.8

1.5 billion years shown below

Billions of years

TODAY

JWST

What JWST sees

Hazy area

When did the cosmic fog clear?

Quasar light is absorbed by atoms in hazy areas.

Early galaxies have fewer light-modifying heavy elements than older ones.

Early quasar

The dark ages end as neutral atoms become reionized, creating a universe transparent to visible starlight.

A quasar gets brighter as its growing black hole swallows more cosmic materials.

LOOKING TO LIGHT FOR CLUES
Scientists are using the James Webb Space Telescope (JWST) to explore questions about the earliest objects in the universe.

Where are the earliest galaxies?

Early galaxy

Why did some black holes get so big?

Supermassive black hole

One billion years after the big bang

JWST has revealed that the first spiral galaxies developed surprisingly early on.

JWST records the first unambiguous measurement of a rotating disk.

JWST's Ring Nebula compared with Hubble's

Eventually, every star will reach the end of its life. For a sunlike star, that means blowing off its outer layers in a planetary nebula, while its core contracts down to form a white dwarf. Images of the Ring Nebula, Messier 57, from JWST (left) and Hubble (right) highlight different sets of features. While Hubble sees emitted and reflected visible light, JWST's infrared views spotlight the knots and cavities within the gases and plasmas, including a faint outer layer of hydrogen that's beyond Hubble's capabilities to reveal.

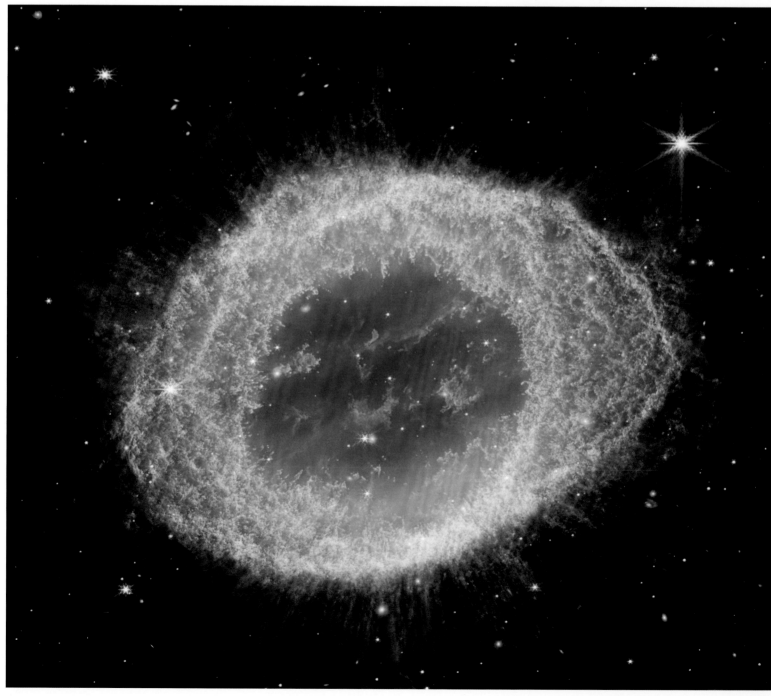

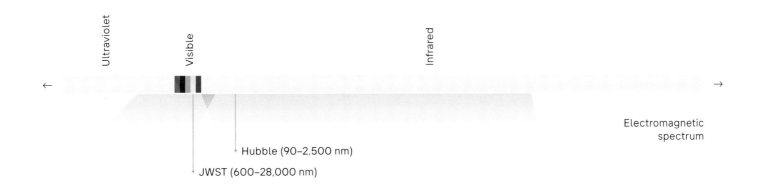

Ultraviolet

Visible

Infrared

Electromagnetic
spectrum

Hubble (90–2,500 nm)

JWST (600–28,000 nm)

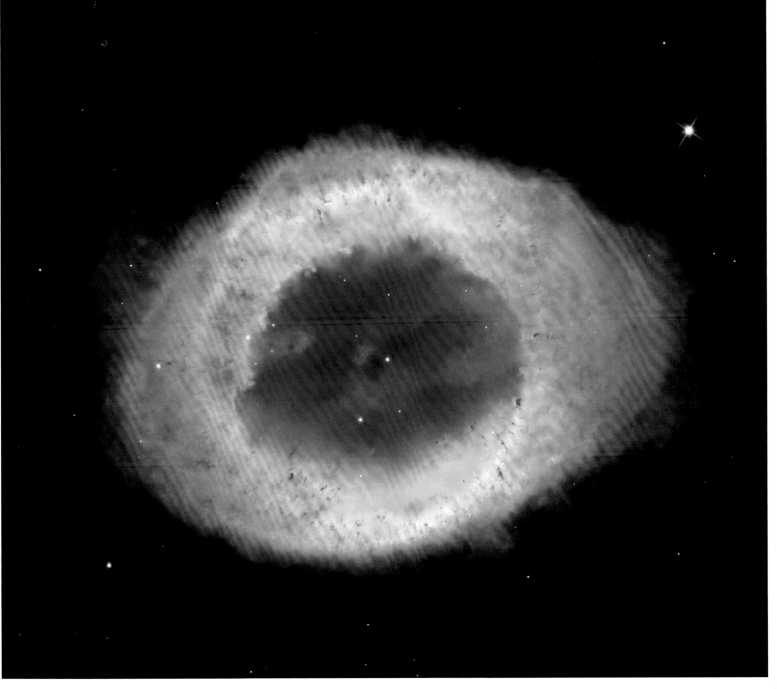

T-08.118.

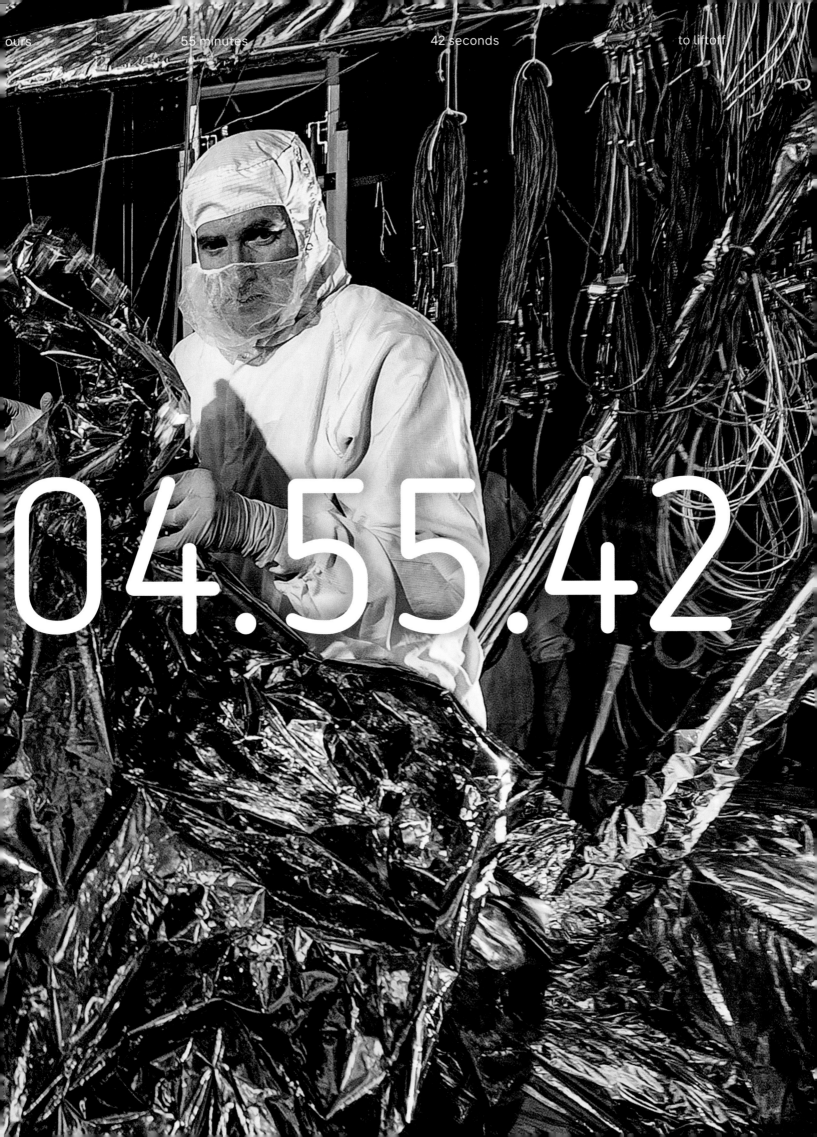

04.55.42

C1.3

● Instruments

In order to make the most of the light it collects, JWST is outfitted with four unique science instruments.

The Near-Infrared Camera (NIRCam) is JWST's main imager. Sensitive to light in the wavelength range from 550 to 5,000 nanometers, it can detect light from young, middle-age, and old stars and galaxies, ranging from those in our cosmic backyard to sources deeper than ever probed.

The Near-Infrared Spectrograph (NIRSpec) can teach us about the mass, temperature, and chemical composition of objects. By observing the fingerprints of atoms and molecules across cosmic distances, it can determine what's present inside an astronomical object from anywhere in the universe. NIRSpec gauges its targets and, controlling its focus with its microshutter array, can record the spectrum of more than 100 objects simultaneously.

The Mid-Infrared Instrument (MIRI) reveals cooler material, such as dust. Armed with both a camera and a spectrograph, it is particularly sensitive to distant galaxies and material in the outer reaches of stellar systems, including our own Kuiper belt. Designed to perceive wavelengths between 5,000 and 28,000 nanometers, MIRI offers capabilities unmatched by any other JWST instrument.

And finally, the Fine Guidance Sensor/Near-Infrared Imager and Slitless Spectrograph (FGS/NIRISS) helps both point and orient the telescope and also possesses unique capabilities for measuring the atmospheric contents of exoplanets.

All together, these four instruments help JWST achieve science goals inaccessible to any prior space telescope.

(previous) **Prepping for extreme temperature tests**

At the Goddard Space Flight Center, an engineer prepares JWST components for testing in a Space Environment Simulator, where temperature and pressure conditions simulate those of deep space. A thermal blanket must cover the wires running on the floor, to prevent the heat they generate from contaminating the test. To be declared flight-ready, JWST and all its components must be subjected to precisely the same conditions they will experience in space.

Putting the pieces together

Here, in 2016, the Integrated Science Instrument Module, with all instruments and electronics installed, is lowered onto the Optical Telescope Element of the observatory. In a room kept spotlessly clean, a crane lifts the science instrument package and lowers it onto an enclosure on the telescope's back, for engineers and technicians to secure the two elements together. The room is kept very quiet during this process, enabling the team to detect any problems via sight, touch, and sound.

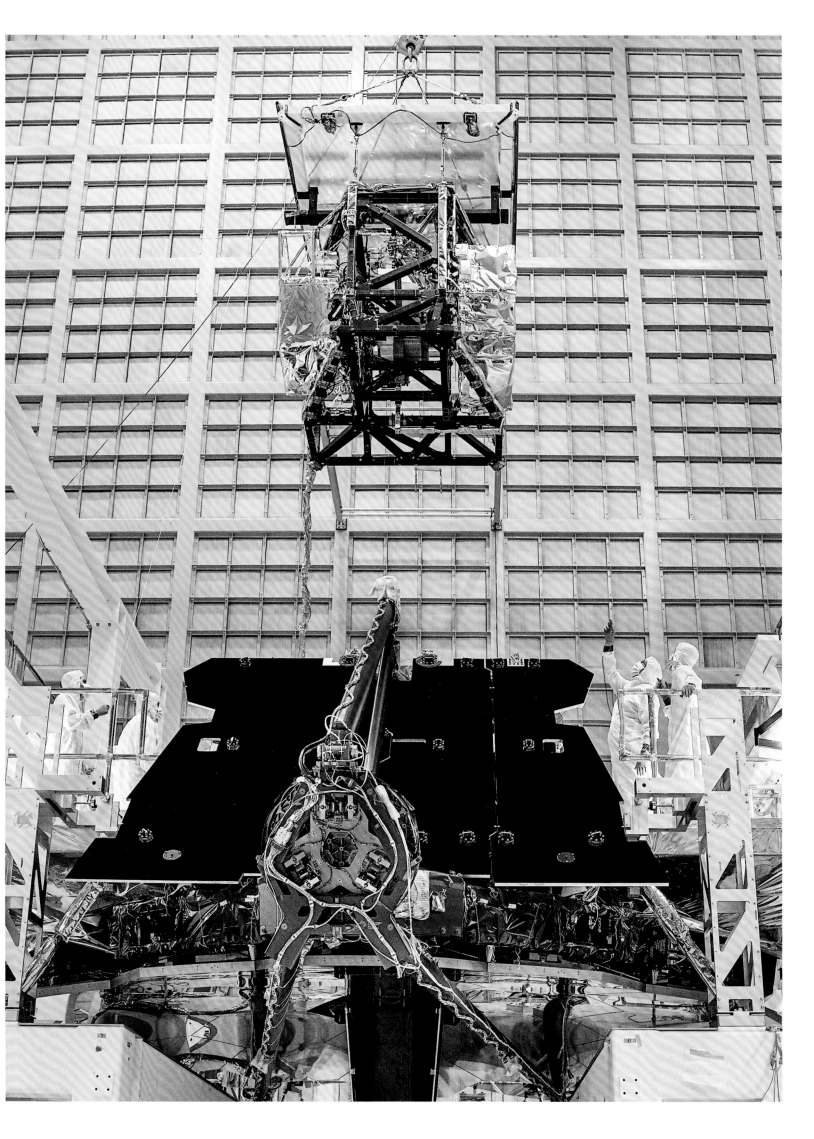

Four main science instruments

JWST's four primary instruments serve complementary purposes, from capturing images to guiding the observatory. All four instruments require intense cold to operate correctly, so the sunshield passively cools them down to about 37 kelvin (close to −400°F), which is adequate for three of the instruments: NIRCam, NIRSpec, and FGS/NIRISS. MIRI, however, must stay even colder, requiring an additional cryocooler to lower its temperature closer to absolute zero, down to about 6 kelvin (−449°F).

NIRCam NIRSpec MIRI FGS/NIRISS

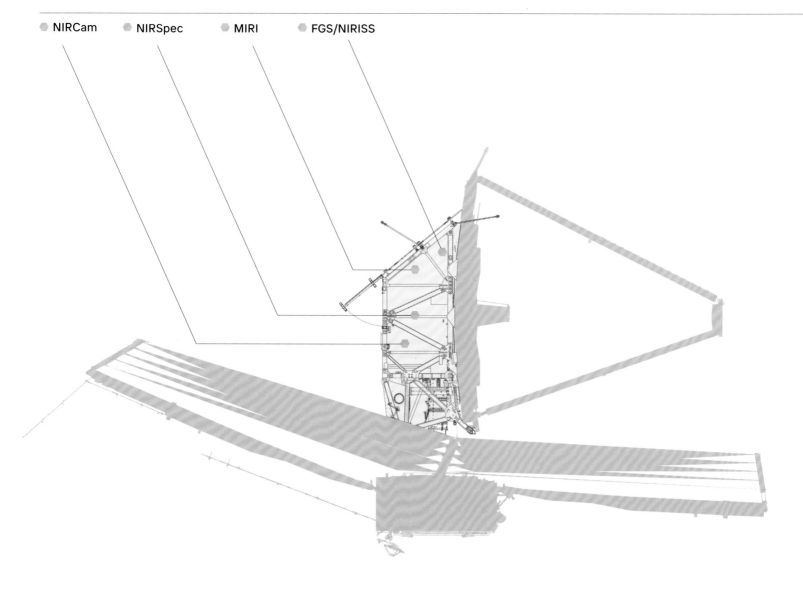

NIRCam
Near-Infrared Camera

NIRSpec
Near-Infrared
Spectrograph

MIRI
Mid-Infrared
Instrument

FGS/NIRISS
Fine Guidance Sensor/
Near-Infrared Imager and
Slitless Spectrograph

Instrument
Wavelength Range

0.6 to 5 micrometers

Instrument
Wavelength Range

0.6 to 5.3 micrometers

Instrument
Wavelength Range

4.9 to 28.8 micrometers

Instrument
Wavelength Range

0.6 to 5 micrometers

Gamma	Gamma	Gamma	Gamma
X-Ray	X-Ray	X-Ray	X-Ray
Ultraviolet	Ultraviolet	Ultraviolet	Ultraviolet
Visible Light	Visible Light	Visible Light	Visible Light
Near-Infrared	Near-Infrared	Near-Infrared	Near-Infrared
Mid-Infrared	Mid-Infrared	Mid-Infrared	Mid-Infrared
Far-Infrared	Far-Infrared	Far-Infrared	Far-Infrared
Microwave	Microwave	Microwave	Microwave

NIRCam

The Near-Infrared Camera (NIRCam) is the primary imager aboard JWST. It also serves other purposes, including precisely measuring properties of the observatory itself during calibration and commissioning operations. Here, an engineer uses a powerful 3D microscope to align the focal-plane-assembly detectors, essential to the operation of the 18 mirror segments. At the end of this process, the focal plane assembly will be ready to install onto NIRCam.

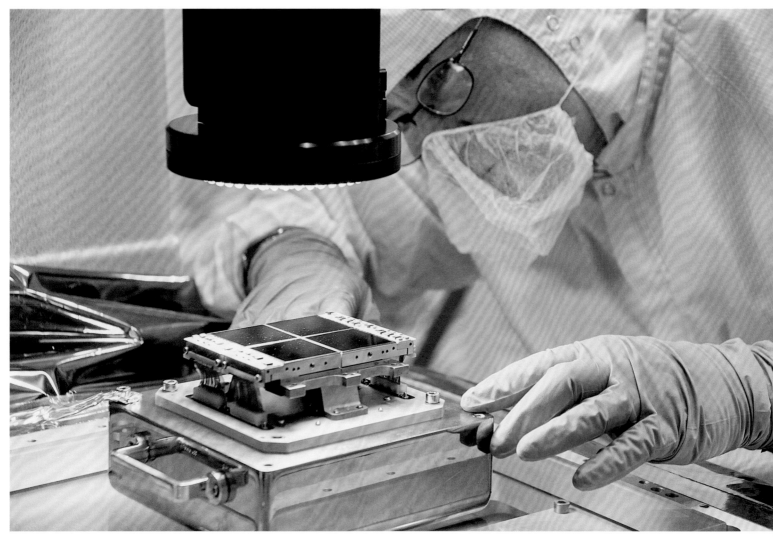

The Near-Infrared Spectrograph (NIRSpec), encased in a silver shroud at right, is responsible for taking spectra across near-infrared wavelengths. Although its field of view spans just 1/400 of a square degree (a unit of measurement meaning a square in the sky, one degree on each side), NIRSpec can break the light from more than 100 individual objects within that tiny field into their component wavelengths, thus taking a spectrum of those objects all at once. NIRSpec is the first multi-object spectrograph in space.

NIRSpec

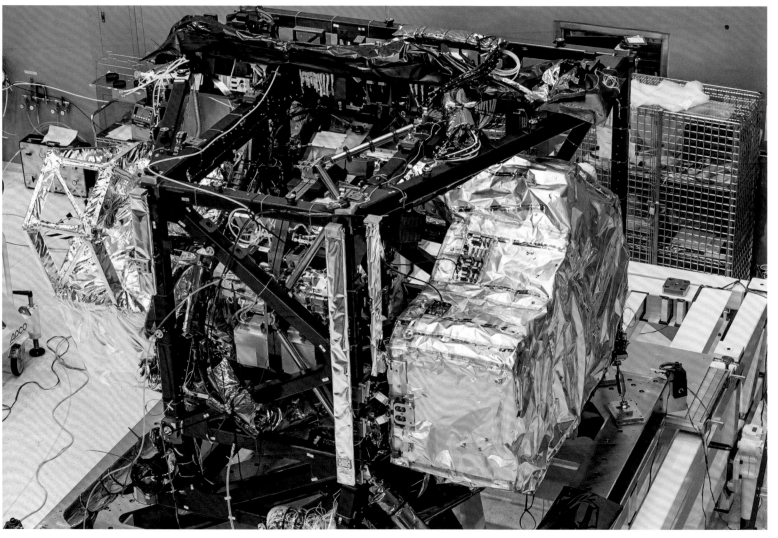

MIRI

The Mid-Infrared Instrument (MIRI) arguably represents JWST's greatest technological leap, with a sensitivity nearly 100 times that of its predecessor, NASA's Spitzer telescope. This all-in-one instrument performs both photometric and spectroscopic imaging within its field of view, and requires its own dedicated cryocooler (not shown in this photo) to keep it more than 30°C (54°F) cooler than the rest of the observatory.

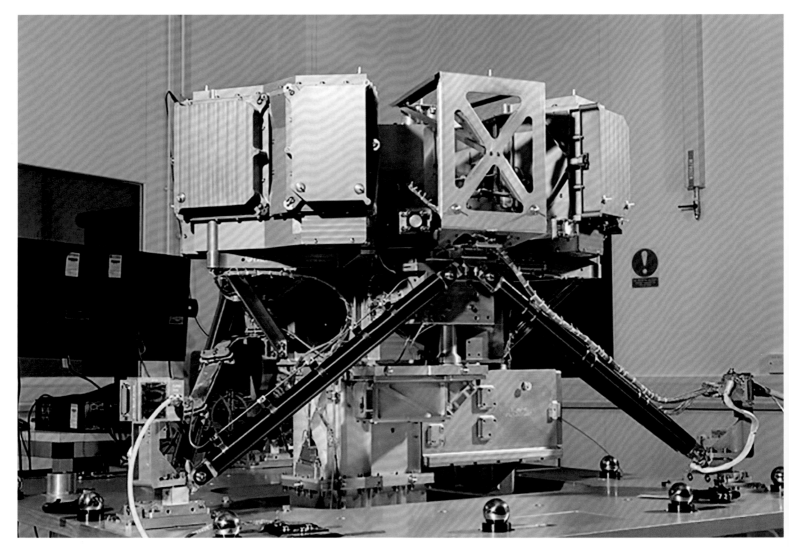

The Fine Guidance Sensor/Near-Infrared Imager and Slitless Spectrograph (FGS/NIRISS) is arguably the most essential instrument aboard, since it allows the observatory to orient itself and locate targets to point at. Produced by the Canadian Space Agency in partnership with NASA, it had to be draped at the end of each workday to protect all its components against contamination.

FGS/NIRISS

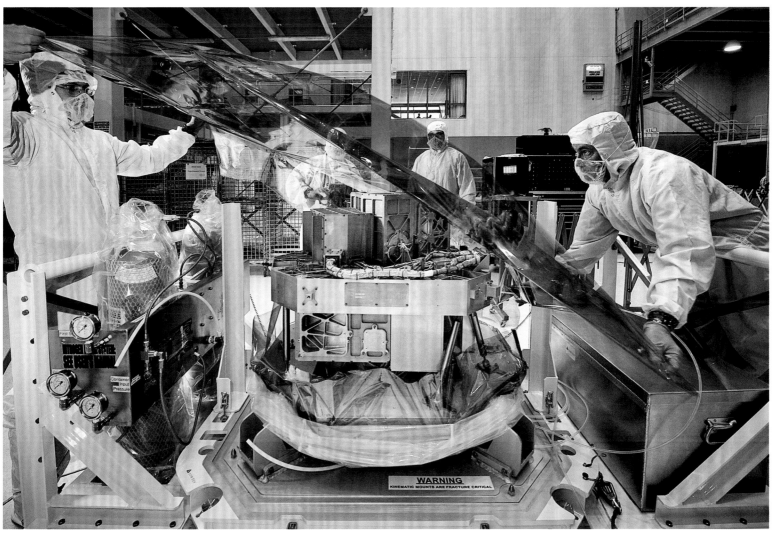

The folding mirror & optical assembly

The James Webb Space Telescope has the largest primary mirror of any space telescope ever, spanning 6.5 meters (21.3 ft) across. But despite having more than seven times the surface area and light-gathering power of the Hubble Space Telescope, it is actually much lighter than its smaller predecessor. JWST weighs in at 6,200 kilograms (13,700 lb), as opposed to Hubble's 12,200 kilograms (27,000 lb). This is no coincidence, but rather by design. The key to weight saving lies in the first-of-its-kind folding mirror and overall optical assembly.

Instead of having a single primary mirror, as Hubble does, JWST has a segmented design that allows for 18 primary mirror segments, each machined independently out of a strong, lightweight, nonreactive substrate of beryllium—one of Earth's lightest metals, one-third the weight of aluminum. Only the front surface of each segment serves an optical purpose, and so approximately 92 percent of the beryllium substrate was machined away from the rear, reducing JWST's total weight to well below Hubble's.

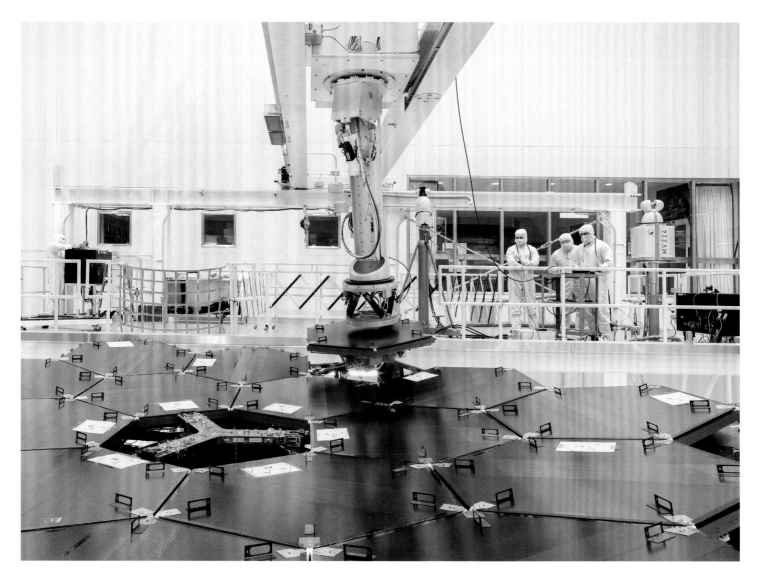

Final mirror installation

Here, in February 2016, the last of JWST's mirror segments are installed onto the backplane of the Optical Telescope Element. Covers still protect them as a robotic arm maneuvers the final segment into position. Each segment measures 1.3 meters (4.3 ft) end to end, and all combine to create one enormous mirror surface with a diameter of 6.5 meters (21.3 ft).

Struts and actuators attach to the back side of each segment, allowing each mirror to be precisely flexed, curved, and positioned relative to the others. When all 18 segments are aligned into a single plane, they produce a geometrically perfect surface with only minuscule variations in shape. These struts and actuators determine the shape of JWST's mirrors, enabling astronomers to image the universe with unprecedented precision.

On the front, outward-facing side of each of JWST's mirror segments, a series of thin coatings were deposited, including the gold coating that gives them their unique color and makes them highly reflective at infrared wavelengths. Since gold is much denser than beryllium, minimizing the thickness of these coatings to just 100 nanometers also helped minimize JWST's overall weight. Though JWST's mirror segments cover a surface area of 26.3 square meters (283 sq ft), it took only 48 grams (1.7 oz) of gold to coat all of them.

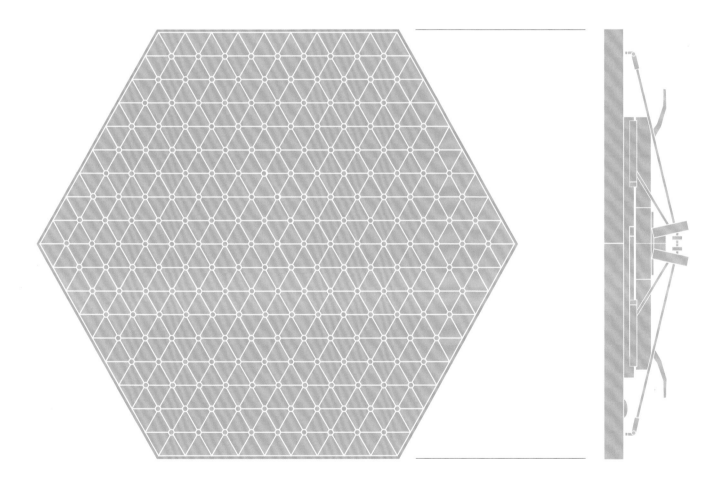

Watching the weight of mirrors

All the mirror segments, made of solid beryllium coated in gold, had enormous amounts of material removed from their back sides to reduce their weight. When first manufactured, the mirror segments each weighed about 250 kilograms (550 lb), but ultimately 92 percent of their mass was machined away, leaving each one weighing in at just 20.1 kilograms (44.3 lb) and only 1 millimeter (about 1/25 of an inch) thick. Actuators and other shaping and positioning apparatuses were then installed on their backs, bringing the overall mass of each primary mirror segment up to 39.5 kilograms (87 lb).

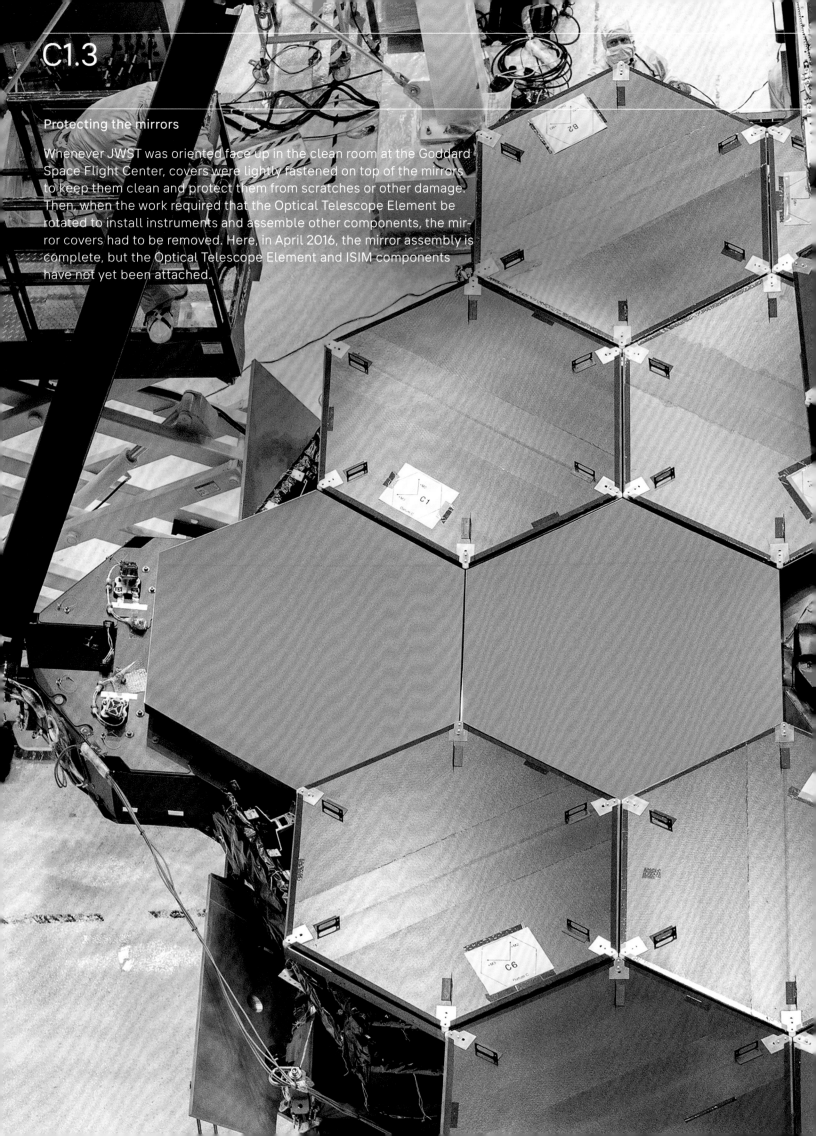

Protecting the mirrors

Whenever JWST was oriented face up in the clean room at the Goddard Space Flight Center, covers were lightly fastened on top of the mirrors to keep them clean and protect them from scratches or other damage. Then, when the work required that the Optical Telescope Element be rotated to install instruments and assemble other components, the mirror covers had to be removed. Here, in April 2016, the mirror assembly is complete, but the Optical Telescope Element and ISIM components have not yet been attached.

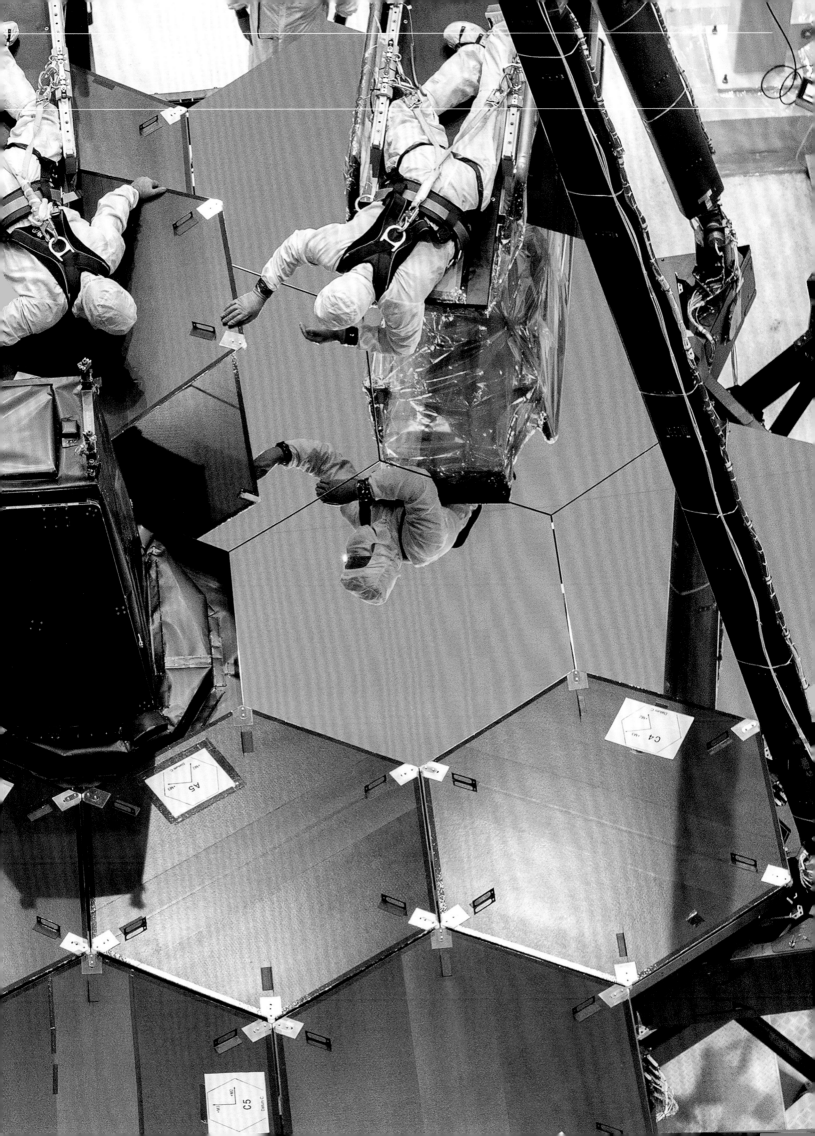

C1.4

● **Cooling technologies**

In order to observe the universe at infrared wavelengths, JWST's mirrors and instruments must be cooled. If they are too warm, then instead of seeing light from the distant objects JWST is attempting to observe, the instruments would be swamped by thermal noise—heat radiating from the telescope itself.

For NIRCam, NIRSpec, and FGS/NIRISS—the three instruments that rely on near-infrared wavelength observations—simply cooling everything down to 37 kelvin (nearly −400°F) is enough. At JWST's distance of 1.5 million kilometers (932,000 mi) from Earth, that temperature is achievable through purely passive cooling means, thanks to JWST's five-layer sunshield.

For MIRI, the Mid-Infrared Instrument, to receive light from wavelengths from 5,000 to 28,000 nanometers, colder temperatures are required. Hence, MIRI is outfitted with a specially designed low-vibration cryocooler that actively keeps it even colder than the other instruments: 7 kelvin (around −450°F).

This combination of passive and active cooling technologies enables JWST to make low-noise observations across the full spectrum of its infrared wavelength range.

The full mirror, in all its glory

More than 100 people worked during 2017 to confirm that JWST could withstand the frigid temperatures and other stresses it would experience at its final destination in outer space. Here JWST emerges from the enormous thermal-vacuum testing chamber at NASA's Johnson Space Center in Houston, Texas. Soon after, the Optical Telescope Element and ISIM were jointly put through a series of similar tests. Complicating these procedures, Hurricane Harvey lashed southeastern Texas in late August, dumping more than 125 centimeters (50 in) of rain in some areas of Houston and flooding NASA facilities.

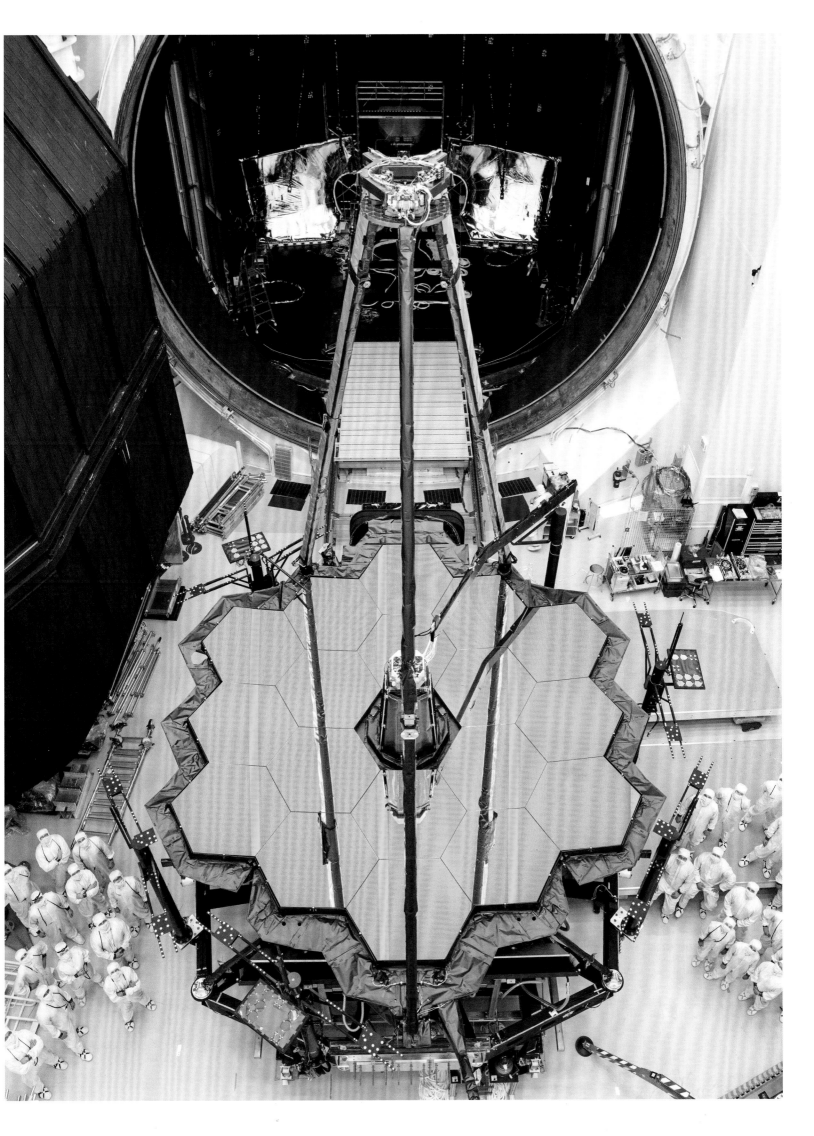

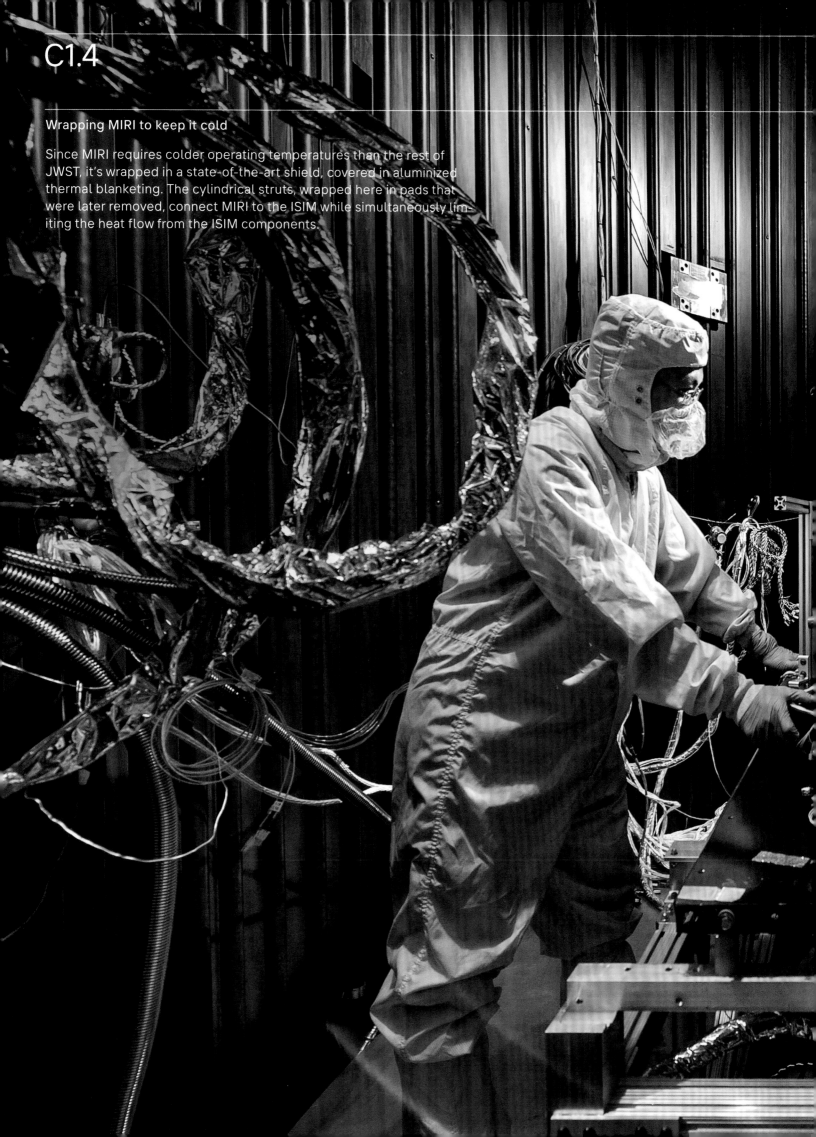

Wrapping MIRI to keep it cold

Since MIRI requires colder operating temperatures than the rest of JWST, it's wrapped in a state-of-the-art shield, covered in aluminized thermal blanketing. The cylindrical struts, wrapped here in pads that were later removed, connect MIRI to the ISIM while simultaneously limiting the heat flow from the ISIM components.

In order for JWST to achieve its unprecedented sensitivity at infrared wavelengths, it needs to stay cold. Its mirrors, optical assembly, and instruments all require temperatures no greater than about 50 kelvin (−370°F), colder than liquid nitrogen. Just as objects that get too hot will radiate at visible wavelengths, glowing red, orange, yellow, or even white-hot as temperatures rise, this same phenomenon causes objects that aren't kept sufficiently cold to radiate at infrared wavelengths. This is the primary reason why the Hubble Space Telescope, in low Earth orbit and coated in reflective mate-rial, cannot reliably probe wavelengths beyond about two microns: It's simply too warm. That heat creates thermal noise, preventing the telescope from acquiring reliable data at these longer wavelengths.

JWST, at the L2 Lagrange point, is sufficiently distant from Earth to shield it from our planet's thermal emissions. It's always in direct sunlight, however, and therefore the entire telescope must be shielded continuously from the sun's radiation. The novel solution, implemented for the first time aboard JWST, is a five-layer passive cooling system known as

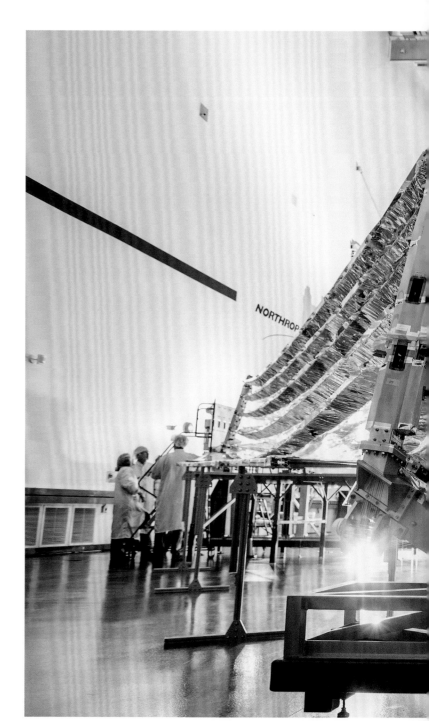

Five-layer sunshield

During a 2014 test, all five of the sunshield's layers were unfolded, tensioned, and separated for the first time. Thanks to the five-layer structure of the sunshield, the telescope always has a warm side that faces the sun and a cool side that successfully shields the telescopes, instruments, and electronics from the sun. The interior layers reflect and shunt heat out of the openings on all sides. This design protects the telescope and its elements, keeping them passively cooled to between 42 and 37 kelvin (−384°F and −393°F).

a sunshield. The five layers, each roughly the size of a tennis court, were folded up around the two sides of the telescope in a zigzag pattern to fit within the launch vehicle. Once JWST was released from the launch vehicle, the sunshield unfolded early on in the deployment process, achieving its stretched and tensioned position and beginning its cooling work before any of the mirror segments or instruments were deployed or commissioned.

The sunshield layers deployed similarly to how a skydiver's parachute does, unfolding and stretching out to form a diamond-like shape that shields the telescope and instrument module from the sun. The outer layer on the sun-facing side is optimized for maximum reflectivity, reaching temperatures of up to 383 kelvin (230°F), while the inner layers are cooler, designed to successively radiate heat away from the telescope and its instruments. The inside of the coldest layer typically sits between 32 and 42 kelvin (around −400°F), rendering the mirrors and instruments cold enough for the infrared observing that JWST was designed to perform.

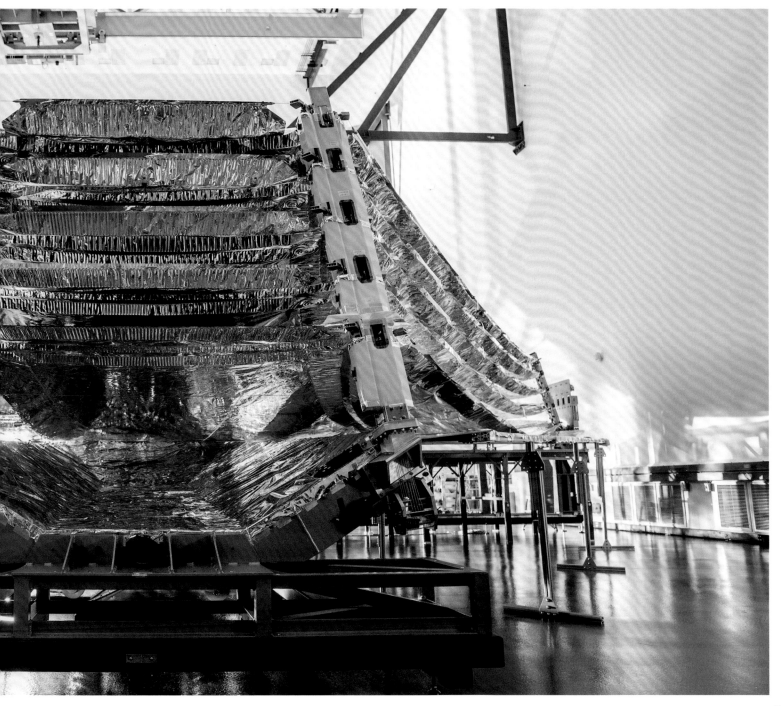

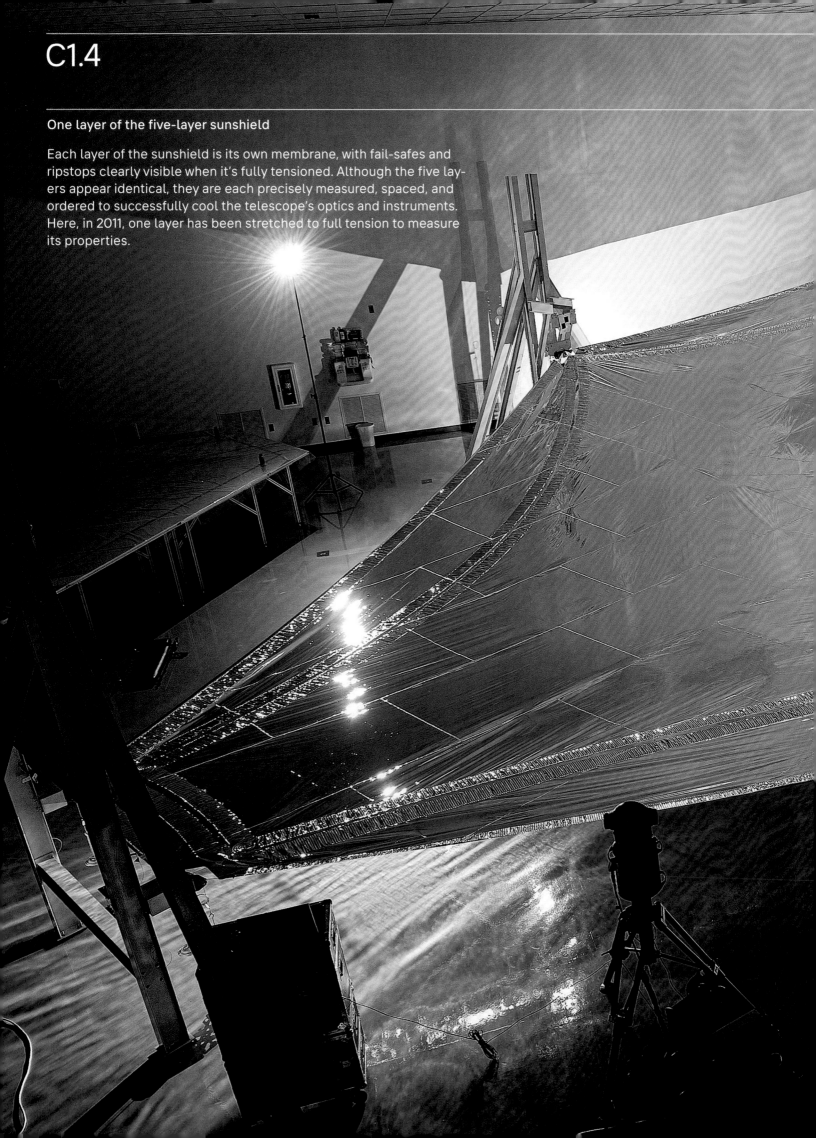

C1.4

One layer of the five-layer sunshield

Each layer of the sunshield is its own membrane, with fail-safes and ripstops clearly visible when it's fully tensioned. Although the five layers appear identical, they are each precisely measured, spaced, and ordered to successfully cool the telescope's optics and instruments. Here, in 2011, one layer has been stretched to full tension to measure its properties.

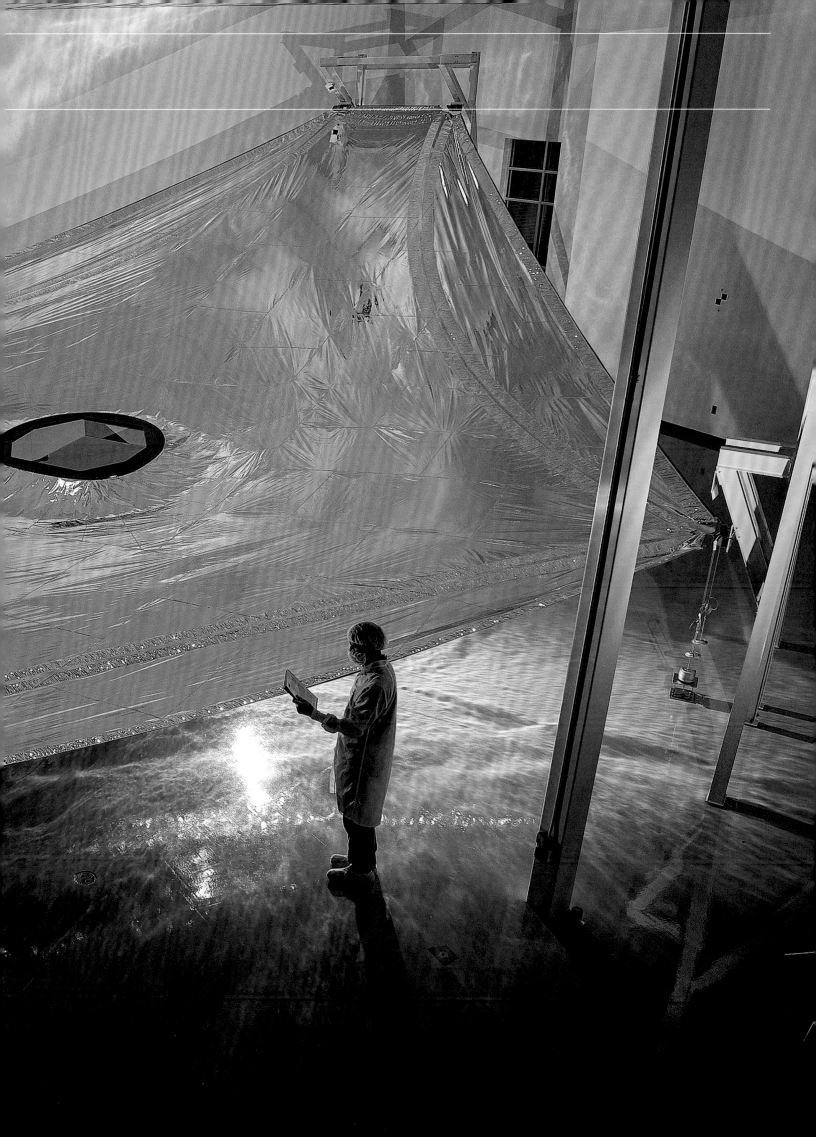

C1.5

⬤ Testing & inspection

When it came to the James Webb Space Telescope, NASA's famous mantra "Failure is not an option" was of paramount importance. The most ambitious space telescope of all time would have been a total loss if it didn't launch and deploy correctly, and that meant there was no margin for error. Every screw had to remain tight during launch; every fastener had to release at the proper moment of deployment and not before; communications systems had to remain continuously operational; and every component had to remain undamaged through all the stresses experienced during the launch, deployment, and journey through the vacuum of space. Without total success at every stage, including a successful orbital insertion, JWST would have simply become the most expensive piece of space junk ever launched.

The only way to ensure success was to stress-test the telescope and its components at every stage, making sure that they remained assembled and undamaged by any of the motion and pressure extremes JWST would encounter. Any failures—and there were a few—had to be analyzed, fixed, and overcome prior to the telescope being declared flight-ready. Only after passing the full suite of checkpoints from NASA and Northrop Grumman (the primary contractor responsible for JWST's construction) could JWST be cleared for launch— a process that required years of painstaking work.

Lights out

The ghostly blurs in this long-exposure photo are actually engineers and technicians at work during a lights-out inspection of JWST at the Goddard Space Flight Center. Technicians and contamination control engineers inspected the telescope after vibration and acoustic testing, using specialized ultraviolet flashlights to reveal contaminants that show up better in the dark.

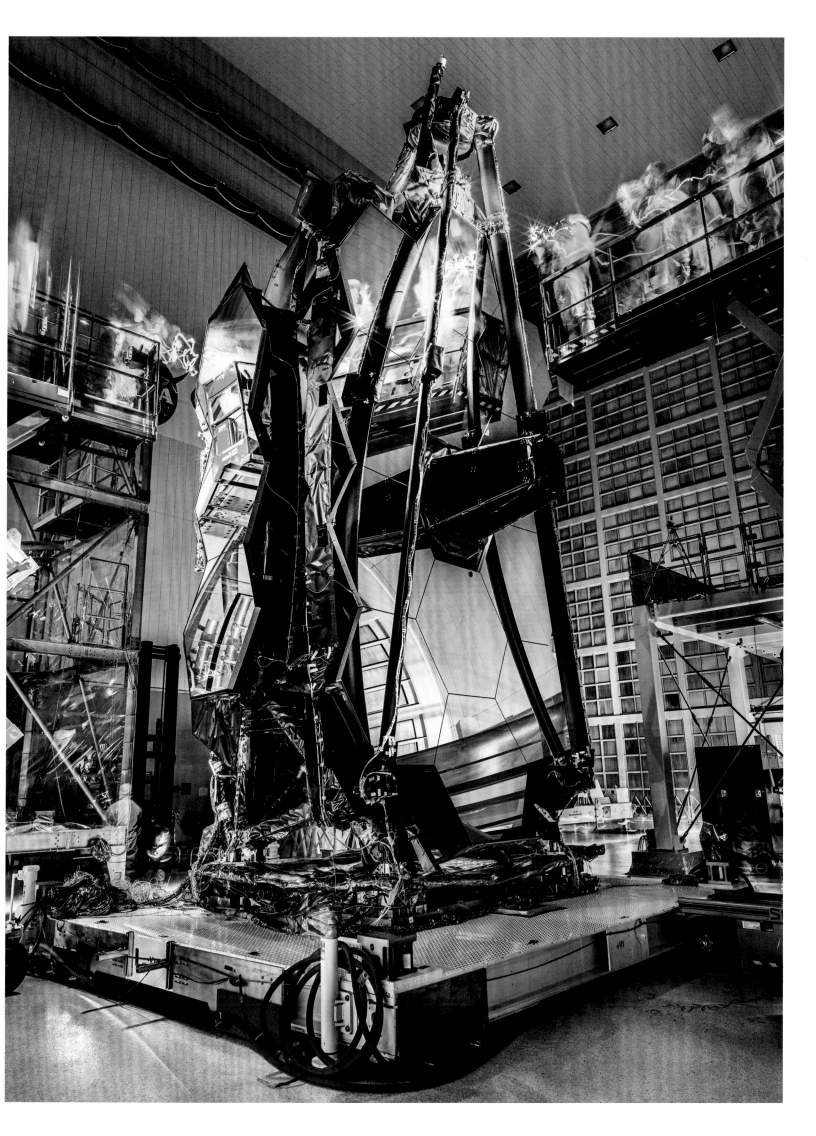

Years of extensive testing

Every component of JWST was tested over and over. First came the comprehensive systems tests to check the software and electrical systems—executing more than a thousand instruction sequences until each could be repeated flawlessly. Next, ground segment testing via a network emulating NASA's Deep Space Network confirmed that JWST would respond to commands—not only Turn On and Move but also operational commands to instruments. Most nail-biting of all, acoustic and vibrational tests simulated deafening noise, jarring shakes, cacophonous rattles, and relentless vibrations—the rigors of launch. After one more comprehensive systems test and a full systems evaluation, JWST was ready to be stowed and shipped for launch.

① Cables are hooked up to send commands to power on and test JWST's science instruments.

② Lacing cords securely attach thermal blankets to JWST without exposing any sticky adhesives.

③ Removing the lens cap from JWST's aft optics subsystem enables light to be sent to the observatory's tertiary and steering mirrors.

④ During testing and inspection, all five layers of the JWST sunshield, including its associated hardware, are stretched and tensioned at full-scale.

⑤ Behind the primary mirror of JWST are protective thermal and optical barriers, here being inspected by a blanket technician and an optical engineer.

⑥ Inside the giant thermal vacuum test chamber at NASA's Johnson Space Center is JWST Pathfinder, a test version of the telescope, wrapped in thermal blanketing.

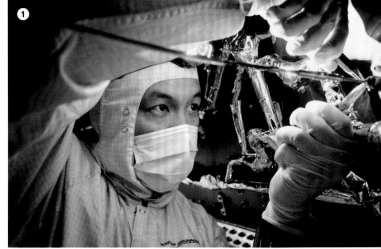

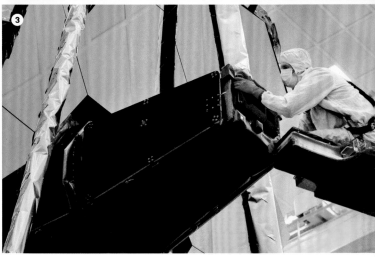

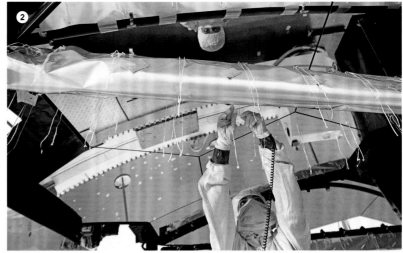

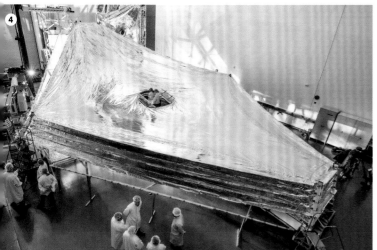

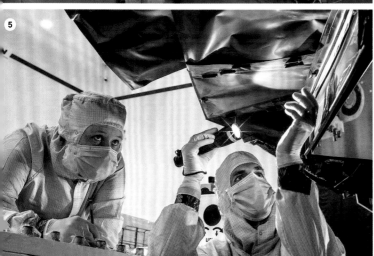

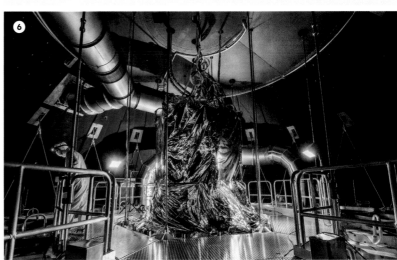

T-05.71.

12.02.53

Cleanliness

One of the hazards facing JWST and its components during assembly and testing was the presence of dust, dirt, oils, and other contaminants. Without sufficient precautions, they could easily get into the telescope, degrading its performance. A single touch to a mirror from a human finger, for example, would make a catastrophic difference in the telescope's optical performance. For this reason, the telescope's mirrors, instruments, sunshield, and supporting systems were all kept in the cleanest of clean rooms ever designed and maintained. Technicians who worked on JWST were required to wear full-body suits that prevented human skin or breath from touching the telescope. A special type of dry ice "snow" was developed should JWST's mirrors require extra cleaning, as more conventional methods would have risked imprinting scratches on the mirrors' surfaces.

Over the years of building JWST, a great many advances in clean-room technologies ensured that it would be not just the largest and most powerful space observatory ever flown, but also the cleanest of all time—from its mirror surfaces to its instruments and electronics.

(previous) **Center of curvature**

To measure the shape created by all 18 mirror segments working together, light reflected off the mirror is compared with light from a hologram representing the ideal JWST mirror-surface shape. This 2016 white-light inspection occurred both before and after vibration and acoustic testing, thus revealing any degradation induced by those tests.

The art of cleanliness

A contamination control engineer at the Goddard Space Flight Center inspects an enormous wall of filters that help keep the clean room free of dust, dirt, oils, and other contaminants. The darker squares have already filtered out particulates. Advances in clean-room technology have ensured that JWST is more pristine than any of the previous generation of NASA space telescopes.

C1.6

Snow blasting

To keep JWST's polished, gold-coated mirrors clean and scratch free, technicians can blast them with "snow" made of frozen carbon dioxide (dry ice)—a process used only if some unfortunate contamination occurs. Here, the process is being tested on a replica mirror.

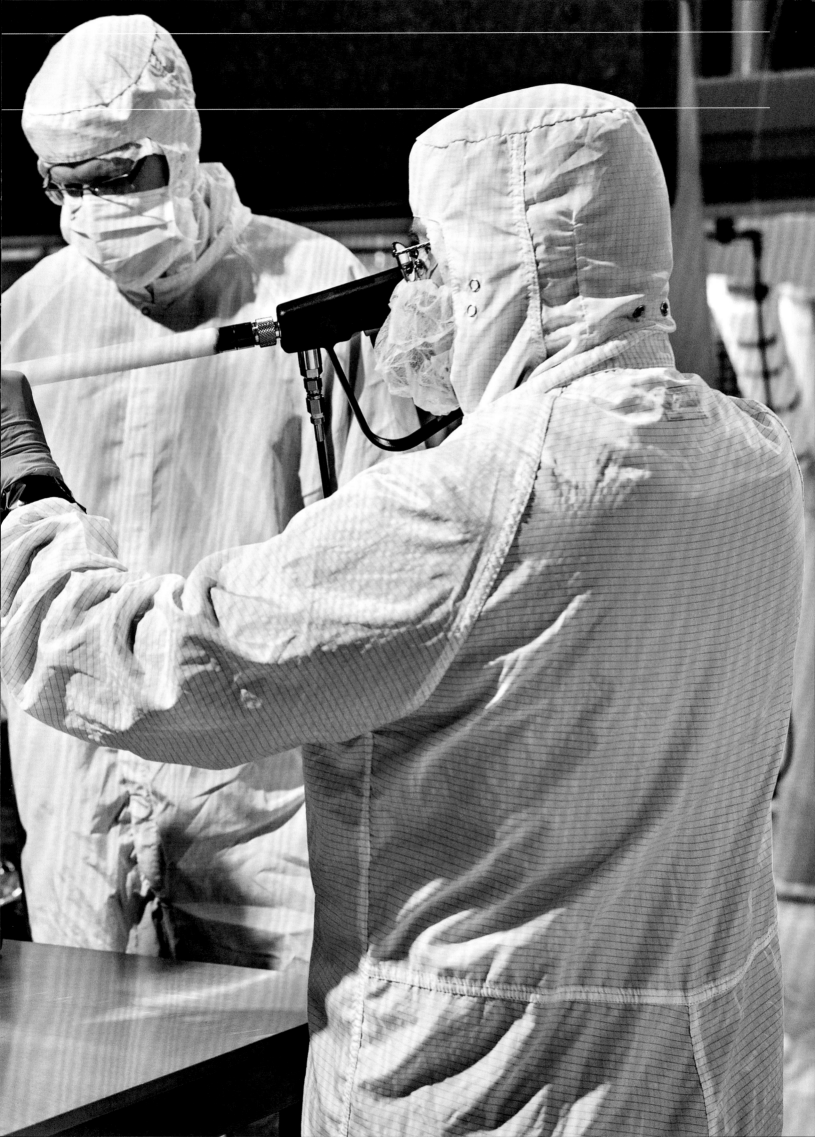

C1.6

NASA reflected

Although primarily designed to reflect and focus infrared light, JWST's mirrors also reflect visible wavelengths of light, as seen in this 2017 image. It also shows the majesty and scale of the fully unfolded primary mirror as well as the struts, which hold the secondary mirror, here in their stowed and upright positions. Once the final testing and inspection were completed, the mirrors were folded up so that the full observatory could be transported.

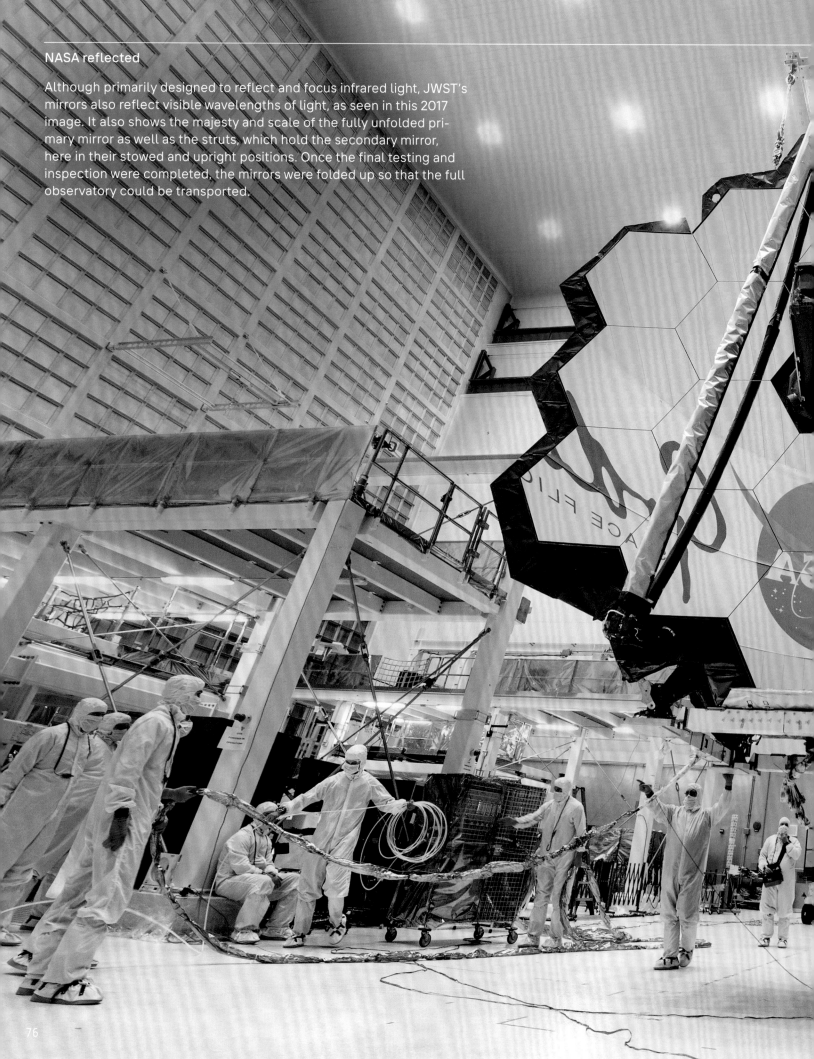

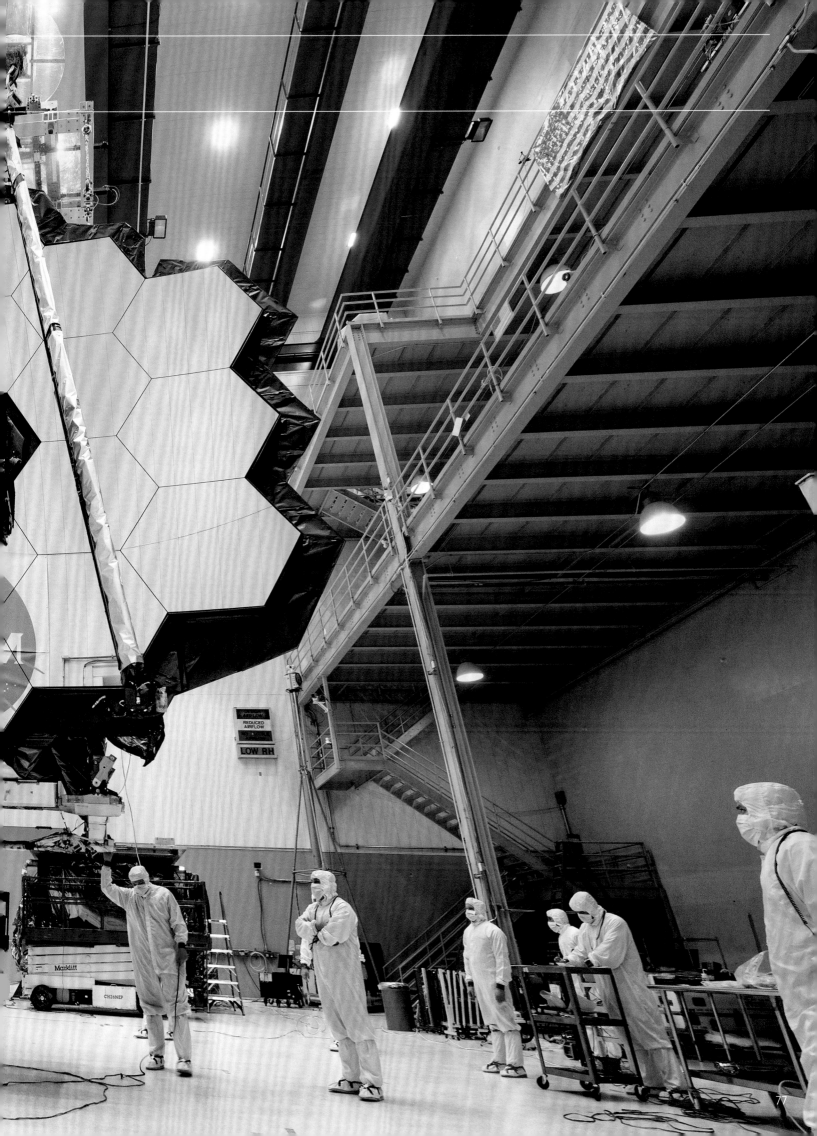

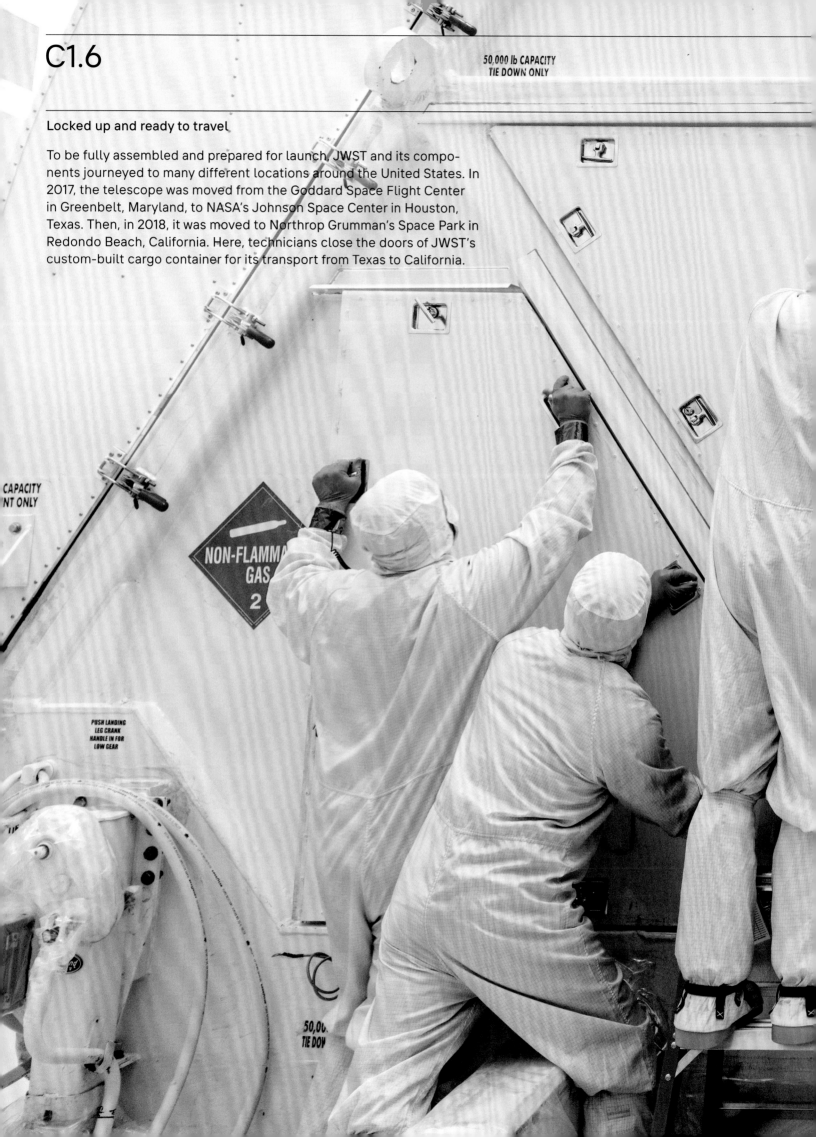

Locked up and ready to travel

To be fully assembled and prepared for launch, JWST and its components journeyed to many different locations around the United States. In 2017, the telescope was moved from the Goddard Space Flight Center in Greenbelt, Maryland, to NASA's Johnson Space Center in Houston, Texas. Then, in 2018, it was moved to Northrop Grumman's Space Park in Redondo Beach, California. Here, technicians close the doors of JWST's custom-built cargo container for its transport from Texas to California.

50,000 lb CAPACITY
TIE DOWN ONLY

CAPACITY
NT ONLY

NON-FLAMMA
GAS
2

PUSH LANDING
LEG CRANK
HANDLE IN FOR
LOW GEAR

50,00
TIE DOW

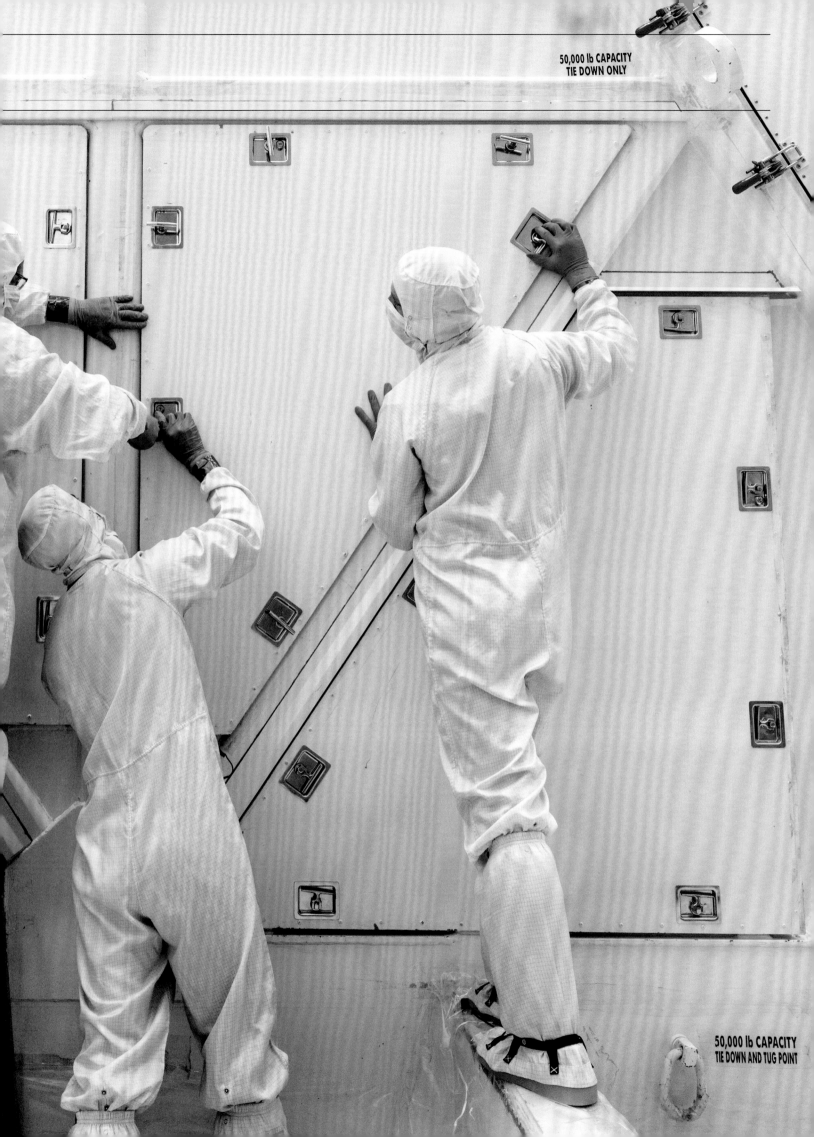

50,000 lb CAPACITY
TIE DOWN ONLY

50,000 lb CAPACITY
TIE DOWN AND TUG POINT

C2

Chapter 2 Launch & Deployment

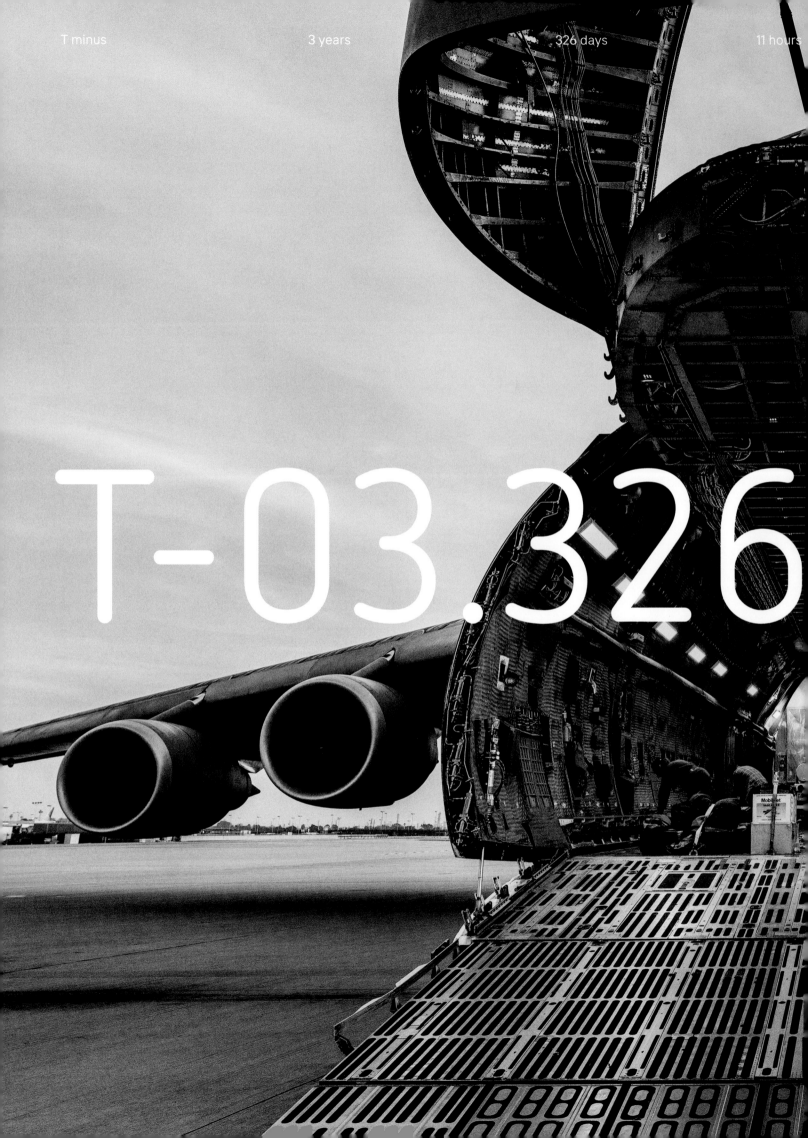

T-03.326

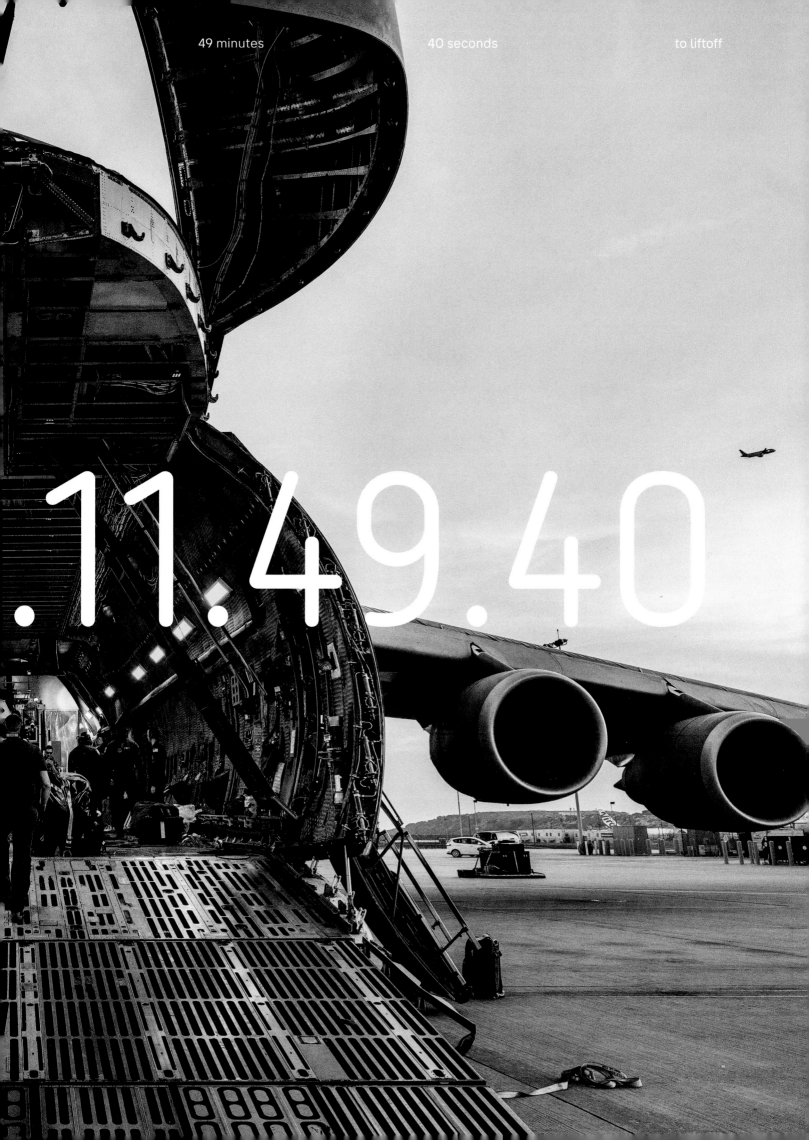

.11.49.40

Ready to go

After decades of planning, designs and redesigns, component construction and integration, and full systems testing, the James Webb Space Telescope was finally deemed ready for launch in 2021. Tens of thousands of hours of work by thousands of scientists, engineers, and technicians would come down to a few critical moments that would determine whether JWST would be humanity's greatest space telescope or the most expensive failure in space exploration history.

Everything had to go exactly right. The entire observatory needed to be packed, stowed, and shipped from the United States to French Guiana. The telescope had to be packed inside the Ariane 5 rocket that would launch it. The launch itself had to release JWST at the critical moment on the right trajectory at the proper speed to reach the L2 Lagrange point.

Once in space, each component had to successfully deploy, from the solar panels to the optical assembly to the sunshield and more. The thrusters needed to fire to insert the telescope into orbit. Much of the fuel on board JWST would be expended in reaching its distant destination, and however much fuel was left would determine the overall lifetime of the telescope. Astronomers planned for a mission lifetime of at least five and a half years, perhaps even 10. Everything we hoped to accomplish with JWST hinged on the success of its launch and deployment.

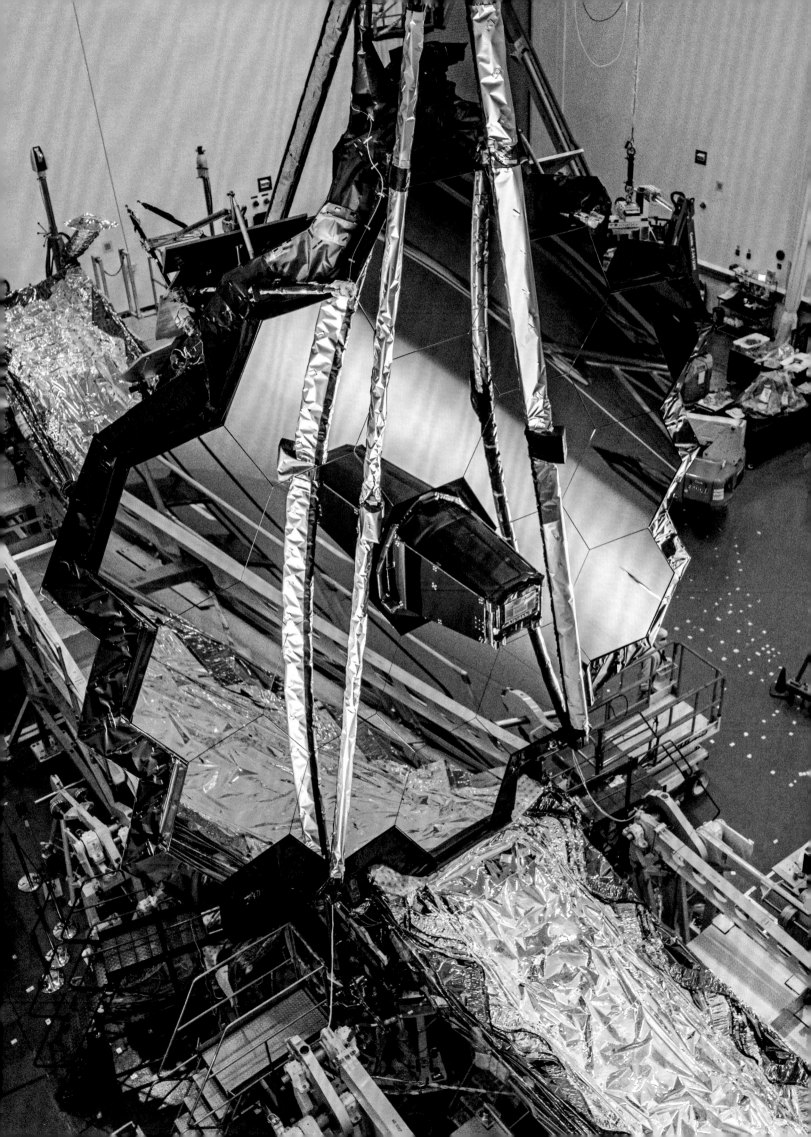

Global collaboration

With thousands of scientists, engineers, and technicians from more than a dozen countries participating in the enterprise, the James Webb Space Telescope represents a truly global effort to probe the universe as never before. With large contributions from NASA, plus instruments from the European Space Agency (ESA) and the Canadian Space Agency (CSA) and a launch vehicle procured by ESA, JWST represents humanity's greatest space telescope of the 21st century.

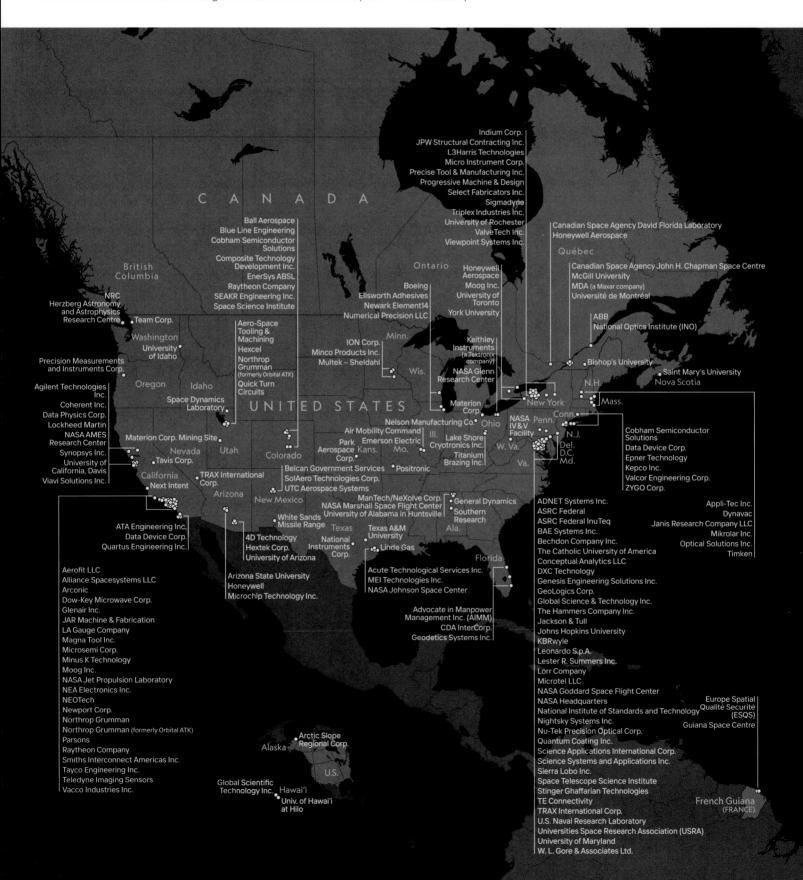

CANADA

British Columbia

Québec

Ontario

UNITED STATES

Washington

Oregon

Idaho

Nevada

Utah

Colorado

California

Arizona

New Mexico

Texas

Minn.

Wis.

Ill.

Kans.

Mo.

Ohio

W. Va.

Va.

Ala.

Florida

New York

Penn.

N.J.

Del.

D.C.

Md.

Conn.

Mass.

N.H.

Nova Scotia

Alaska

U.S.

Hawai'i

French Guiana (FRANCE)

Indium Corp.
JPW Structural Contracting Inc.
L3Harris Technologies
Micro Instrument Corp.
Precise Tool & Manufacturing Inc.
Progressive Machine & Design
Select Fabricators Inc.
Sigmadyne
Triplex Industries Inc.
University of Rochester
ValveTech Inc.
Viewpoint Systems Inc.

Ball Aerospace
Blue Line Engineering
Cobham Semiconductor Solutions
Composite Technology Development Inc.
EnerSys ABSL
Raytheon Company
SEAKR Engineering Inc.
Space Science Institute

NRC Herzberg Astronomy and Astrophysics Research Centre

Team Corp.

Aero-Space Tooling & Machining
Hexcel
Northrop Grumman (formerly Orbital ATK)
Quick Turn Circuits

University of Idaho

Precision Measurements and Instruments Corp.

Agilent Technologies Inc.
Coherent Inc.
Data Physics Corp.
Lockheed Martin
NASA AMES Research Center
Synopsys Inc.
University of California, Davis
Viavi Solutions Inc.

Space Dynamics Laboratory

Materiel Corp. Mining Site

Tavis Corp.

TRAX International Corp.

Next Intent

ION Corp.
Minco Products Inc.
Multek – Sheldahl

Boeing
Ellsworth Adhesives
Newark Element14
Numerical Precision LLC

Honeywell Aerospace
Moog Inc.
University of Toronto
York University

Keithley Instruments (a Tektronix company)

NASA Glenn Research Center

Materion Corp.

Nelson Manufacturing Co.

Air Mobility Command
Park Aerospace Corp.

Emerson Electric

Lake Shore Cryotronics Inc.

Titanium Brazing Inc.

NASA IV&V Facility

Canadian Space Agency David Florida Laboratory
Honeywell Aerospace

Canadian Space Agency John H. Chapman Space Centre
McGill University
MDA (a Maxar company)
Université de Montréal

ABB
National Optics Institute (INO)

Bishop's University

Saint Mary's University

Cobham Semiconductor Solutions
Data Device Corp.
Epner Technology
Kepco Inc.
Valcor Engineering Corp.
ZYGO Corp.

Belcan Government Services
SolAero Technologies Corp.
UTC Aerospace Systems

Positronic

ManTech/NeXolve Corp.
NASA Marshall Space Flight Center
University of Alabama in Huntsville

White Sands Missile Range

General Dynamics
Southern Research

Texas A&M University

4D Technology
Hextek Corp.
University of Arizona

National Instruments Corp.

Linde Gas

Arizona State University
Honeywell
Microchip Technology Inc.

Acute Technological Services Inc.
MEI Technologies Inc.
NASA Johnson Space Center

Advocate in Manpower Management Inc. (AIMM)
CDA InterCorp.
Geodetics Systems Inc.

ATA Engineering Inc.
Data Device Corp.
Quartus Engineering Inc.

Aerofit LLC
Alliance Spacesystems LLC
Arconic
Dow-Key Microwave Corp.
Glenair Inc.
JAR Machine & Fabrication
LA Gauge Company
Magna Tool Inc.
Microsemi Corp.
Minus K Technology
Moog Inc.
NASA Jet Propulsion Laboratory
NEA Electronics Inc.
NEOTech
Newport Corp.
Northrop Grumman
Northrop Grumman (formerly Orbital ATK)
Parsons
Raytheon Company
Smiths Interconnect Americas Inc.
Tayco Engineering Inc.
Teledyne Imaging Sensors
Vacco Industries Inc.

ADNET Systems Inc.
ASRC Federal
ASRC Federal InuTeq
BAE Systems Inc.
Bechdon Company Inc.
The Catholic University of America
Conceptual Analytics LLC
DXC Technology
Genesis Engineering Solutions Inc.
GeoLogics Corp.
Global Science & Technology Inc.
The Hammers Company Inc.
Jackson & Tull
Johns Hopkins University
KBRwyle
Leonardo S.p.A.
Lester R. Summers Inc.
Lorr Company
Microtel LLC
NASA Goddard Space Flight Center
NASA Headquarters
National Institute of Standards and Technology
Nightsky Systems Inc.
Nu-Tek Precision Optical Corp.
Quantum Coating Inc.
Science Applications International Corp.
Science Systems and Applications Inc.
Sierra Lobo Inc.
Space Telescope Science Institute
Stinger Ghaffarian Technologies
TE Connectivity
TRAX International Corp.
U.S. Naval Research Laboratory
Universities Space Research Association (USRA)
University of Maryland
W. L. Gore & Associates Ltd.

Appli-Tec Inc.
Dynavac
Janis Research Company LLC
Mikrolar Inc.
Optical Solutions Inc.
Timken

Arctic Slope Regional Corp.

Global Scientific Technology Inc.
Univ. of Hawai'i at Hilo

Europe Spatial Qualité Sécurité (ESQS)
Guiana Space Centre

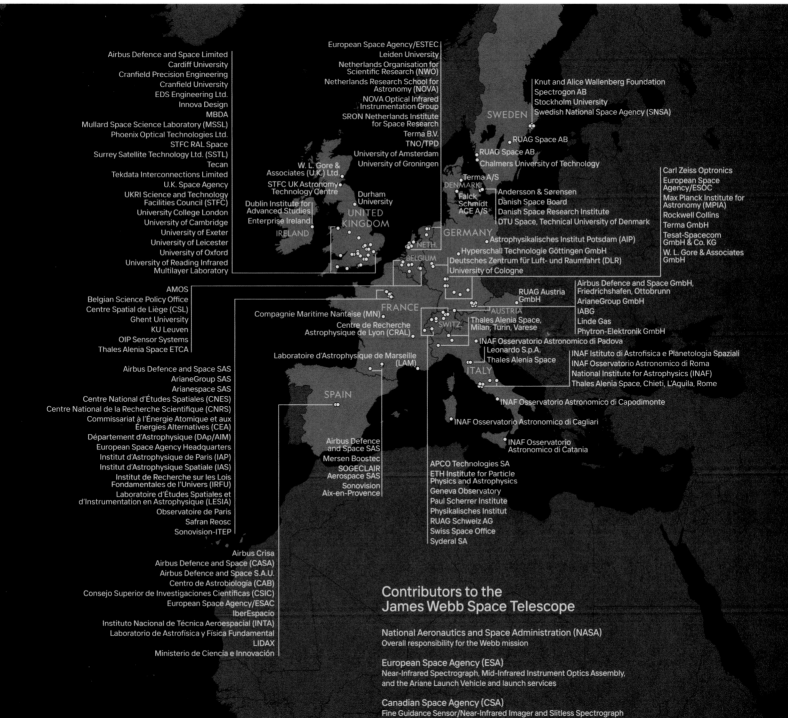

Airbus Defence and Space Limited
Cardiff University
Cranfield Precision Engineering
Cranfield University
EDS Engineering Ltd.
Innova Design
MBDA
Mullard Space Science Laboratory (MSSL)
Phoenix Optical Technologies Ltd.
STFC RAL Space
Surrey Satellite Technology Ltd. (SSTL)
Tecan
Tekdata Interconnections Limited
U.K. Space Agency
UKRI Science and Technology
Facilities Council (STFC)
University College London
University of Cambridge
University of Exeter
University of Leicester
University of Oxford
University of Reading Infrared
Multilayer Laboratory

AMOS
Belgian Science Policy Office
Centre Spatial de Liège (CSL)
Ghent University
KU Leuven
OIP Sensor Systems
Thales Alenia Space ETCA

Airbus Defence and Space SAS
ArianeGroup SAS
Arianespace SAS
Centre National d'Études Spatiales (CNES)
Centre National de la Recherche Scientifique (CNRS)
Commissariat à l'Énergie Atomique et aux
Énergies Alternatives (CEA)
Département d'Astrophysique (DAp/AIM)
European Space Agency Headquarters
Institut d'Astrophysique de Paris (IAP)
Institut d'Astrophysique Spatiale (IAS)
Institut de Recherche sur les Lois
Fondamentales de l'Univers (IRFU)
Laboratoire d'Études Spatiales et
d'Instrumentation en Astrophysique (LESIA)
Observatoire de Paris
Safran Reosc
Sonovision-ITEP

Airbus Crisa
Airbus Defence and Space (CASA)
Airbus Defence and Space S.A.U.
Centro de Astrobiología (CAB)
Consejo Superior de Investigaciones Científicas (CSIC)
European Space Agency/ESAC
IberEspacio
Instituto Nacional de Técnica Aeroespacial (INTA)
Laboratorio de Astrofísica y Física Fundamental
LIDAX
Ministerio de Ciencia e Innovación

European Space Agency/ESTEC
Leiden University
Netherlands Organisation for
Scientific Research (NWO)
Netherlands Research School for
Astronomy (NOVA)
NOVA Optical Infrared
Instrumentation Group
SRON Netherlands Institute
for Space Research
Terma B.V.
TNO/TPD
University of Amsterdam
University of Groningen

W. L. Gore &
Associates (U.K.) Ltd.
STFC UK Astronomy
Technology Centre
Dublin Institute for
Advanced Studies
Enterprise Ireland

Durham
University
UNITED
KINGDOM
IRELAND
NETH.
BELGIUM

Compagnie Maritime Nantaise (MN)
Centre de Recherche
Astrophysique de Lyon (CRAL)

Laboratoire d'Astrophysique de Marseille
(LAM)

FRANCE

SPAIN

Airbus Defence
and Space SAS
Mersen Boostec
SOGECLAIR
Aerospace SAS
Sonovision
Aix-en-Provence

Knut and Alice Wallenberg Foundation
Spectrogon AB
Stockholm University
Swedish National Space Agency (SNSA)
SWEDEN

RUAG Space AB

RUAG Space AB
Chalmers University of Technology

Terma A/S
DENMARK
Falck
Schmidt
ACE A/S
Andersson & Sørensen
Danish Space Board
Danish Space Research Institute
DTU Space, Technical University of Denmark

GERMANY
Astrophysikalisches Institut Potsdam (AIP)
Hyperschall Technologie Göttingen GmbH
Deutsches Zentrum für Luft- und Raumfahrt (DLR)
University of Cologne

RUAG Austria
GmbH
AUSTRIA
SWITZ.

Thales Alenia Space,
Milan, Turin, Varese
INAF Osservatorio Astronomico di Padova
Leonardo S.p.A.
Thales Alenia Space
ITALY

INAF Osservatorio Astronomico di Capodimonte

INAF Osservatorio Astronomico di Cagliari

INAF Osservatorio
Astronomico di Catania

APCO Technologies SA
ETH Institute for Particle
Physics and Astrophysics
Geneva Observatory
Paul Scherrer Institute
Physikalisches Institut
RUAG Schweiz AG
Swiss Space Office
Syderal SA

Carl Zeiss Optronics
European Space
Agency/ESOC
Max Planck Institute for
Astronomy (MPIA)
Rockwell Collins
Terma GmbH
Tesat-Spacecom
GmbH & Co. KG
W. L. Gore & Associates
GmbH

Airbus Defence and Space GmbH,
Friedrichshafen, Ottobrunn
ArianeGroup GmbH
IABG
Linde Gas
Phytron-Elektronik GmbH

INAF Istituto di Astrofisica e Planetologia Spaziali
INAF Osservatorio Astronomico di Roma
National Institute for Astrophysics (INAF)
Thales Alenia Space, Chieti, L'Aquila, Rome

Contributors to the
James Webb Space Telescope

National Aeronautics and Space Administration (NASA)
Overall responsibility for the Webb mission

European Space Agency (ESA)
Near-Infrared Spectrograph, Mid-Infrared Instrument Optics Assembly,
and the Ariane Launch Vehicle and launch services

Canadian Space Agency (CSA)
Fine Guidance Sensor/Near-Infrared Imager and Slitless Spectrograph

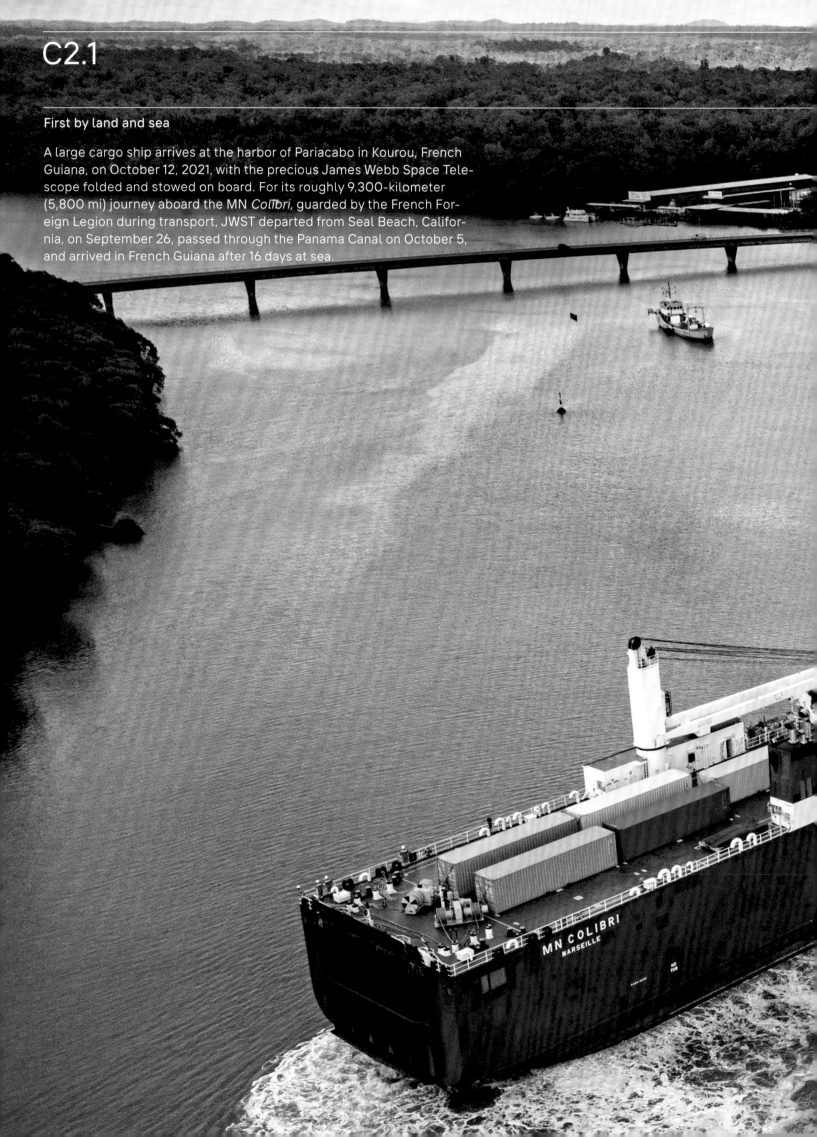

First by land and sea

A large cargo ship arrives at the harbor of Pariacabo in Kourou, French Guiana, on October 12, 2021, with the precious James Webb Space Telescope folded and stowed on board. For its roughly 9,300-kilometer (5,800 mi) journey aboard the MN *Colibri*, guarded by the French Foreign Legion during transport, JWST departed from Seal Beach, California, on September 26, passed through the Panama Canal on October 5, and arrived in French Guiana after 16 days at sea.

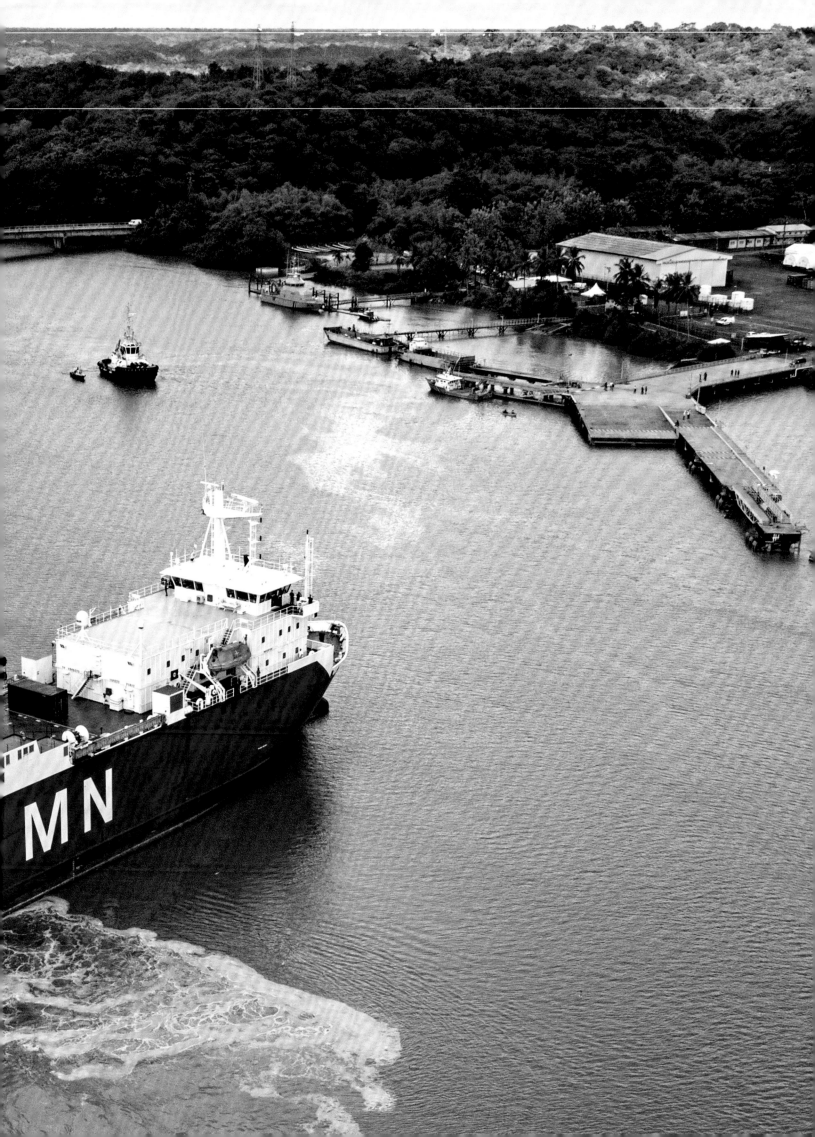

(below) **Off-loading in French Guiana**

A heavy-load tractor steers the folded and stowed James Webb Space Telescope off the ship. JWST traveled inside a custom container 33.5 meters (110 ft) long and weighing 76 metric tons (168,000 lb), but the entire observatory, at only 6.2 metric tons (13,669 lb), fit neatly inside the container. When folded up, JWST is nearly 11 meters (36 ft) long but less than 4.5 meters (15 ft) wide, designed to fit inside its launch vehicle, an Ariane 5 rocket.

Spaceport arrival

The tractor transports JWST from the port to the Guiana Space Centre, where the Ariane 5 rocket awaits. Procured by the European Space Agency, the rocket was specially adapted to accommodate its unique payload: the fully folded and launch-ready JWST.

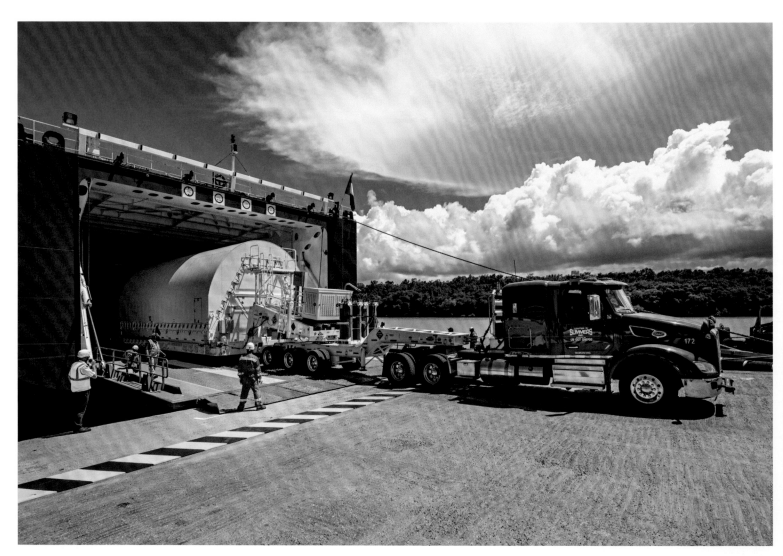

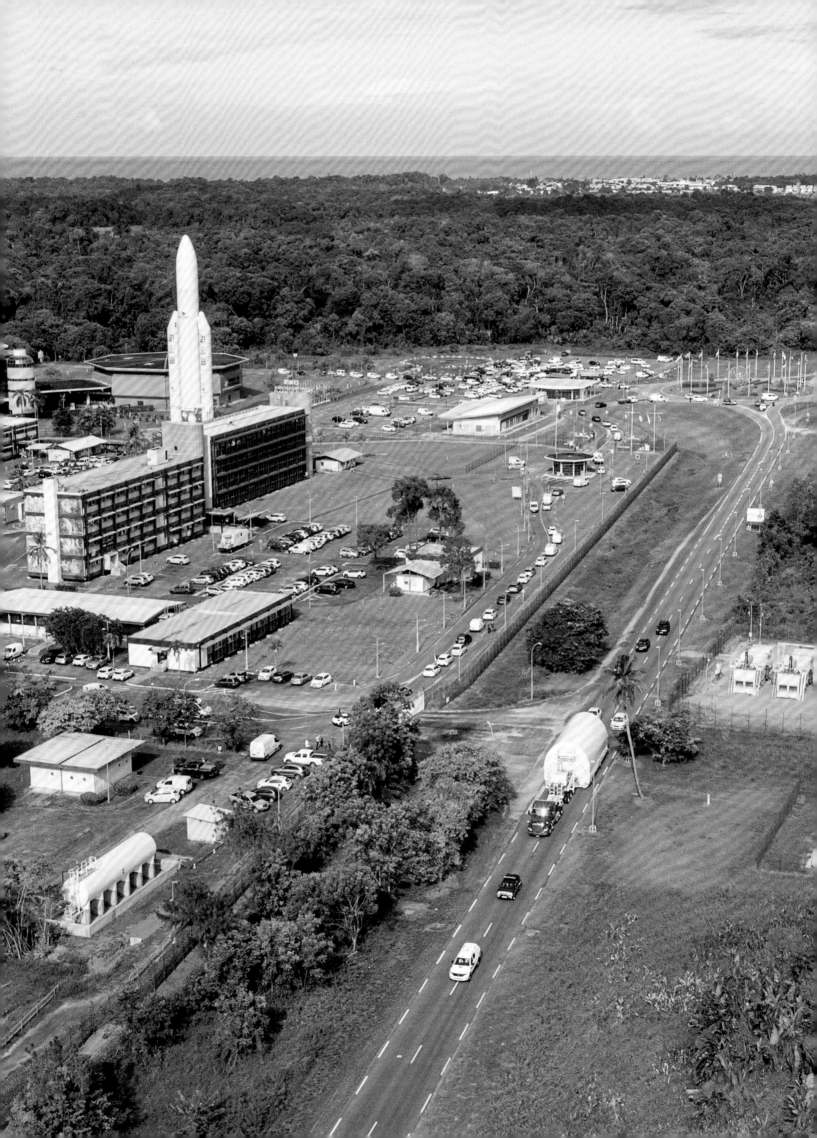

Final preparations

Dimension and weight restrictions, plus engineering plans for folding and stowing, had to be calculated to wed JWST to an Ariane 5 rocket, modified to accommodate the observatory as payload. NASA and Northrop Grumman scientists, engineers, and technicians were responsible for JWST and its specifications, while European Space Agency and Arianespace scientists and engineers were responsible for those of the rocket. Upon arrival at the spaceport in French Guiana, the marriage of the two was finally consummated.

① Prior to its shipment from California, JWST was folded and stowed to fit in its shipping container.

② The rocket's fairing, or nose cone, was lowered over the observatory and locked in place for its December 25, 2021, launch.

③ Still in its shipping container, JWST enters its final clean room for inspection, fueling, and placement inside the launch vehicle.

④ Technicians watch cautiously as the folded JWST is removed from its shipping container inside the spaceport's clean room.

⑤ In French Guiana, the fueling team, wearing special hazmat suits, supplies JWST with fuel for its lengthy journey through space.

⑥ A specialized crane lifts JWST onto its flight launch adapter, securely connecting the observatory to the Ariane 5 rocket until final separation occurs in space.

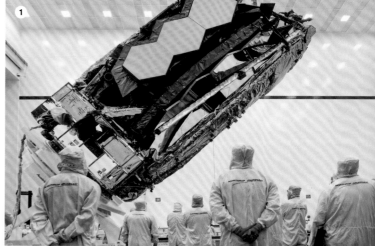

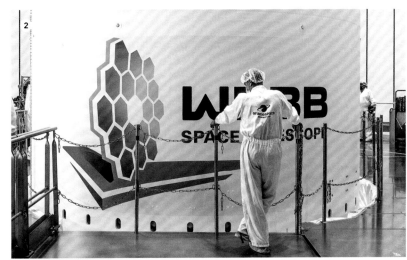

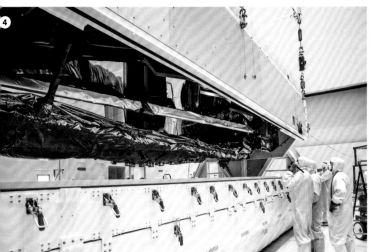

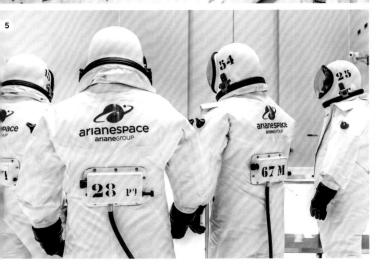

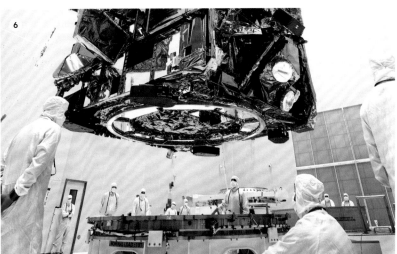

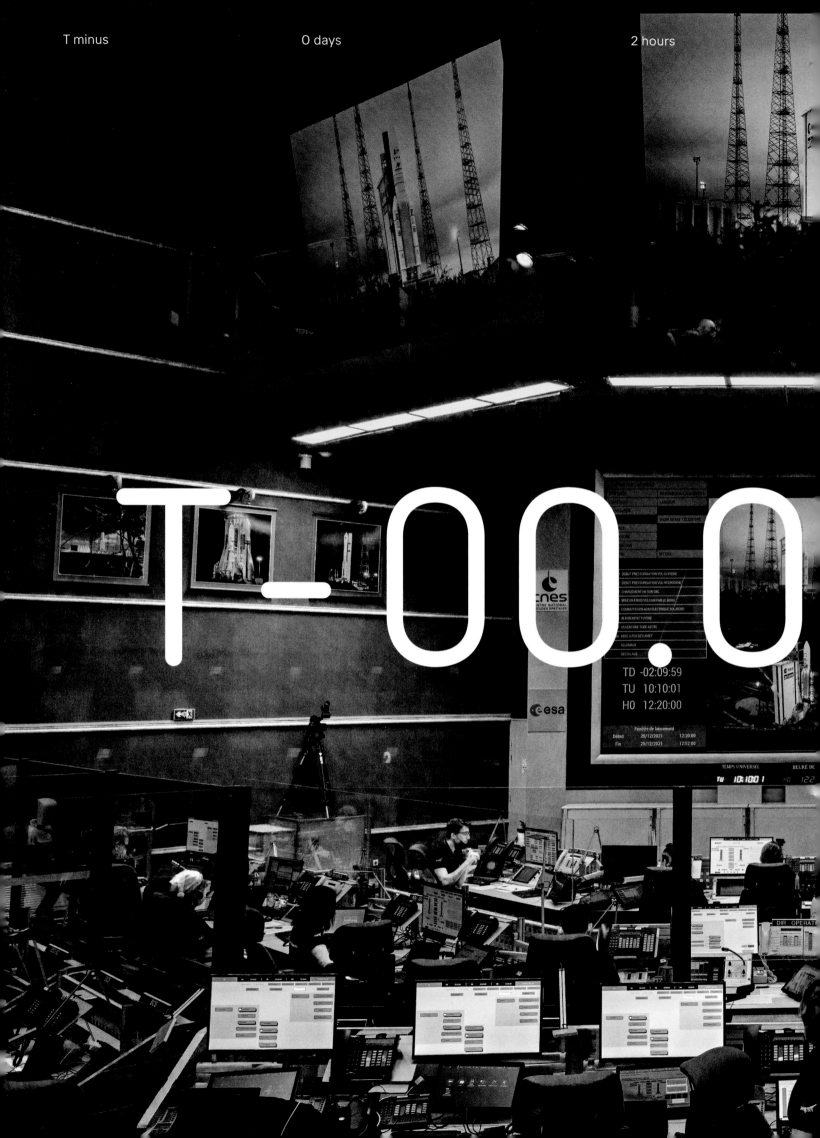

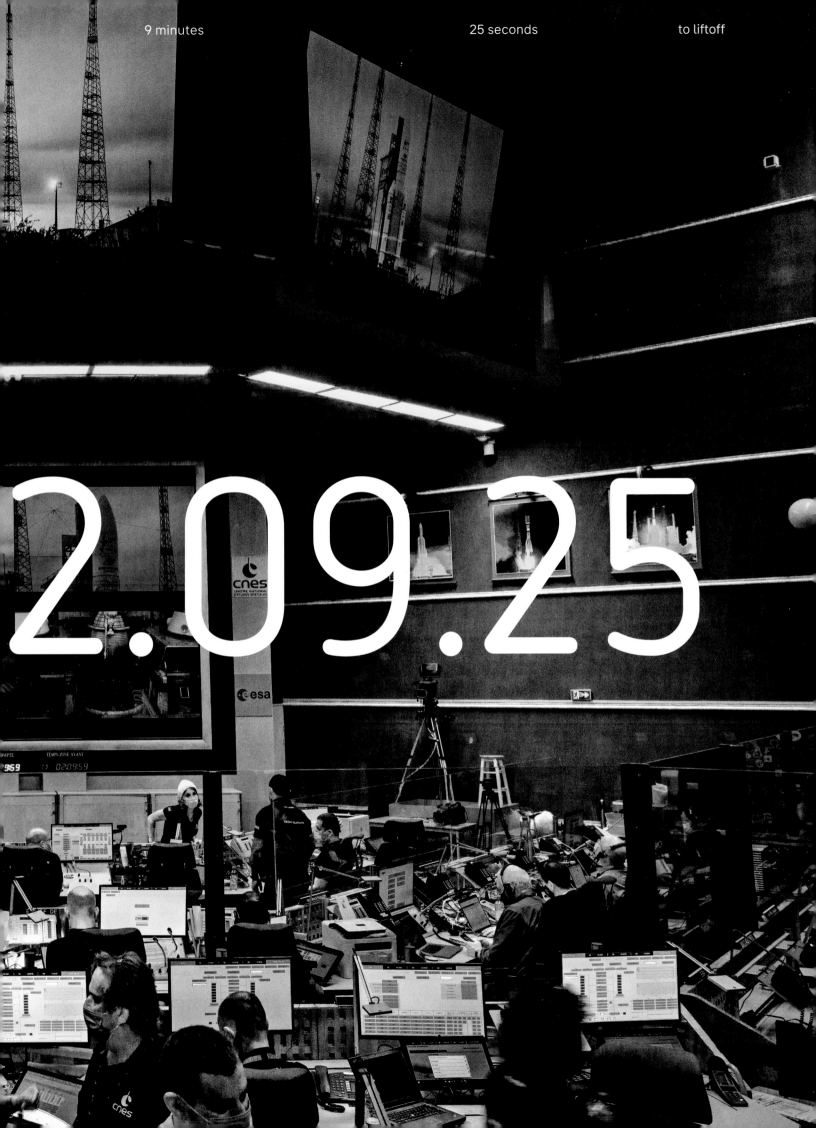

2.09.25

C2.2

⬤ **Mission launch**

JWST's components came from many sites around the world. Most were assembled in Greenbelt, Maryland, then shipped to Houston, Texas, for additional evaluation, and then to Redondo Beach, California, where the final stages of testing and assembly occurred. Ultimately, the fully assembled observatory, weighing in at more than 6,200 kilograms (13,700 lb), had to be transported 9,300 kilometers (5,800 mi) through international waters, including through the Panama Canal, to reach its launch site in French Guiana, on the northeastern coast of South America.

For the final stage of its terrestrial journey, the telescope was packed in a specially designed suitcase known as STTARS: the Space Telescope Transporter for Air, Road, and Sea. Every precaution was taken to ensure this transport went smoothly. Roads were checked for potholes before the telescope was driven across them. The shipping route was plotted to avoid passage through rough and stormy waters. And the route was kept a secret until transportation was complete, with the French Foreign Legion guiding the shipping vessel to protect it from possible encounters with pirates.

On October 12, 2021, after a 16-day journey at sea, the observatory arrived safely in the harbor of Pariacabo, near the town of Kourou, French Guiana. It underwent two additional months of testing and inspection and then was loaded into the Ariane 5 rocket, where it would face the most critical moment of all: the launch itself.

(previous) **Mission control**

On December 25, 2021, teams at the Guiana Space Centre monitor the countdown of the Ariane 5 rocket with JWST on board: a scene that highlights the importance of international collaboration in ensuring JWST's mission success.

Ready for rollout

On December 23, 2021, just two days before launch, the Ariane 5 rocket stands ready—fully assembled and fueled, with the folded observatory inside its nose cone. It will travel upright along these tracks from the final assembly building to the launch pad, seen in the distance.

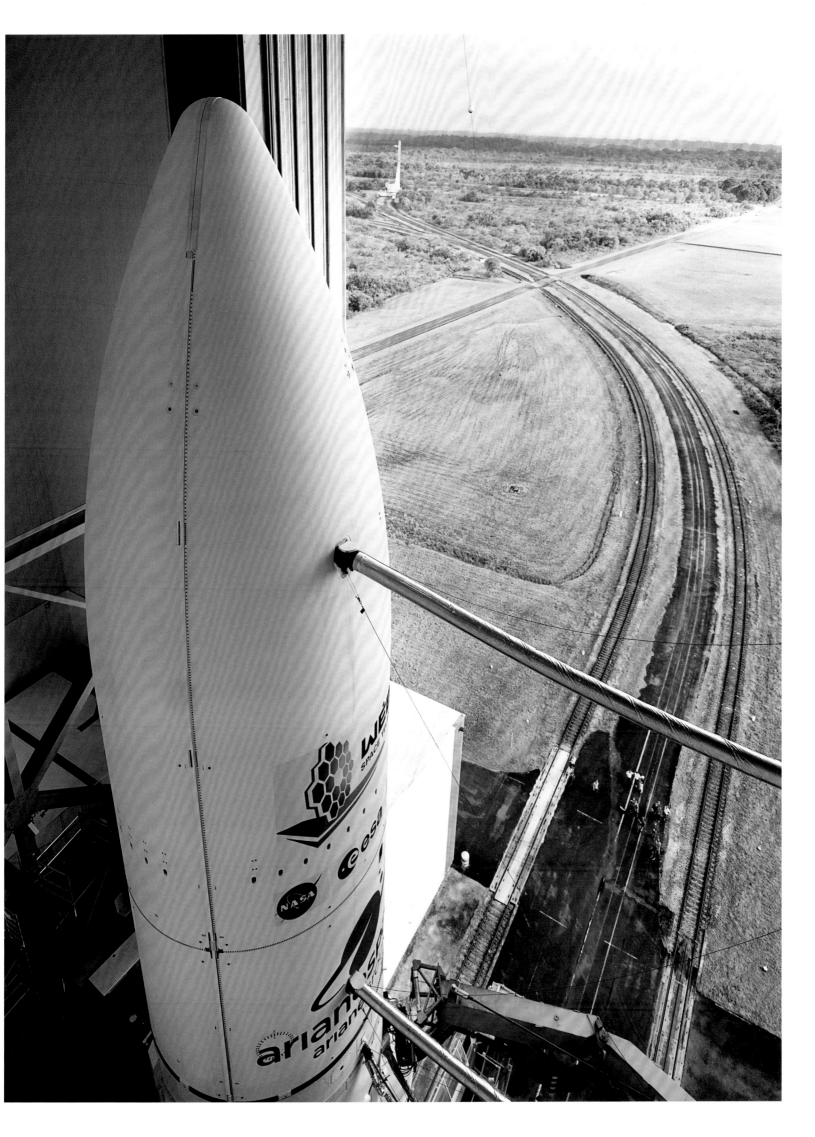

We have liftoff

JWST and its instruments had been tested over and over. Would the Ariane 5 live up to expectations as well? The moment the rocket achieved liftoff, all worries vanished, as the rocket propelled itself into the air. The most daring space mission of the 21st century was quite literally off to a flying start.

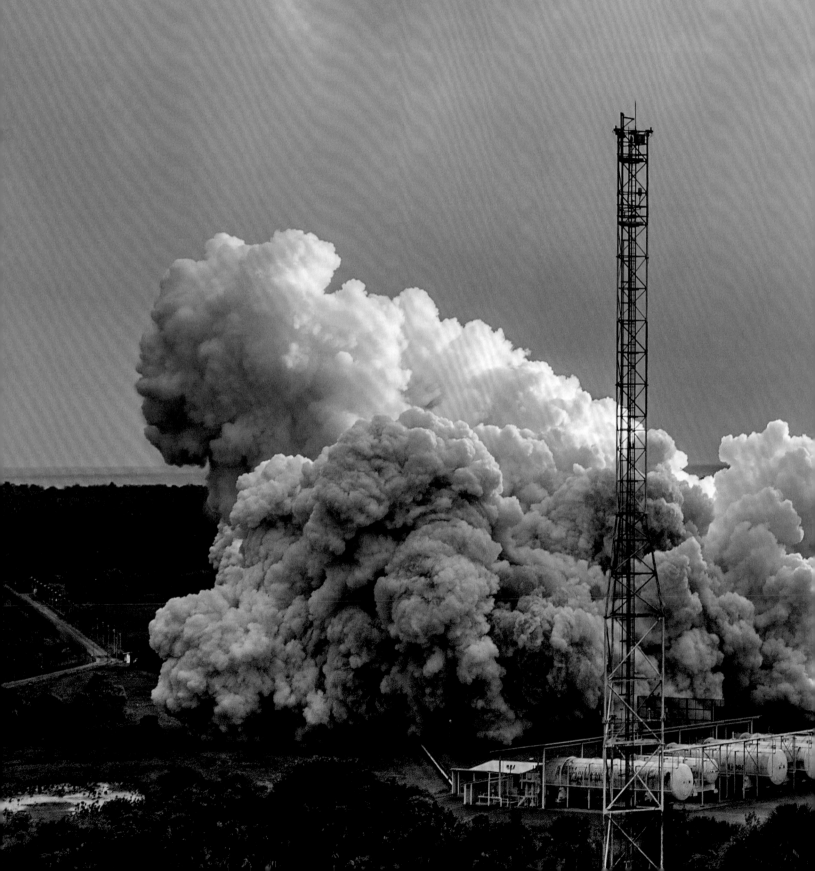

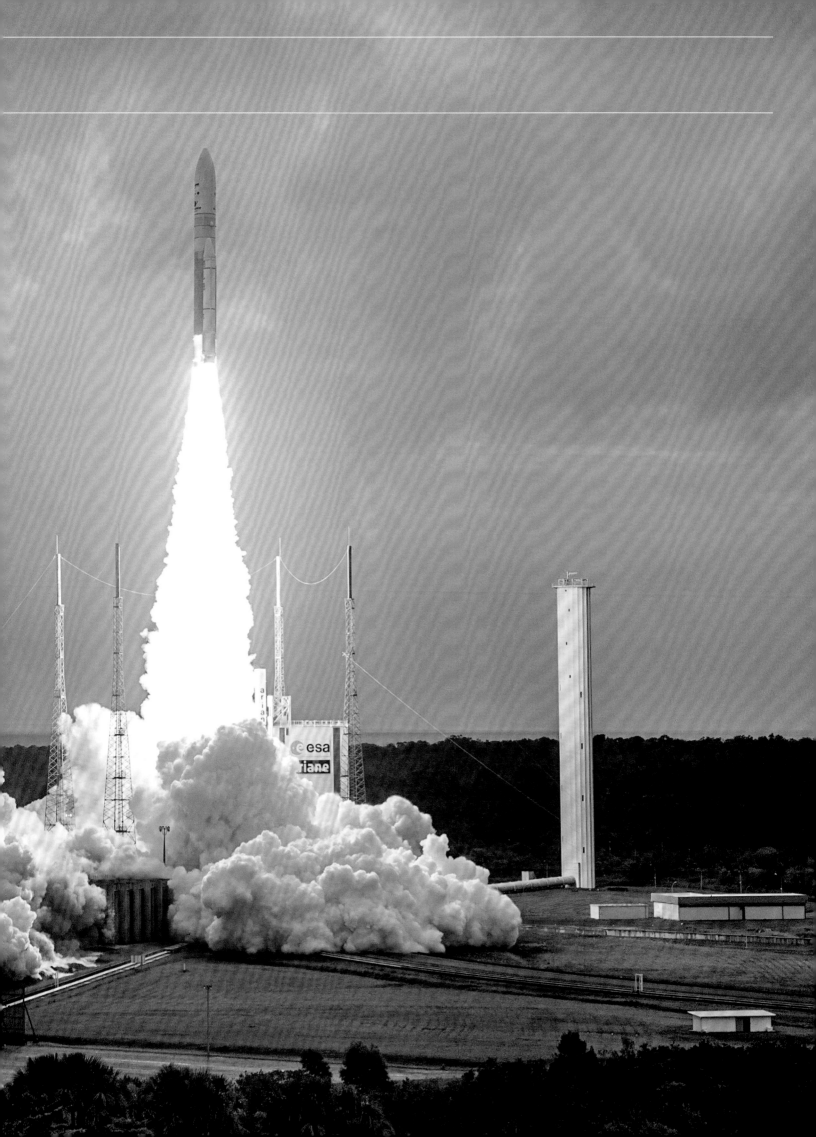

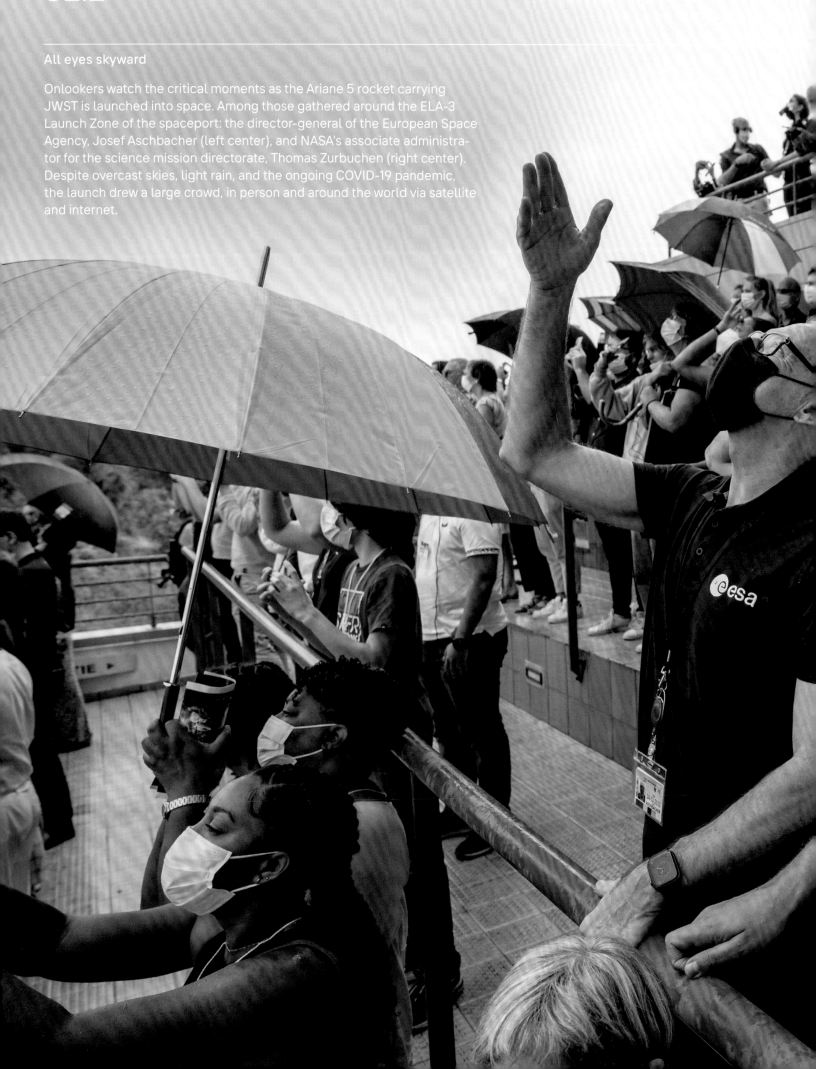

C2.2

All eyes skyward

Onlookers watch the critical moments as the Ariane 5 rocket carrying JWST is launched into space. Among those gathered around the ELA-3 Launch Zone of the spaceport: the director-general of the European Space Agency, Josef Aschbacher (left center), and NASA's associate administrator for the science mission directorate, Thomas Zurbuchen (right center). Despite overcast skies, light rain, and the ongoing COVID-19 pandemic, the launch drew a large crowd, in person and around the world via satellite and internet.

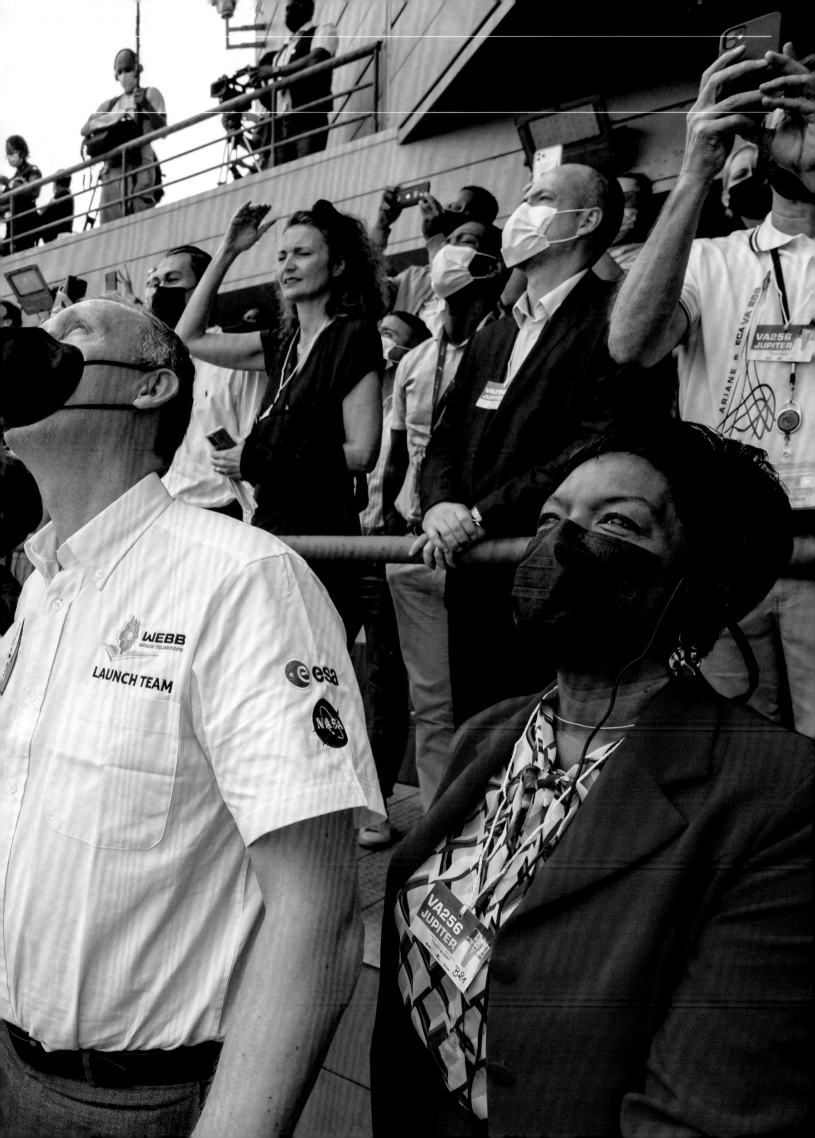

Leaving Earth behind

As the Ariane 5 rocket, with JWST on board, neared the end of the first stage of its journey, it was already in space, well above the Kármán line, which traditionally defines the boundary of Earth's atmosphere. As the first-stage booster fell away, there was no longer any need for an aerodynamic nose cone, and so that protective covering was released as well, as shown in this artist's conception. The second stage fired onward, setting JWST on its ultimate trajectory toward the L2 Lagrange point, located 1.5 million kilometers (932,000 mi) from Earth on the opposite side from the sun.

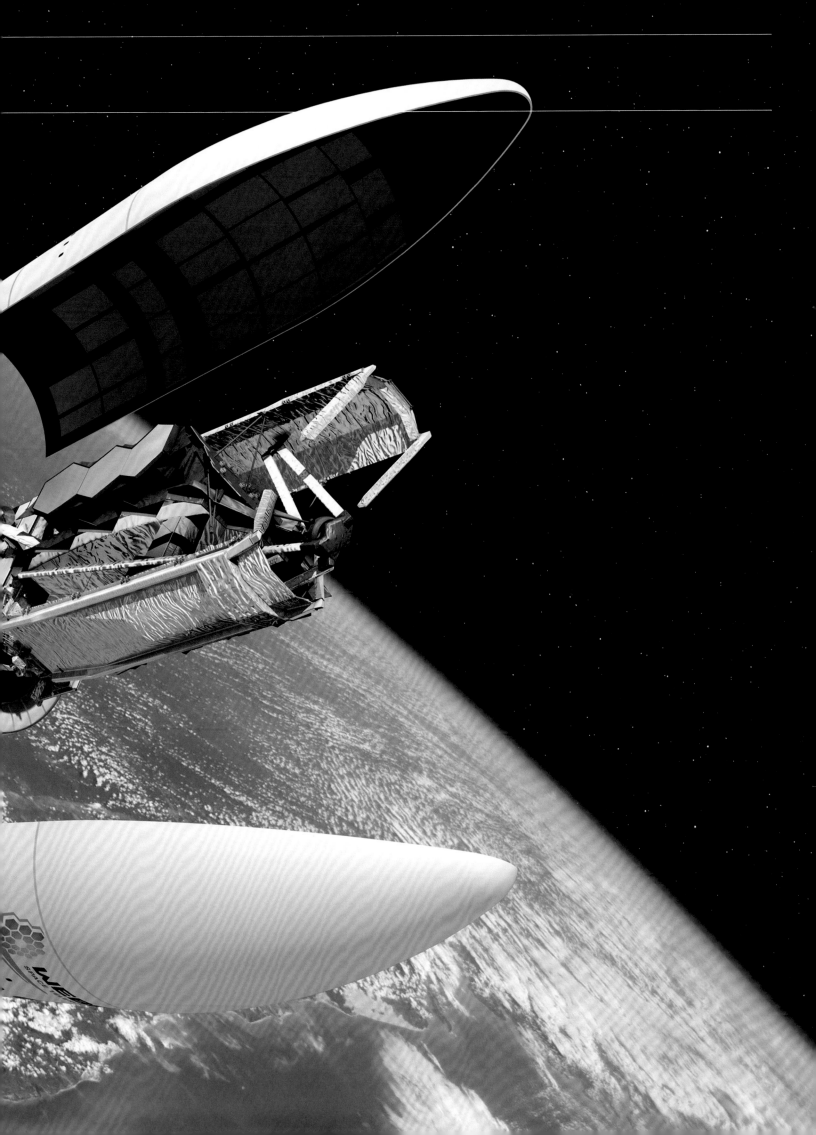

C2.3

● Component deployment

Before JWST could function properly, every component had to deploy as designed, and the entire completed observatory had to wind up in orbit around the L2 Lagrange point, 1.5 million kilometers (932,000 mi) from Earth.

After its separation from the Ariane 5 launch vehicle, the first step, programmed into the observatory, was deployment of the solar array, ensuring that the observatory had a continuous source of power. Two hours postlaunch, the high-gain antenna deployed, enabling JWST to send data to and receive commands from Earth.

The schedule called for the first trajectory correction 12 hours after launch. The initial launch itself was so exquisite, though, that hardly any fuel expenditure was required at that time. A second trajectory correction occurred two and a half days after launch, when JWST was at the same distance from Earth as the moon is. After that, the major deployment sequences were initiated by remote command from Earth.

First the sunshield pallets unfurled, followed by the release of all remaining launch locks, which ensured that no accidental out-of-order deployments occurred. The telescope and spacecraft bus, or main structure of the observatory, then moved apart as the instrument's tower assembly extended. Next, the full sunshield was unfolded and tensioned, enabling the start of passive cooling. Six days after launch, when JWST was more than halfway to its L2 destination, the secondary mirror deployed, followed by the primary mirror's side wings. JWST was well on its way to becoming an operational observatory.

A glittering farewell

As JWST separated from the second (and final) stage of the Ariane 5 launch vehicle, cameras on board the rocket captured this iconic moment. The highly reflective components on the opposite side of the observatory from the Optical Telescope Element gleam in the sunlight; a blue planet Earth carves a curve out of the darkness. This image represents humanity's final close-up view of the remarkable observatory, heading into space as it unfolds and deploys.

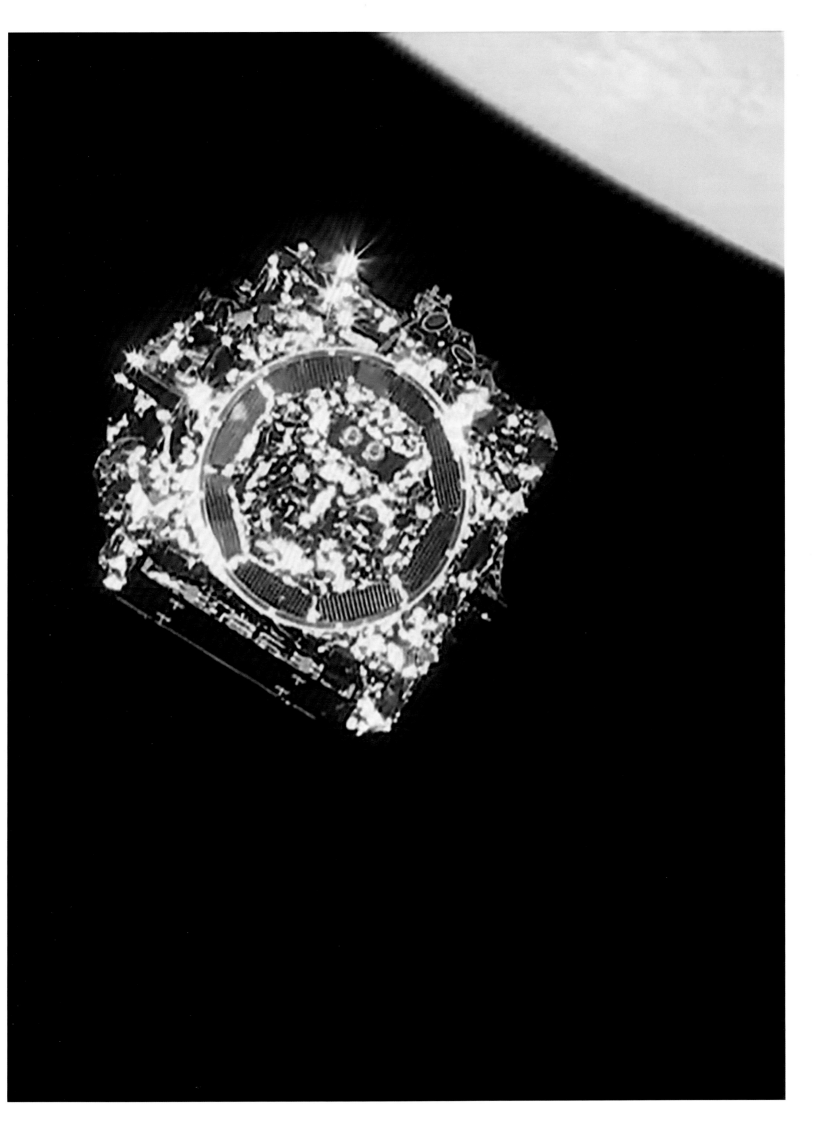

Focus on
Powering up, play by play

On Christmas Day, 2021, JWST, stowed inside an Ariane 5 rocket, was slated to launch from French Guiana. Because this South American site is so close to the Equator, it was ideal for launching a rocket with arguably the most valuable payload ever sent to space. Decades of work by thousands of scientists, engineers, and technicians would all boil down to one critical moment. The specter of a 2018 launch anomaly—breaking a streak of 82 consecutive Ariane 5 successes—hung over the moment. Launch, deployment, and orbital insertion at the L2 Lagrange point, some 1.5 million kilometers (932,000 mi) from Earth, all had to

succeed before any useful science data could be acquired.

Humanity watched from across the globe, knowing that only with a successful launch could JWST achieve its designed science lifetime of 5.5 to 10 years. The hydrazine fuel on board JWST, required for its science operations, would have to be expended to compensate for any imperfections in the launch trajectory once it was released from the rocket. A best-case launch scenario would lead to an even longer science lifetime for JWST; a worst-case scenario would demand that JWST expend too much fuel to correct course, leaving it too fuel-deficient to complete its mission.

Course correction

At several points during JWST's journey from Earth to its final destination, it performed midcourse corrections. Just as a driver's hands regularly make slight corrections to the steering wheel to keep a car on the road, JWST scientists back at mission control regularly issued commands for the spacecraft to orient itself and fire its onboard thrusters, ensuring that it remained on course for proper orbital insertion. This illustration portrays JWST's first midcourse correction, with most of the observatory (except the solar panels that power it) still folded up. Opposite, illustrations convey the sequence of JWST's mirrors unfolding.

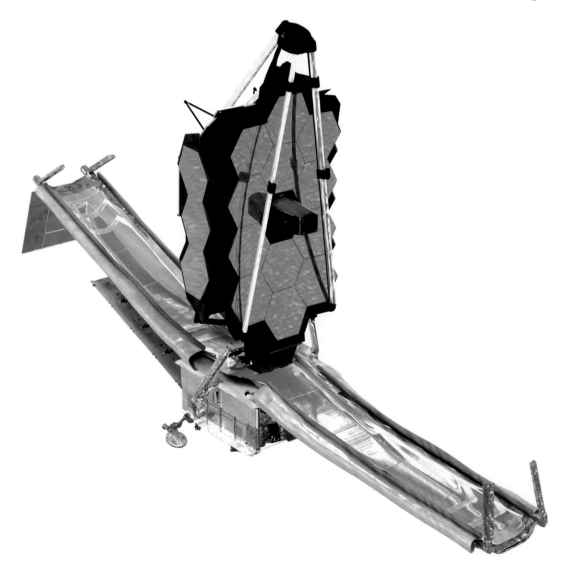

The countdown commenced, the rocket's thrusters fired, and liftoff was achieved. The Ariane 5, with JWST on board, soared upward through the atmosphere as the French word *nominal* rang out over and over again from French Guianese mission control, confirming that all systems were operating within the expected tolerances. The projected trajectory of the rocket, illustrated with a green line on mission control screens prior to launch, was traced out perfectly by the yellow line tracking the Ariane 5's actual flight path. The first stage of the rocket separated and fell back to Earth, just as planned. The second stage continued on, with JWST attached.

At last, clear of Earth's atmosphere, JWST was released. Cameras from the rocket's final stage caught the unexpected: The solar panels began automatically deploying. Five minutes had been allotted for course corrections before the panels got the signal to stretch out, but the flawless launch had rendered the wait unnecessary. Onboard sensors triggered the automatic deployment of JWST's panels: No fuel needed to be expended at this time, owing to the exquisite perfection of the launch. With that serendipitous event, JWST's expected lifetime suddenly leaped to between 22 and 23 years. The JWST era was off to a spectacular beginning.

(1) Fully folded position

(2) Forward and aft sunshield pallets are lowered.

(3) Pallet structures extend, balancing out solar pressure on the sunshield.

(4) Sunshield layers are tensioned one at a time, enabling JWST to begin passive cooling.

(5) Mirror deployments begin, extending and properly positioning the secondary mirror.

(6) The primary mirror's wing segments unfold.

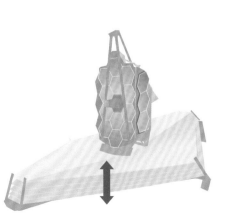
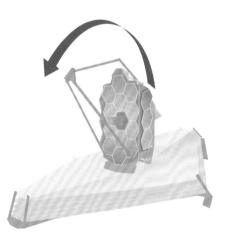
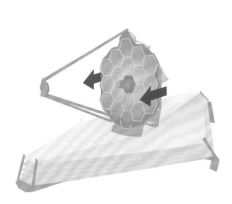

T+14.0

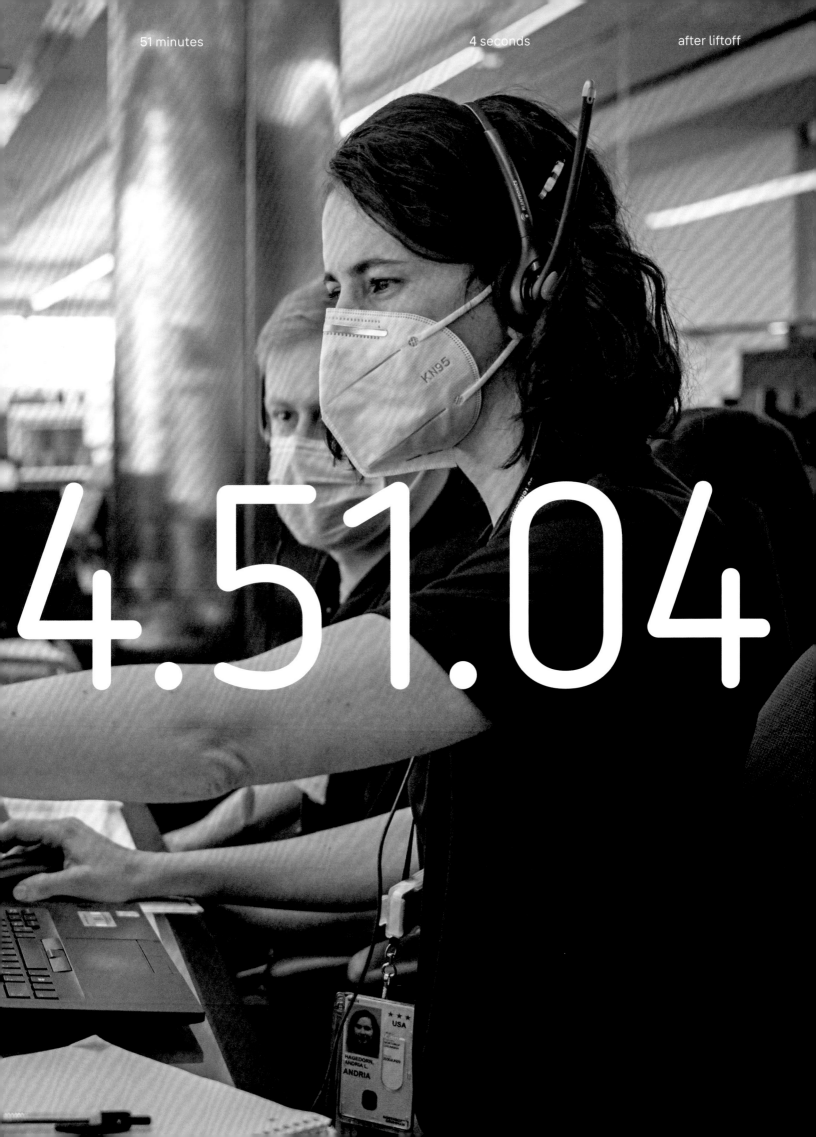

4.51.04

C2.4

● Commissioning checklist

Once the observatory itself had unfolded, it began cooling down, creating the necessary conditions for hardware and software activation. The warm electronics and flight software came online first, shepherding JWST to its final destination at the L2 Lagrange point, which it reached on January 24, 2022. A midcourse correction burn, using its onboard fuel for thrust, inserted it into orbit around L2, where it remains today.

Its first main instruments were then activated, including NIRCam, enabling calibration first of the individual mirror segments and later of the full optical assembly. Multiple rounds of coarse and fine phasing aligned one point in NIRCam's field of view, subsequently enabling alignment of all science instruments over their entire fields of view.

Finally MIRI, the coldest of JWST's instruments, entered its final cooldown, driven by an active cryocooler. It ultimately reached a frigid 6 to 7 kelvin (around −450°F), much colder than the other instruments, which are passively cooled and remain at around 37 kelvin (a bit above −400°F). After several iterations of phasing and alignment with all instruments operational, JWST's optics, at last, were perfect.

(previous) **Command center**

At the Mission Operations Center of the Space Telescope Science Institute in Baltimore, Maryland, JWST timeline coordinator Andria Hagedorn monitors the unfolding progress of JWST's second primary mirror wing as it rotates into position—one of the hundreds of deployment steps intensely monitored from the ground to ensure mission success.

Full deployment

JWST had to undergo a rigorous sequence of deployment steps before the telescope could be calibrated, the mirrors focused, and the science instruments primed to gather and analyze light. Once fully unfurled, as shown in this illustration, JWST becomes continuously powered by solar energy, while the sunshield passively cools all optical elements and instruments by shielding them from the sun. The hot, sun-facing side of JWST allows communication with Earth, while the opposing cold side gathers and focuses light from across the universe and delivers it to the four main instruments aboard JWST.

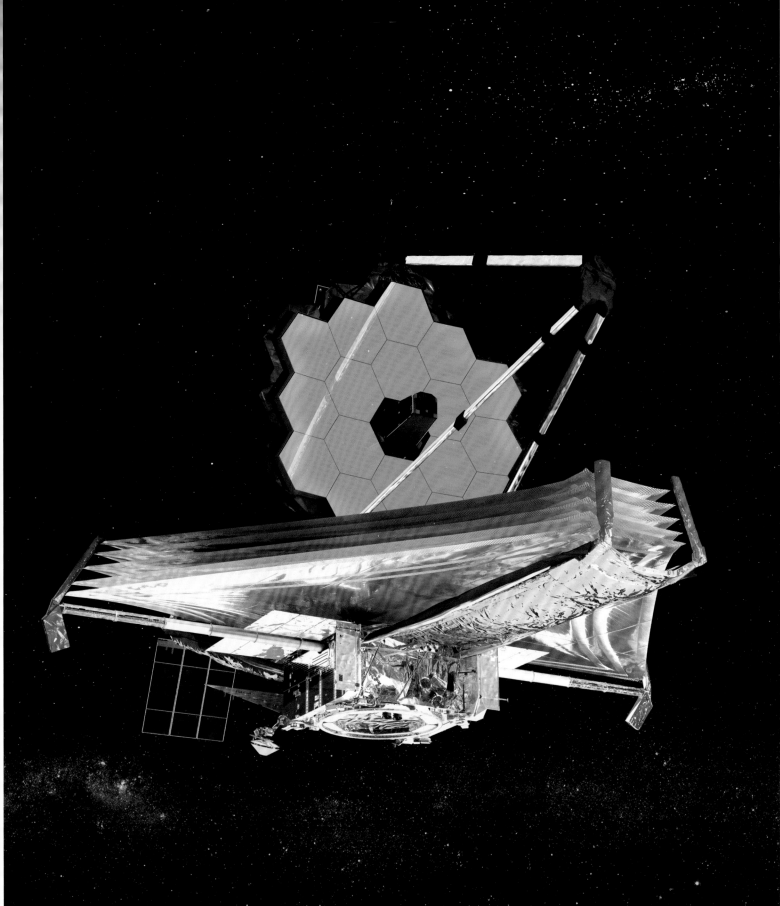

First light, first selfie

They look like random points of light, but these images show the same star viewed by each of JWST's 18 primary mirror segments; for a final result, these images require alignment. When a telescope focuses light into its instruments for the first time, it's a moment known as "first light" ①. Calibration aligns ② and focuses ③ all 18 images. Once they are stacked ④, JWST operates as a unified telescope. The image opposite was conveyed by a special lens aboard JWST back to scientists checking instruments and alignment: a highly useful selfie.

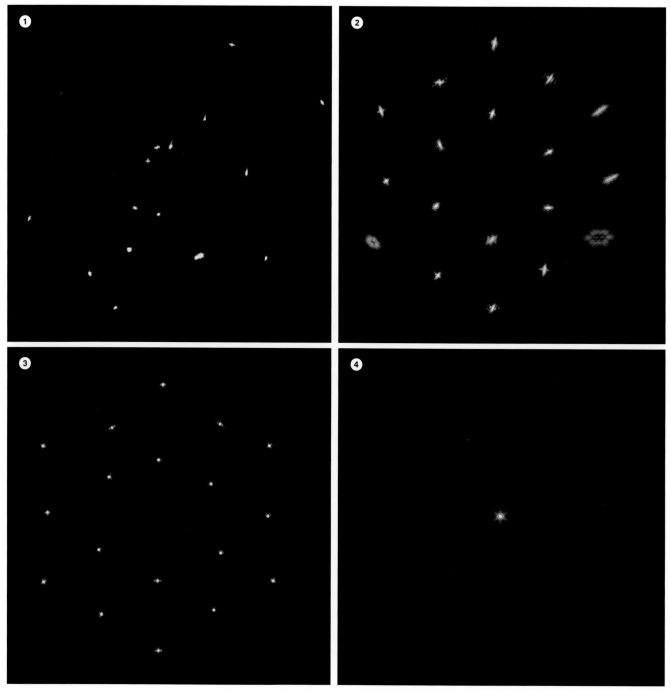

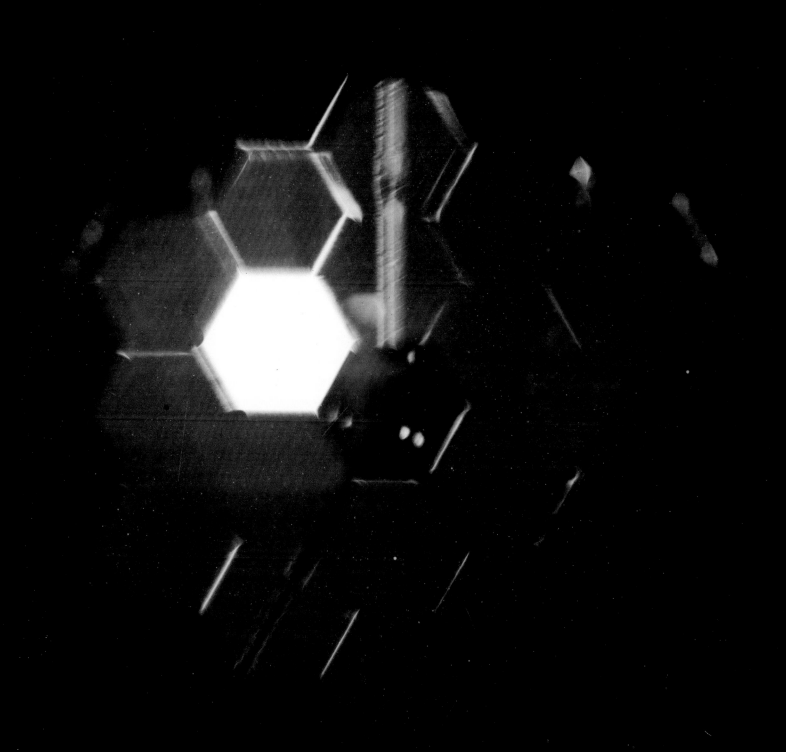

C2.5

● **Science-ready**

Once the telescope's optics and instruments were aligned, all possible observing modes needed to be checked out. Just as telescope filters can isolate specific wavelengths of light, different modes of observing can extract specific details about the objects being observed. If you want to observe planets close to a star, for example, you'll use a coronagraphy mode to block the parent star's light. If you want to separate the light coming from an object into its individual wavelengths, you'll use a spectroscopy mode. If you want to make color images where each color highlights a different wavelength range, you'll use an imaging mode.

Combining all four major science instruments aboard JWST—the NIRCam, NIRSpec, MIRI, and FGS/NIRISS—there are a total of 17 observing modes. Each mode gives astronomers a unique way to measure details about a wide variety of cosmic objects, from molecules in planet-forming disks to light from far-flung galaxies in the vast recesses of the universe. All modes required testing and validation.

By pointing at a rich variety of astronomical targets—quasars, giant exoplanets, pulsing neutron stars, nearby galaxies, and distant gravitational lenses—the various instruments and their modes could be tested. And indeed, each of the 17 modes was tested, calibrated, verified, and approved between June 2 and July 10, 2022.

At last, the James Webb Space Telescope was fully science-ready.

Successful alignment

JWST observed the first-light image (④, p. 112) for quite a long time while scientists and engineers on the ground properly aligned and calibrated JWST's optics. Once the primary mirror segments are all aligned, they can produce one unified image using one of the four instruments—NIRCam in this case. The eight diffraction spikes seen in this image—six large and two small—are a characteristic common to all bright point sources viewed by JWST. In the background, many fainter, more distant stars and galaxies can be seen, showcasing the incredible sensitivity and precision of a properly aligned, calibrated space telescope.

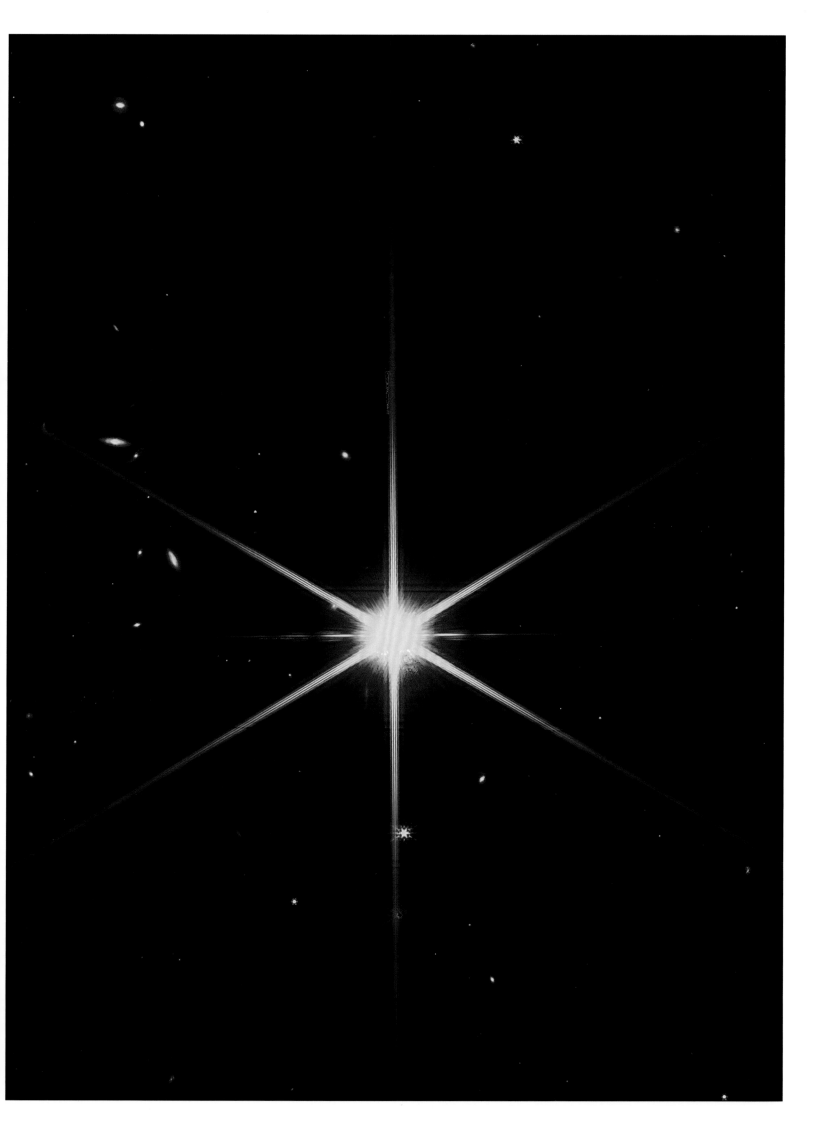

C2.5

Hubble sees the Cat's Eye

A little over 3,000 light-years away, the Cat's Eye Nebula—a dying star not so different from the sun—blows off its outer layers to produce a spectacular phenomenon known as a planetary nebula. After expanding into a red giant, a sunlike star such as this burns through its core's nuclear fuel and then expels its outer layers while its core contracts, forming a white dwarf. Here in the Cat's Eye Nebula, the outer layers shine brightly, as that material is heated and even ionized because of the hot, central stellar remnant. Knots in the nebula, as well as concentric rings, teach us about the end-stage evolution of stars.

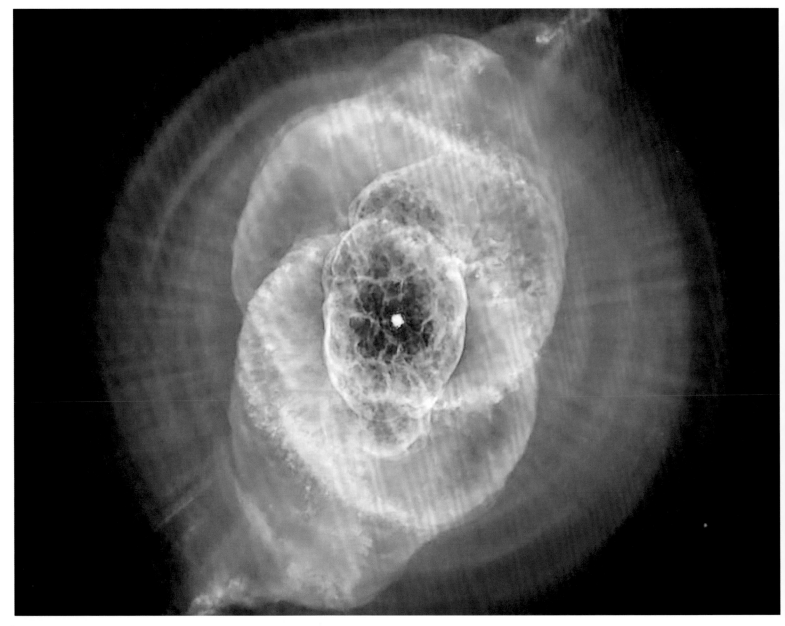

JWST sees the Cat's Eye

Instrument calibration includes comparing the JWST images of well-known astronomical objects with images from other telescopes. Here JWST's MIRI views the Cat's Eye Nebula at longer wavelengths, revealing different details from what an optical telescope such as Hubble does. The MIRI image appears bright and oversaturated, which helped JWST's instrument scientists determine how to mitigate those effects: by raising and lowering the temperature of the instrument.

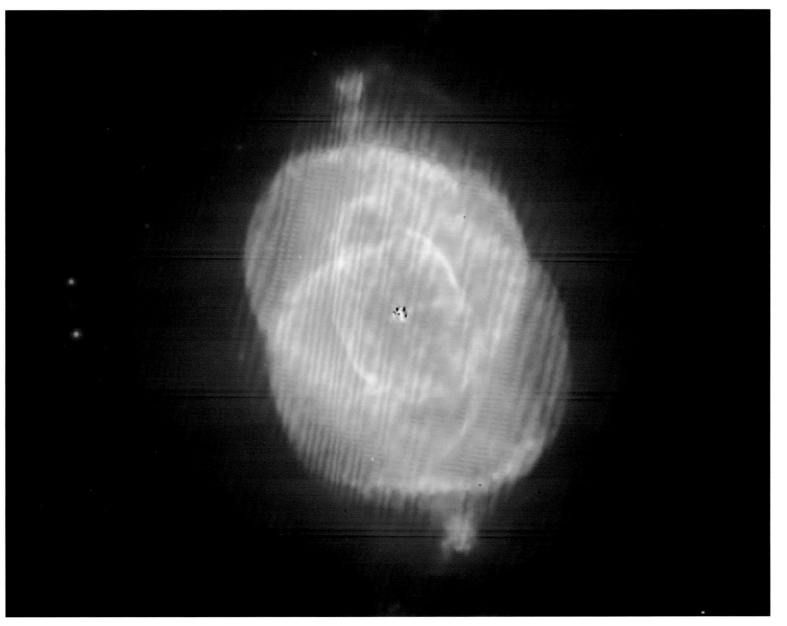

One result of JWST's unique configuration is that in the images it produces, individual stars—or any bright light source arising from a single point—don't appear to be a point but rather to have spiky features, more like a snowflake. Images captured by Hubble famously show four thin spikes coming from each star; by contrast, JWST displays a star with eight spikes: six large ones and two small ones. This phenomenon arises because JWST doesn't possess a perfectly circular collecting area for its primary mirror, but rather a honeycomb-like pattern composed of 18 individual mirror segments. This resulting shape, known officially as JWST's point-spread function, is called by astronomers the "nightmare snowflake."

A perfectly shaped parabolic mirror with a circular collecting area would focus the light from any point source down to a single point, with no imperfections or distortions. JWST's 18 mirror segments combine into a nearly perfect parabolic shape, down to a precision of about 20 nanometers, but the telescope's collecting area is a far cry from a perfect circle,

A dense star field

If you have too many stars that are too close together in space, your telescope will see them only as a blur of light. If you have stars that are shrouded in dust, you will see just hazy, luminous clouds. So how would JWST's MIRI perform when it was pointed at a dense star field in the Large Magellanic Cloud, a nearby galaxy 165,000 light-years away? This image was the result, demonstrating the telescope's ability to resolve even a densely packed field of individual stars and tell them apart from dusty features in the same view.

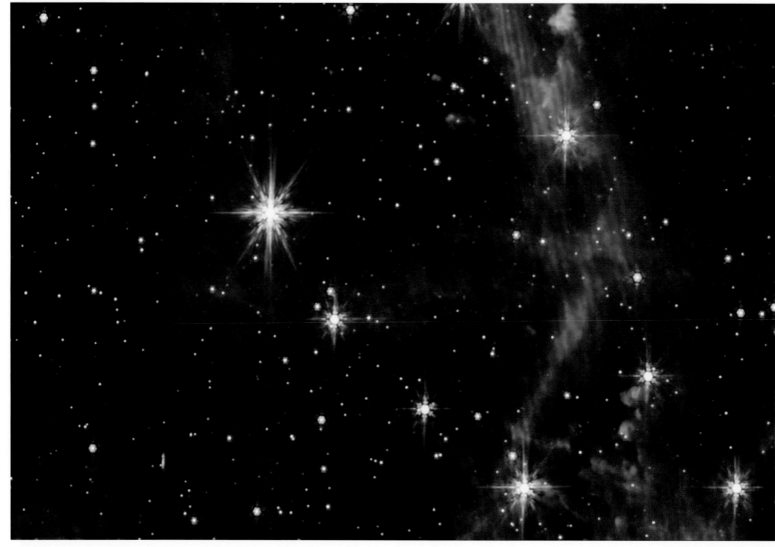

since the 18-piece construction contains both gaps and edges. Overall, the 18 segments are tiled together to make an approximately hexagonal shape, rather than a circle, causing the primary contributor to the largest distortion effect: the six major spikes. The second most important distortion effect is due to the three struts that hold the secondary mirror in place, which overlap with the main collecting area of the primary mirror. This creates six additional minor spikes, but four of them align with four of the primary hexagonal spikes, leaving only two new, smaller ones. (Similar struts explain the four spikes seen in Hubble telescope photos.)

In short, since it is made up of tiled hexagons with gaps between, JWST's mirror creates images with distortions—prominently seen, for example, in JWST's image of Triton, Neptune's largest moon (p. 161), and in the MIRI image below of a dense star field in the Large Magellanic Cloud. Despite the ominous name nightmare snowflake, this shape with beautiful spikes is the key to instantly identifying an image as originating from JWST.

JWST's complete view

With most telescopes, the collected light can be sent to only one instrument at a time. But with JWST, the light that it observes can be sent to multiple instruments at once, with only slightly offset fields of view. Here, with all instruments pointing in the same direction, we see the high-resolution capabilities of NIRSpec, NIRCam, the Fine Guidance Sensor, NIRISS, and MIRI. A set of images such as this helps JWST scientists assess image sharpness and calibrate subtle image distortions.

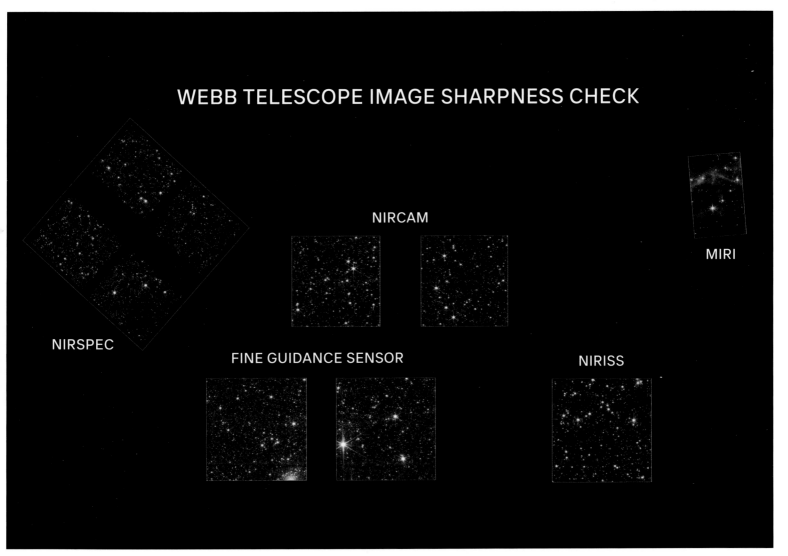

WEBB TELESCOPE IMAGE SHARPNESS CHECK

NIRCAM

MIRI

NIRSPEC

FINE GUIDANCE SENSOR

NIRISS

C2.5

Surprising sharpness

This incredible view, which showcases nearby stars within the Milky Way as well as galaxies located millions or even billions of light-years away, represents the product of a total of 32 hours of JWST's observations of its first-light target: an individual star. The fact that so many faint, distant objects are visible in great detail, including objects extremely close to the brightest stars in this image, spotlights the advanced scientific potential of JWST. At the time this image was taken, it represented the deepest, highest-resolution view of the infrared universe ever acquired.

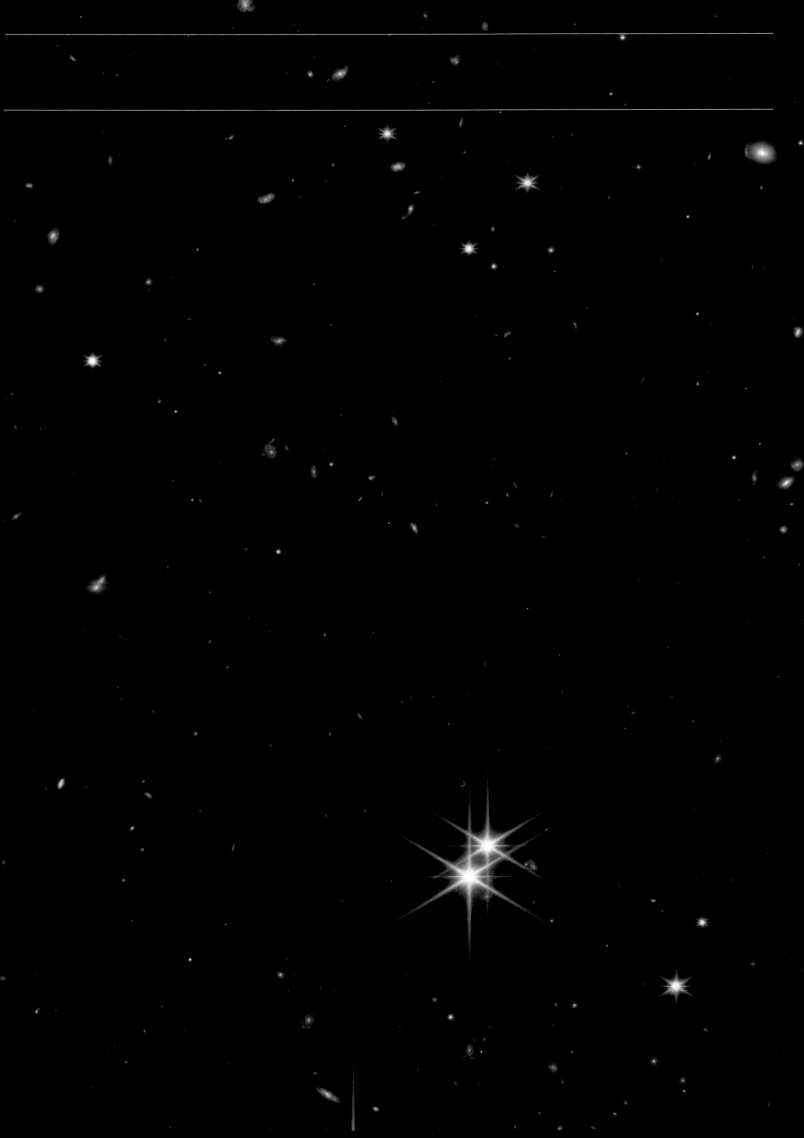

03

Chapter 3 Sights & Science

THE WHITE HOUSE
WASHINGTON

JAMES WEBB
SPACE TELESCOPE

T+198.1

2.18.57

- To find the first stars and galaxies ever to form in the universe. With its large-aperture eyes and ultrasensitive, ultradeep infrared capabilities, JWST can discern fainter, more distant objects better than any other space-based or ground-based telescope can.
- To watch how galaxies grow and merge, and to find out how their supermassive black holes and internal gases evolve within them.
- To peer into star-forming regions and see directly how planets and other objects form around their parent stars.
- And perhaps most ambitiously, to search for signatures of life elsewhere in the universe, in our greatest attempt yet to answer the question: Are we alone?

On that same date, the first science image conveyed by JWST was released: of galaxy cluster SMACS 0723. This deep-field view, showing not only a rich cluster of galaxies but also how the background objects were spectacularly distorted and magnified by gravity, was just the beginning—a preview of all the discoveries soon to emerge from this telescope.

(previous) **Presidential reveal**

On July 11, 2021, U.S. president Joe Biden addressed the country to reveal JWST's first science image. Before the announcement, Biden conducted a behind-the-scenes with Thomas Zurbuchen from NASA (top right), Nancy Levenson from the Space Telescope Science Institute (middle right), and Greg Robinson, NASA's JWST program director (bottom right). Soon after, President Biden and Vice President Kamala Harris addressed the nation and revealed JWST's first views of the universe.

The Southern Ring Nebula

One of JWST's first science releases, this image reveals a star that's similar to the sun but in the very end stages of its life. The bright, central star is a binary companion to the dying star to the left. That small, faint star has blown off its outer layers and is contracting down to form a white dwarf. The infrared light reveals brilliantly shining gaseous features never seen before.

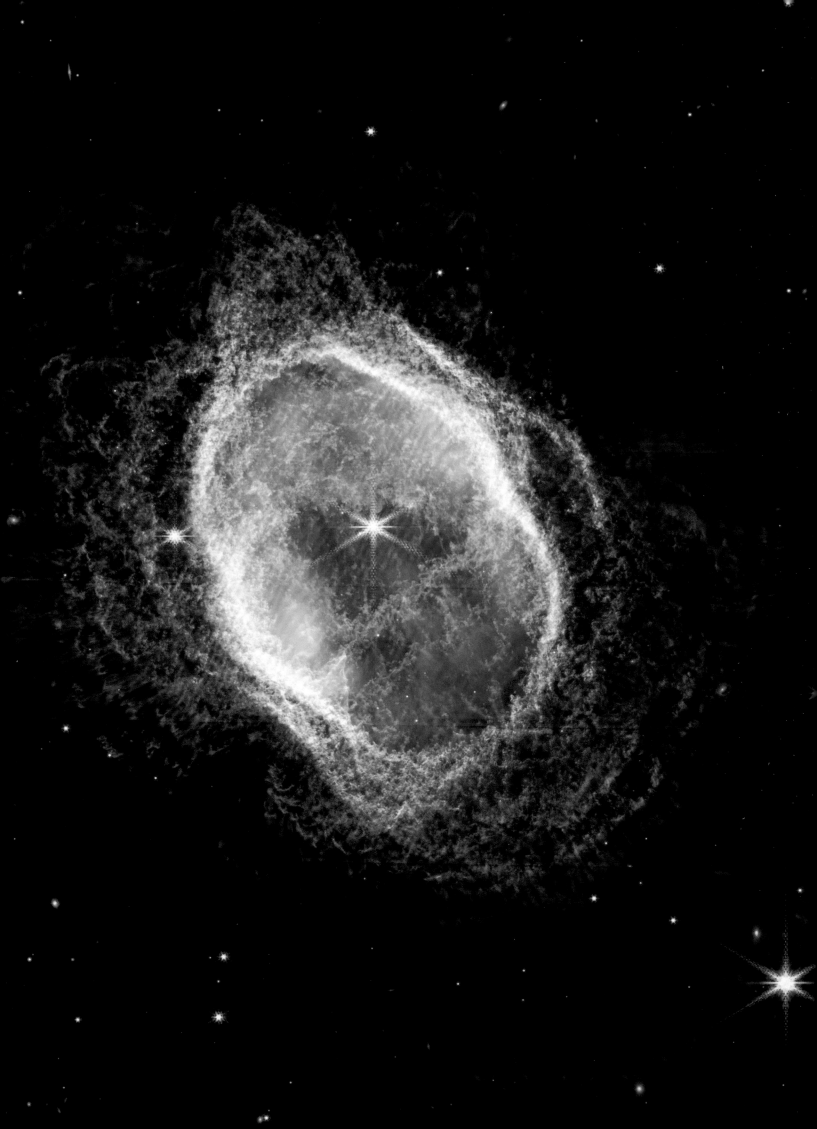

C3.1

Eye-opening view

This is the big one: the first science image—and the first full-color image—released to the world by NASA from the James Webb Space Telescope. It shows the massive galaxy cluster SMACS 0723, including the globular cluster–rich "sparkler galaxy" (at center of inset), located an impressive four billion light-years away. Behind this cluster are even more distant galaxies, and their light gets bent, stretched, and magnified into impressive arcs. The most distant objects revealed here emitted the light that JWST now sees more than 13 billion years ago, while the spiked objects are foreground stars within the Milky Way. Note: Even with JWST's unprecedented capabilities, there are still limits to its resolving power, resulting in the pixelated appearance of the detail shown below.

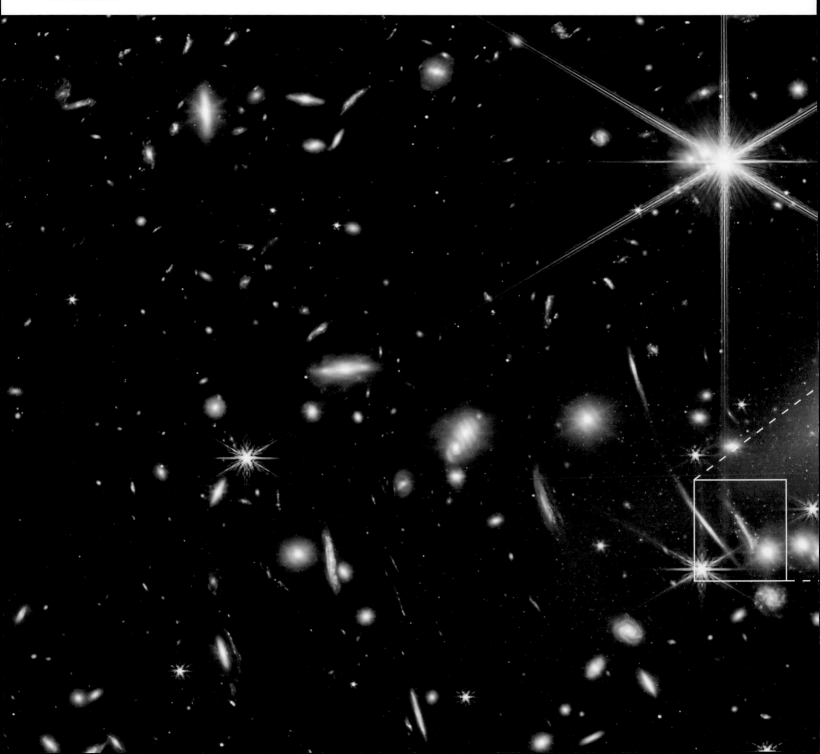

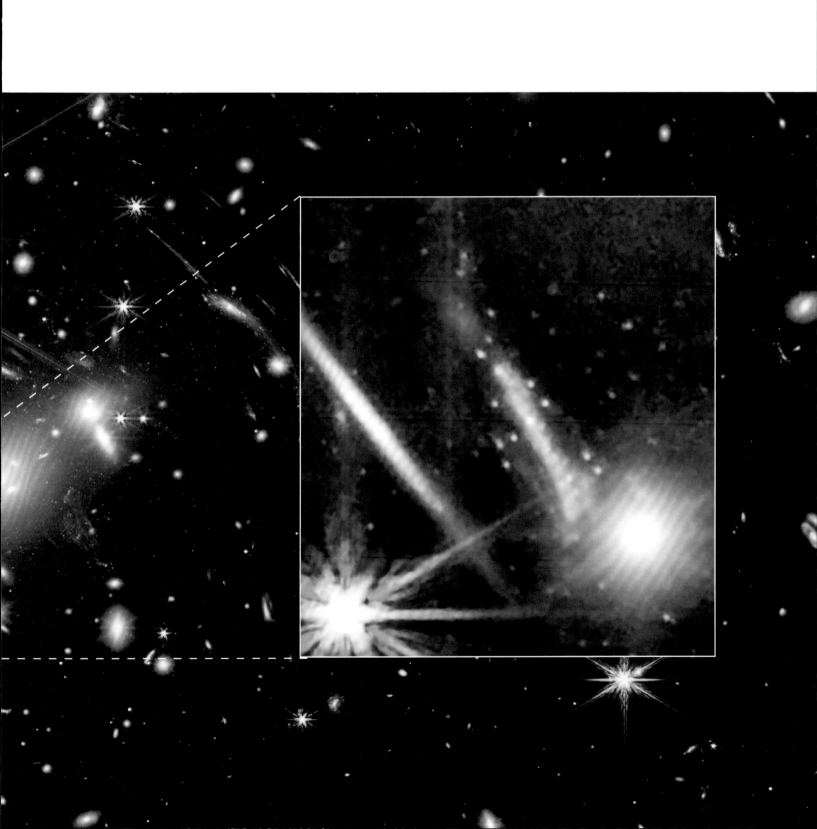

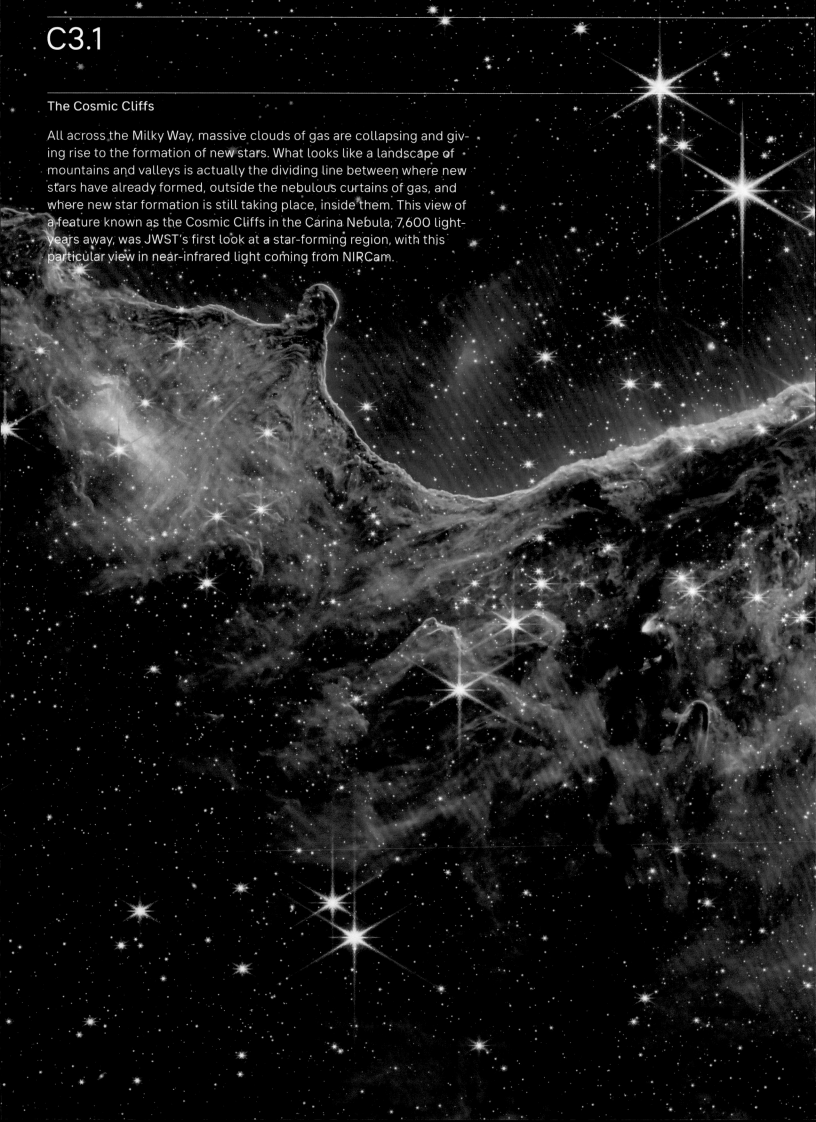

C3.1

The Cosmic Cliffs

All across the Milky Way, massive clouds of gas are collapsing and giving rise to the formation of new stars. What looks like a landscape of mountains and valleys is actually the dividing line between where new stars have already formed, outside the nebulous curtains of gas, and where new star formation is still taking place, inside them. This view of a feature known as the Cosmic Cliffs in the Carina Nebula, 7,600 light-years away, was JWST's first look at a star-forming region, with this particular view in near-infrared light coming from NIRCam.

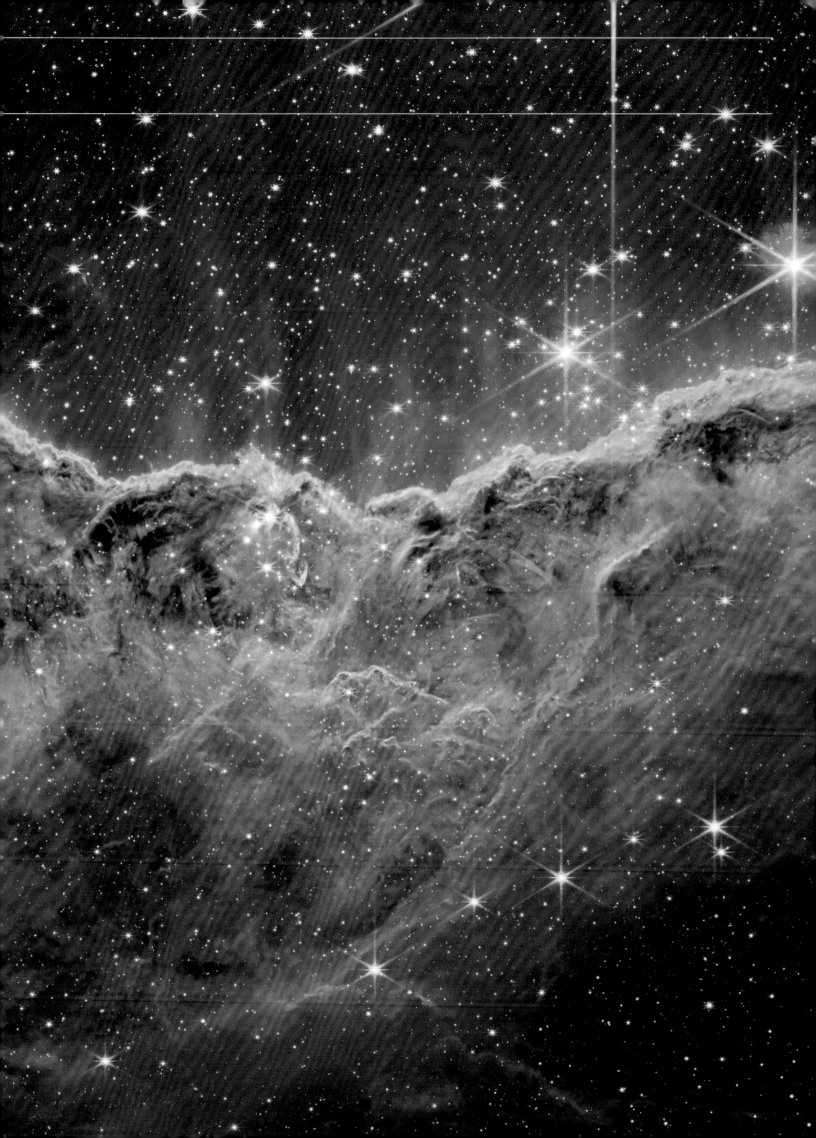

On July 11–12, 2022, the JWST team released the "first science images"—the first images taken for scientific, not calibration, purposes by this new, fully commissioned observatory.

In the Cosmic Cliffs, JWST saw hot, ionized gas being evaporated away by the ultraviolet radiation from newborn stars, which carve cavities within the denser star-forming regions. Jets and outflows of material emerge from gas-rich pillars, where new stars are forming inside. Mid-infrared views reveal young stars within that had never been seen before, showcasing JWST's power.

JWST's eyes caught WASP-96b, a hot, Jupiter-size exoplanet, transiting in front of its parent star, with starlight filtering through the planet's atmosphere. Hot conditions, achieving temperatures of around 1300 kelvin (1880°F), boil any clouds away, enabling JWST to probe this giant planet's atmospheric depths. Remarkably, it found large amounts of water inside. Perhaps, this JWST discovery suggests, even hot, giant planets can be extremely water-rich!

JWST showed the Southern Ring Nebula, a dying, sunlike star, to have a binary stellar companion. Temperatures vary dramatically across the nebula, as showcased within knotlike features appearing in the gas and dust. Outside the main bubble, material is tenuous and low-density, highlighted by ropelike structures at the edges. Can singlet stars, like our

The new JWST view of the Cosmic Cliffs, within the Carina Nebula, reveals an enormous number of stars and protostars within and behind the nebula itself.

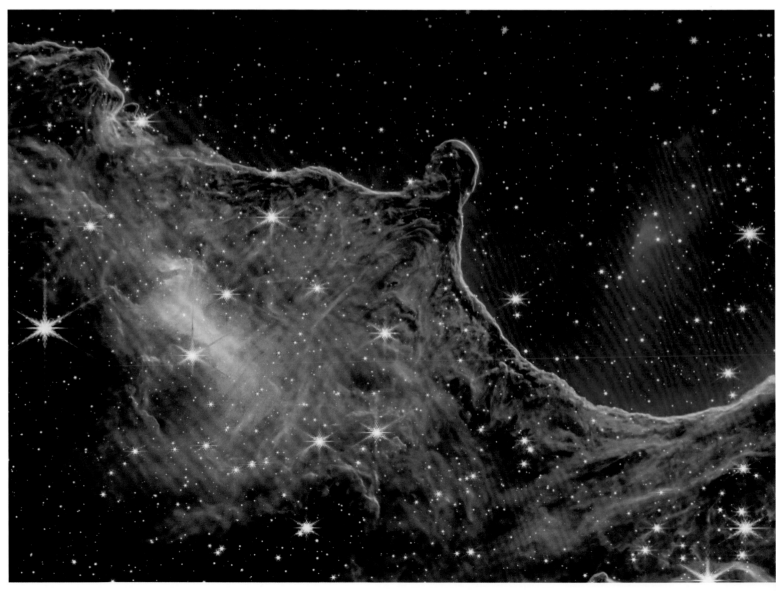

sun, even produce planetary nebulae? JWST's findings hint that perhaps binary companions are a necessity for producing these spectacular sights, calling into question our own sun's ability, billions of years from now, to create one.

Thanks to JWST, we can now observe Stephan's Quintet, the first compact group of galaxies ever discovered. It consists of four interacting galaxies 290 million light-years away, with one foreground interloper merely 40 million light-years distant. JWST revealed tidally disrupted and stripped gas features never seen before, as well as an active supermassive black hole in the topmost galactic member. Beyond the quintet, JWST's spectacular eyes revealed thou-

sands of background galaxies in the great universe beyond.

And, released the day before all the others, the image of galaxy cluster SMACS 0723 reveals many objects that were completely invisible to all previous observatories on Earth or in space. Small galaxies have been discovered near the cluster's center; many galactic shapes, like spirals, ellipticals, and even rings, are visible for the first time. Multiple images of several galaxies appear, due to gravitational lensing, as do some ultradistant background galaxies, representing the first one to two billion years of cosmic history.

What treasures these first five images are, holding the promise that these novel discoveries will be the first of many.

Hubble's view of the Cosmic Cliffs, about a third as sharp as JWST's, shows gas emissions but fewer stars. Images from the two observatories complement one another.

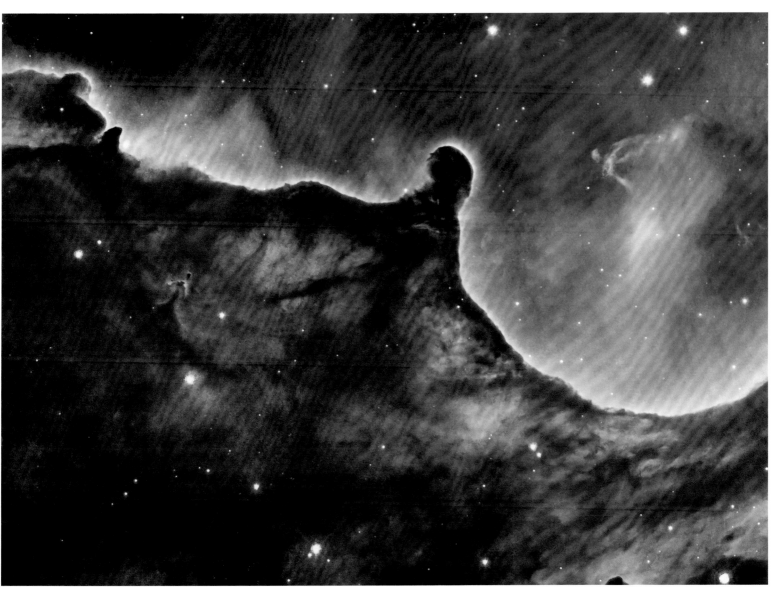

C3.1

A quintet of galaxies

These five famous galaxies compose a compact group known as Stephan's Quintet—named for its discoverer: French astronomer Édouard Stephan. JWST's NIRCam reveals a fascinating array of features. Whitish, wispy trails coming from the topmost galaxy are actually streams of gas that form new stars, ripped out of the galaxy by gravitational interactions with the merging galaxies below. Shocked, heated gas streams across the space between galaxies. To the left, an unrelated, much closer spiral galaxy photobombs this more distant group. Beyond them all, more than a thousand distant galaxies are revealed by JWST's spectacular optics.

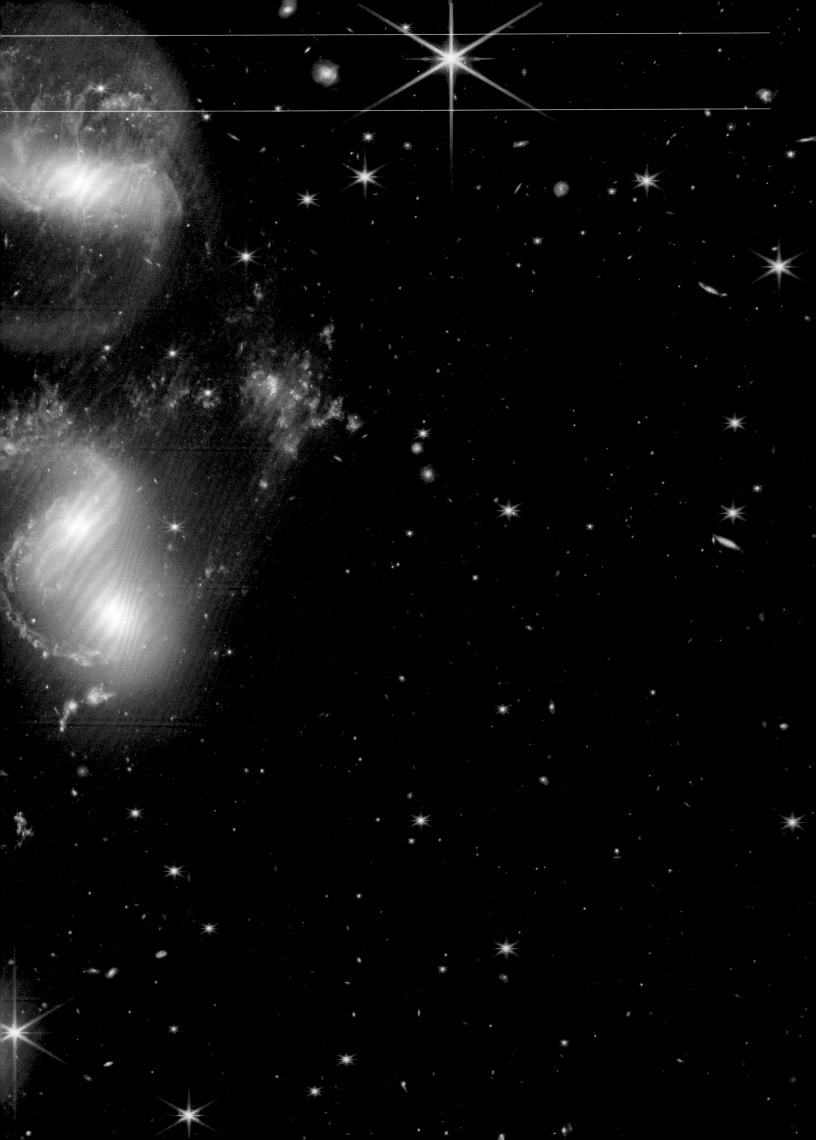

C3.1

An exoplanet's atmosphere

The only one of JWST's first five science releases to not have a JWST image associated with it, this illustration instead shows an artist's interpretation of the "hot Jupiter" exoplanet WASP-96b. Orbiting its parent star every 3.4 days, WASP-96b is 20 percent larger than Jupiter but has only half of Jupiter's mass. By measuring the starlight absorbed by the planet's atmosphere spectroscopically with NIRSpec, JWST was able to detect water vapor, carbon monoxide, carbon dioxide, and even trace amounts of sodium and potassium in this exoplanet's atmosphere.

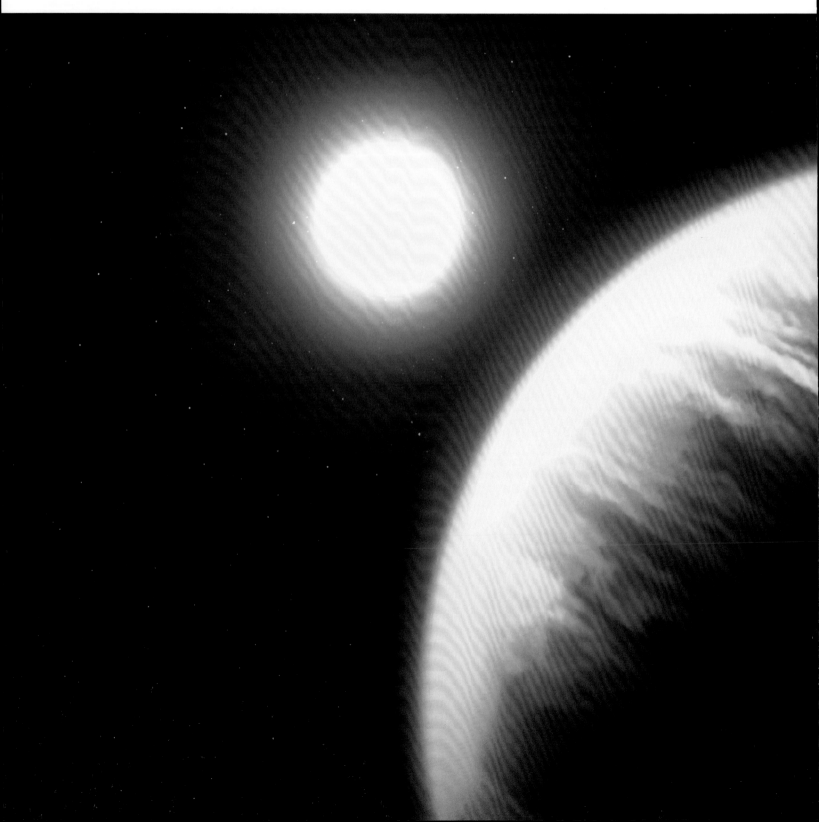

Seeing beyond Hubble

If the Hubble Space Telescope first showed us what the early universe looked like, then JWST is showing us how the universe grew up. While Hubble was able to reveal a significant number of ultradistant galaxies in the very early universe, they appeared as little more than fuzzy smudges in the sky. Additionally, Hubble was sensitive to only the brightest of those early galaxies.

By contrast, JWST has shown us far greater numbers of those ultradistant galaxies, including many that are intrinsically fainter and far lower in mass than anything Hubble is capable of seeing. In addition, JWST now shows us that many of these very young galaxies contain active supermassive black holes, which suggests that early galaxies and super-massive black holes might be more abundant than previously thought.

JWST also sheds light on the star-formation rates and stellar populations inside these early objects, and its findings hint at answers to where cosmic dust comes from, how dusty galaxies evolve into quasars, and how gas flows into and out of these objects. For too long, these were theoretical descriptions of key steps in the formation of galaxies, stars, and planets like Earth. Now, with JWST's quantitative observations, these theories can be tested, confirmed, and, in some cases, revised. In just its first year of science operations, JWST proved its capabilities, providing data-driven answers to questions that previously could be answered only through pure speculation.

A fiery hourglass

Before it was viewed by JWST, this object was known as a "dark cloud," since when viewed in visible wavelengths, it blocks the light from stars behind it. In JWST's infrared views, however, we can clearly see that this is a protostar: a new star forming from a cloud of gas. A planet-forming disk, also known as a protoplanetary disk or proplyd, can be seen edge-on at the image's center. Two giant cavities have been blown out by the central star, glowing a ghostly orange and blue in infrared light, while the bubble-like and tendrilous features represent material sporadically ejected over thousands of years.

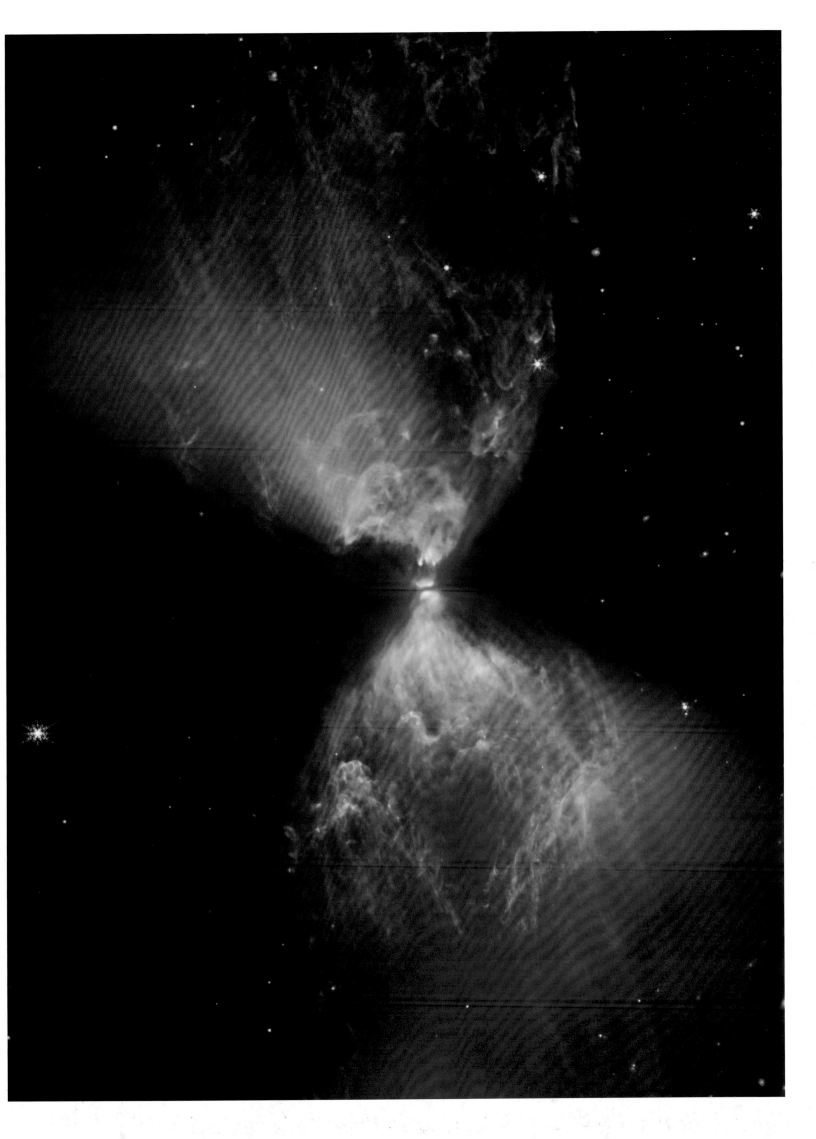

C3.2

Record-breaking galaxy cluster

One of the keys to discovery is deep-field imaging: observing the same small region of sky for long periods of time. Here the faint red objects correspond to the most distant galaxies observable. The seven red-colored galaxies highlighted within five white boxes had the fingerprint of their distance taken by JWST and were all shown to be precisely equidistant from us, indicating that we're witnessing a cluster of galaxies just beginning to assemble. Their light arrives from a time when the universe was just 650 million years old, making this the farthest proto-cluster of galaxies ever found.

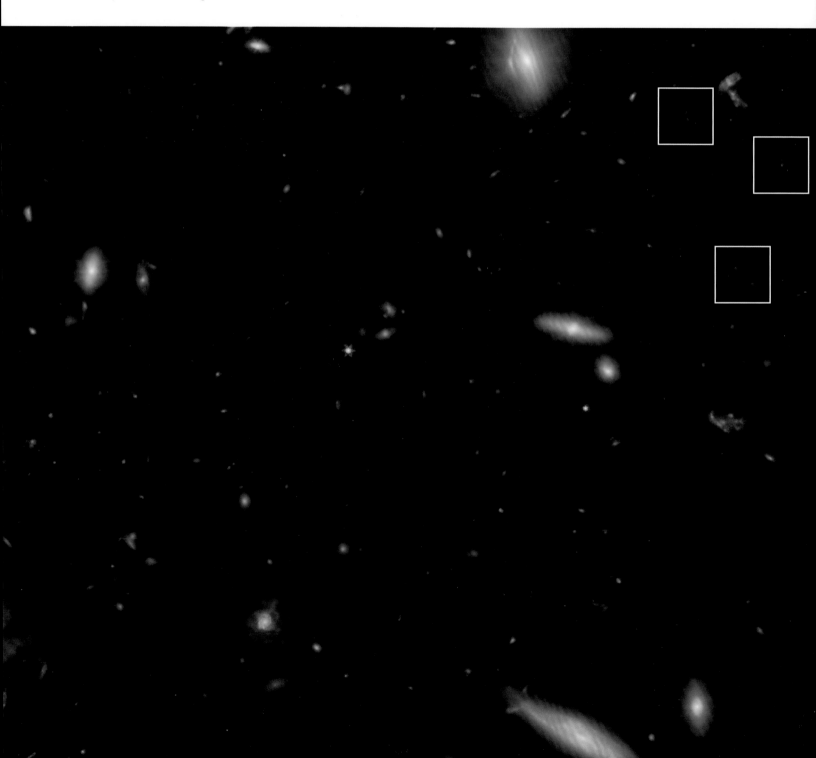

C3.2

The Crab Nebula

What does a supernova look like a thousand years onward? That's what JWST shows as it peers inside the Crab Nebula, a supernova remnant that was first observed in the year 1054. In the time since, the nebula has grown, expanding to a full 11 light-years across, powered by a pulsing, rapidly rotating central neutron star. The swirling white wisps inside represent electrons accelerated by the neutron star's magnetic field: electrons that emit light invisible to human eyes but revealed by JWST. The dense, knotted features are dominated by dust, to which JWST is especially sensitive.

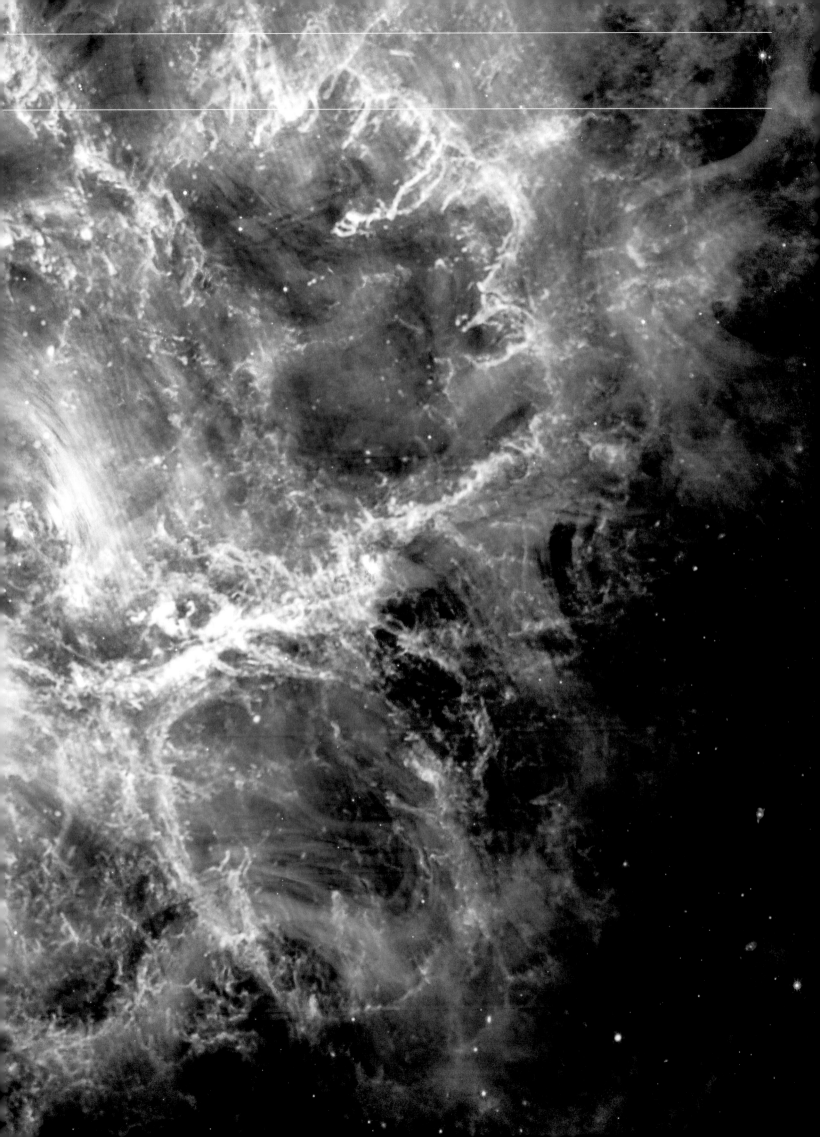

C3.2

Tremendous cosmic smashup

How can you tell if you're looking at one galaxy cluster or multiple galaxy clusters merging together? Optical images can reveal mass, based on how the light from background galaxies gets bent and distorted. If two or more galaxy clusters are colliding, then the gas within them heats up and emits x-rays. If those two maps, mass and gas, don't line up, you have evidence of a cluster in collision, like Pandora's cluster (Abell 2744), shown here.

① A composite image of the galaxies in Pandora's cluster, comparing the mass map (in blue) with the gas map (in pink)

② A reconstructed mass map of Pandora's cluster, based on gravitational lensing

③ The visible-light view of the galaxies in and behind Pandora's cluster, as captured by Hubble

④ The x-ray light emitted by hot gas caused by the collision of galaxies, as captured by NASA's Chandra X-ray Observatory

A hot mess of galaxies

Within Pandora's cluster, as viewed by JWST, an estimated 50,000 individual galaxies can be found. The large, puffy galaxies are giant ellipticals, which lie at the cores of galaxy clusters and can weigh thousands of times the mass of a Milky Way–like galaxy. The light from galaxies behind the cluster gets bent, distorted, and stretched into arcs by the cluster's gravity. The faintest, reddest blobs represent the most distant, earliest galaxies—from as few as 320 million years after the big bang.

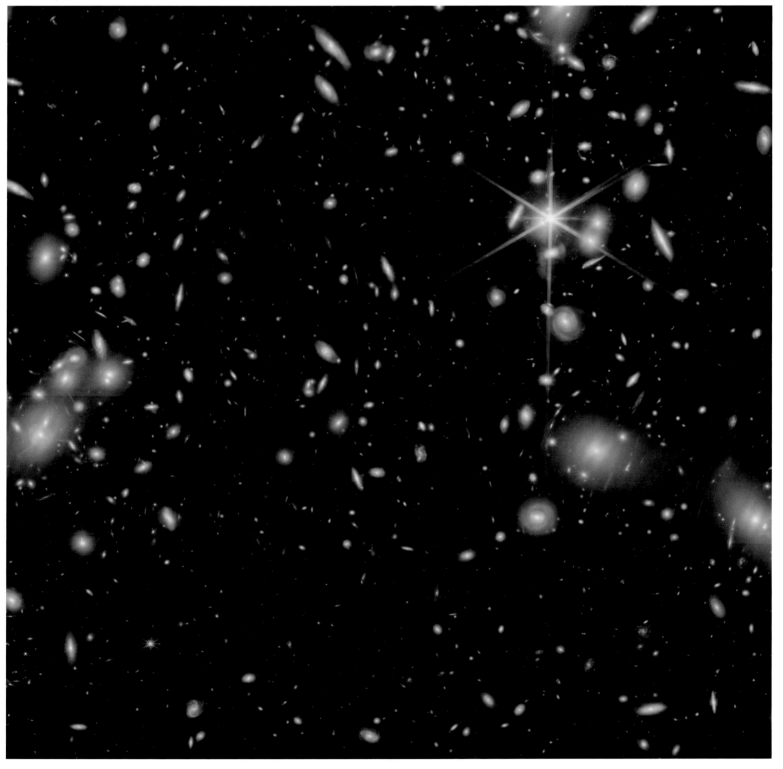

C3.2

Hubble's Pillars of Creation

One of the most famous Hubble images of all, this iconic starscape shows three towering columns of gas. Outside the pillars, young stars emit copious amounts of ultraviolet radiation, evaporating these globules of gas. Inside the pillars, new stars are still in the process of forming. As revealed by Hubble in visible light, the nebula blocks the light from background stars and the stars inside the pillars. Only a select few can pierce through the darkness.

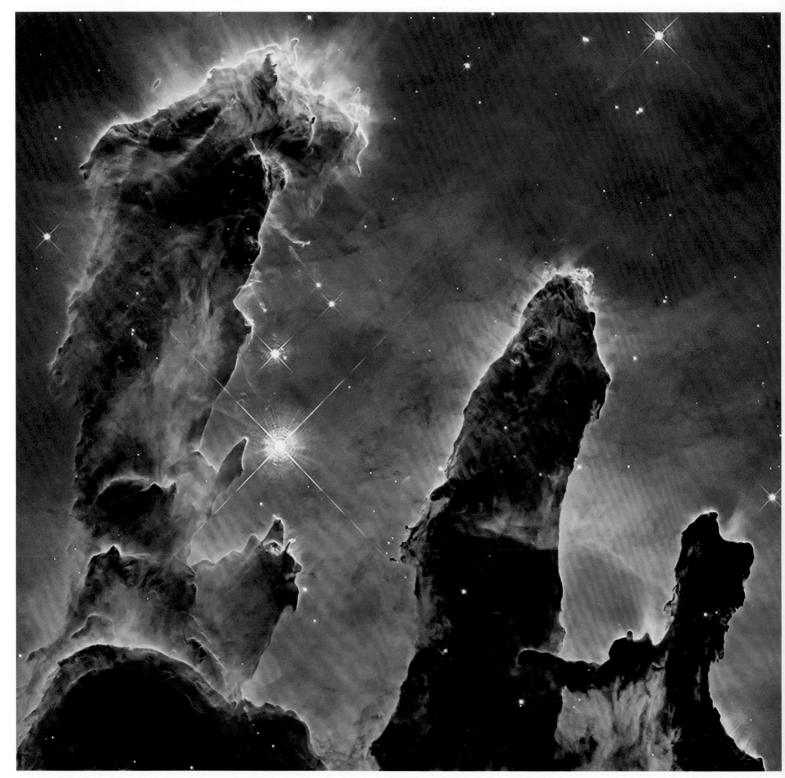

Hubble's Pillars of Creation

Hubble's ghostly infrared pillars

In 2015, Hubble used its near-infrared capabilities—quite limited in both wavelength and resolution compared with those of JWST—to peek through gas and dust, revealing both stars behind the pillars and newly forming stars inside the nebula itself. In Hubble's infrared views, the pillars appear much leaner and more ethereal, since infrared light travels more easily through the dust grains than shorter-wavelength visible-light radiation does.

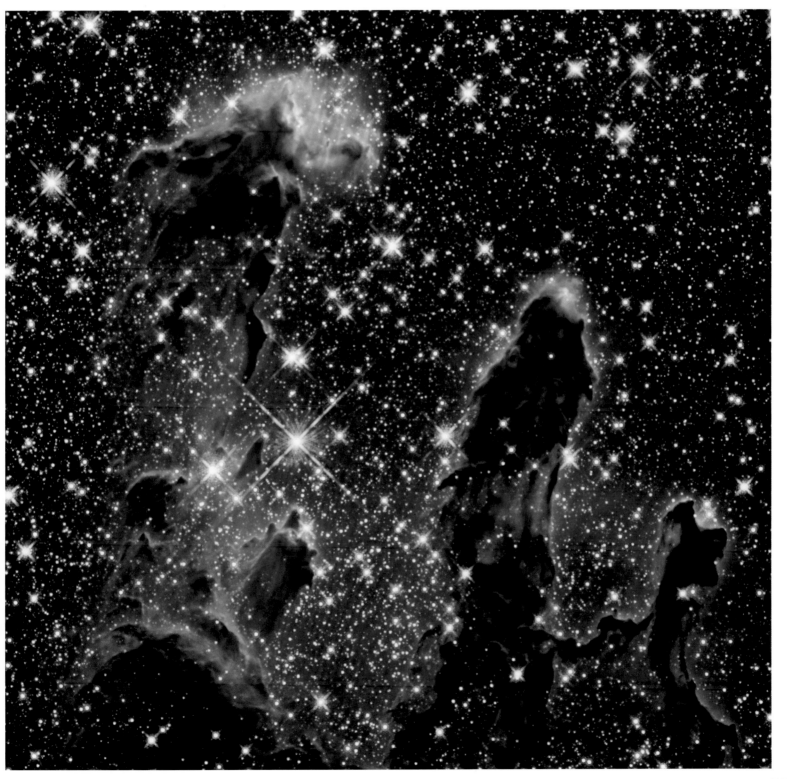

C3.2

JWST's dust-rich perspective

JWST can observe the universe at much longer wavelengths than
Hubble can, thanks to the mid-infrared capabilities of JWST's MIRI.
MIRI is particularly sensitive to dust, giving a phantom-like appear-
ance to these pillars, while only a small selection of cool, red stars
and protostars appear in this long-wavelength JWST view.

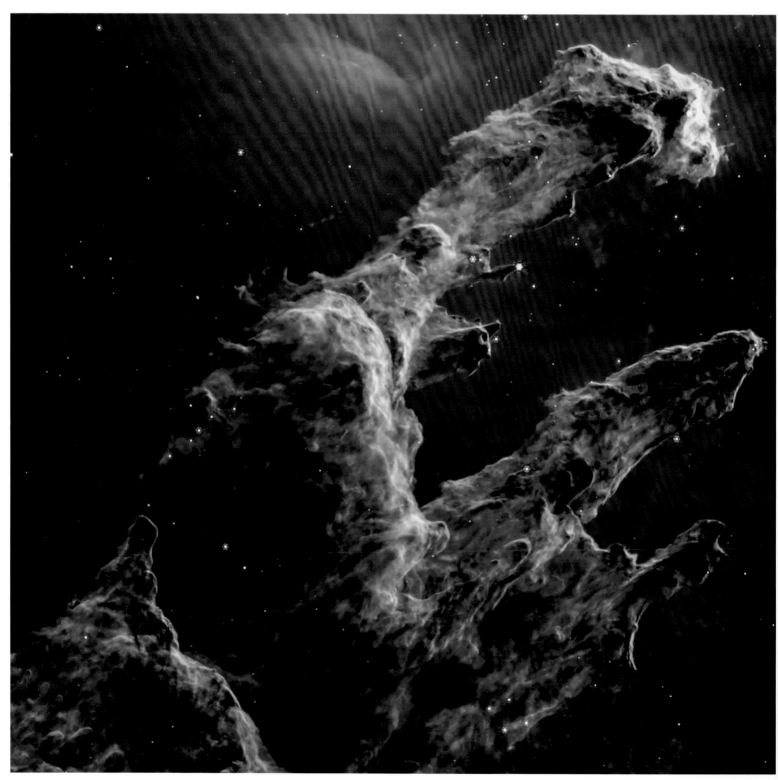

A surfeit of new stars

How many stars exist within the Eagle Nebula, part of the Pillars of Creation? In JWST's NIRCam view, the answer is thousands. Wispy, blue tendrils and wavy lines emanate from the edges of the pillars, further evidence that very young stars are forming inside: Only the newest stars emit outflows of the kind of material that interacts with the gas and dust of the pillars, creating those features.

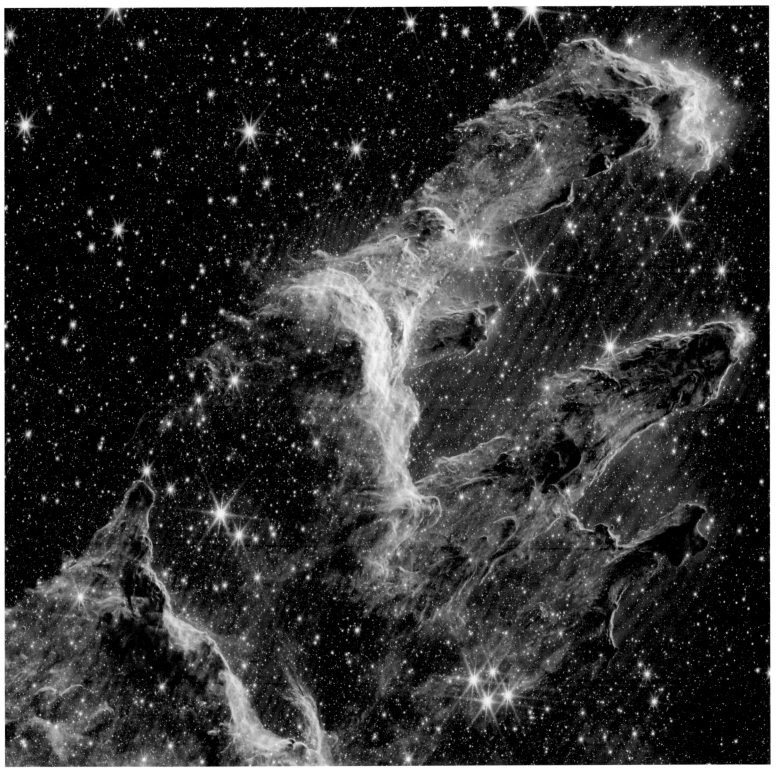

A young star erupts

When young stars form, they don't just gradually accrete surrounding material because of gravitational collapse. They also eject material—known as outflows—from internal processes occurring within. There's still matter (gas and dust) in the interstellar medium around the stars, and these outflows, powered by stellar winds and jets of gas, crash into that matter. The narrow jets appear pink; the multicolored features around them reveal the presence of molecular hydrogen, carbon monoxide, and silicon monoxide.

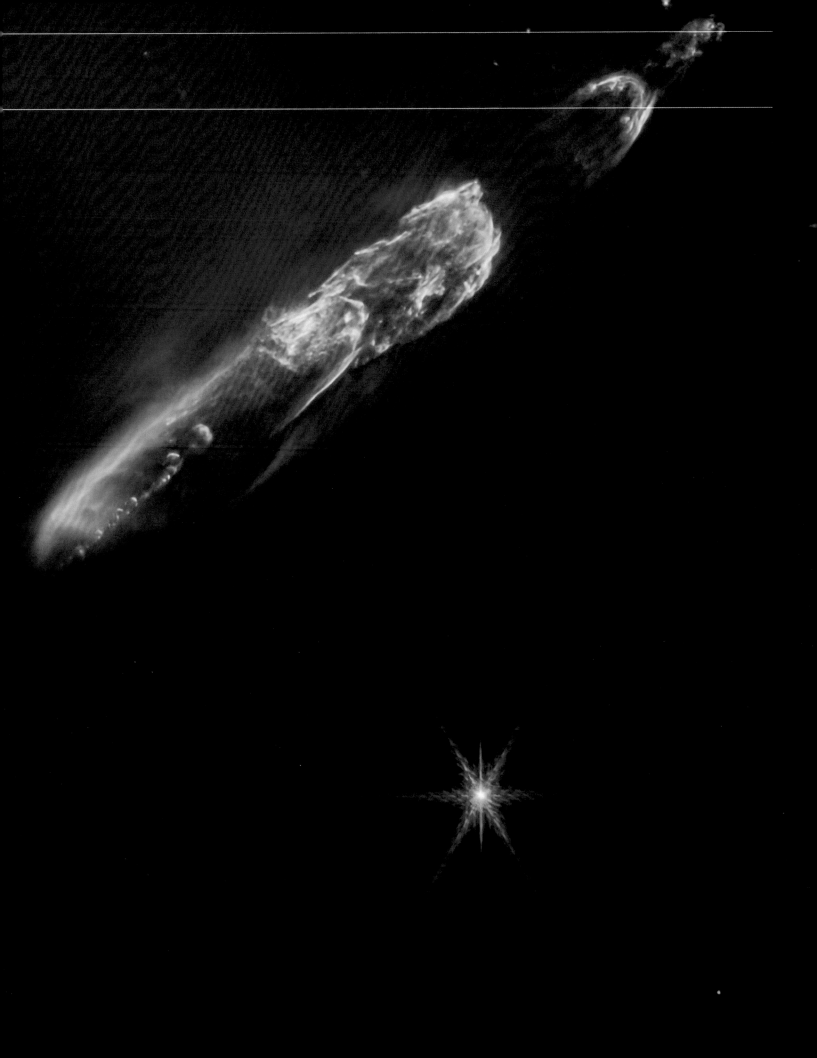

The farthest star of all

This JWST image illustrates gravitational lensing, a powerful natural phenomenon that helps magnify the light from a distant source. The mass of a foreground galaxy cluster behaves as a lens, magnifying background objects by up to a factor of hundreds or even thousands. Here, serendipitously located behind galaxy cluster WHL0137-08, a distant galaxy passes through a region of extreme magnification, creating a feature dubbed the "sunrise arc." Within that galaxy, a single, massive star that's about one million times as bright as the sun is revealed: Earendel, the most distant individual star ever discovered.

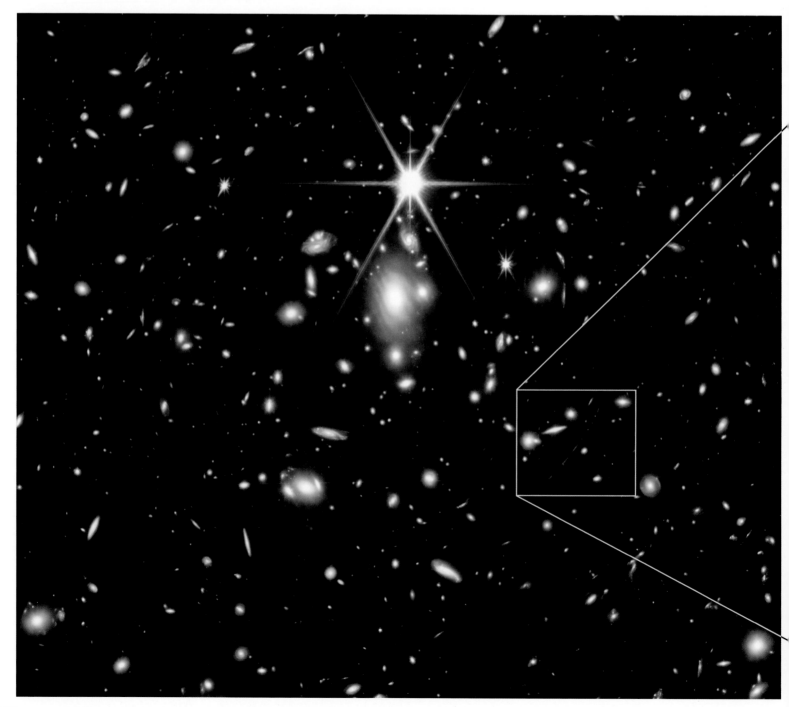

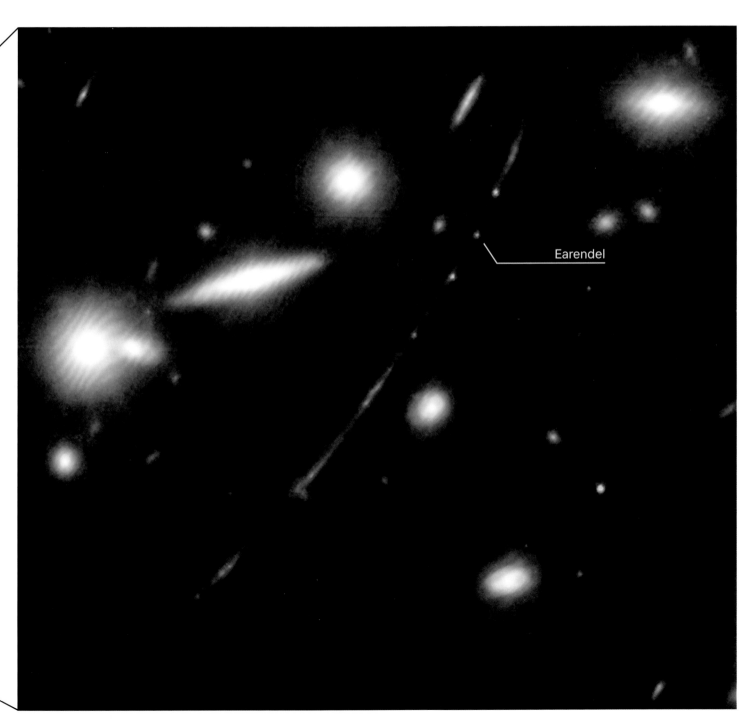

Earendel

● Our solar system's family portrait

Because of JWST's perspective, the observatory imaged first Jupiter, then Neptune, then Uranus, and finally Saturn, allowing us to assemble a family portrait of the giant planets in our solar system. Although each of Earth's larger planetary siblings was already widely recognizable, JWST's infrared capabilities have revealed remarkable new features about all of them.

As JWST pictures it, Jupiter's Great Red Spot appears white, as do all the planet's highly reflective clouds. Its faint rings are prominently illuminated, along with its nearby moons. Auroras glow at its northern and southern polar regions.

For the first and only time since Voyager 2's 1989 flyby, JWST brought Neptune's rings into focus. High-altitude clouds of methane ice reflect sunlight in the infrared and make the planet appear to glow. Ice-covered Triton, one of Neptune's moons, shines brilliantly nearby. A thin band encircling Neptune's equator is a visual signature of how an atmosphere circulates around the globe.

Uranus's series of concentric rings were also brought into clear focus by JWST. Reflective clouds and a bright polar cap appear brighter than the rest of Uranus's atmosphere, while all six of its largest moons shine brilliantly under the watchful gaze of JWST.

Saturn, meanwhile, plays second fiddle to its water-ice dominated rings in JWST observations. The A, B, C, and F rings are all clearly identifiable, along with the Cassini division and the Encke gap, plus three of Saturn's large, inner moons: Dione, Enceladus, and Tethys.

Interstellar interloper

In 2017, the very first object from outside our solar system was discovered passing through it: 'Oumuamua, discovered by the Pan-STARRS telescope on Maui and given a Hawaiian name meaning "a messenger from afar arriving first." Unlike a typical comet, 'Oumuamua showed no evidence of a tail or outgassing but moved in a way that was consistent with the idea that some sort of material was being expelled. The next time an 'Oumuamua-like object passes through, JWST will be able to detect whether it is outgassing nitrogen, hydrogen, or any other molecules or ions.

The king of the planets

What does Jupiter look like to JWST's eyes? This NIRCam image, acquired in July 2022, shows us a remarkable set of features. The Great Red Spot, visible at the lower right, appears white, given its highly reflective cloud tops. The banded features showcase how hurricane-speed winds are stratified across the planet's latitudes. At the poles, blue hazes arise because of Jupiter's auroras, which shine in infrared light. Jupiter's thin rings can also be seen, as can two of its inner moons: Amalthea and Adrastea. In the lower left, faint background galaxies appear alongside our solar system's largest planet.

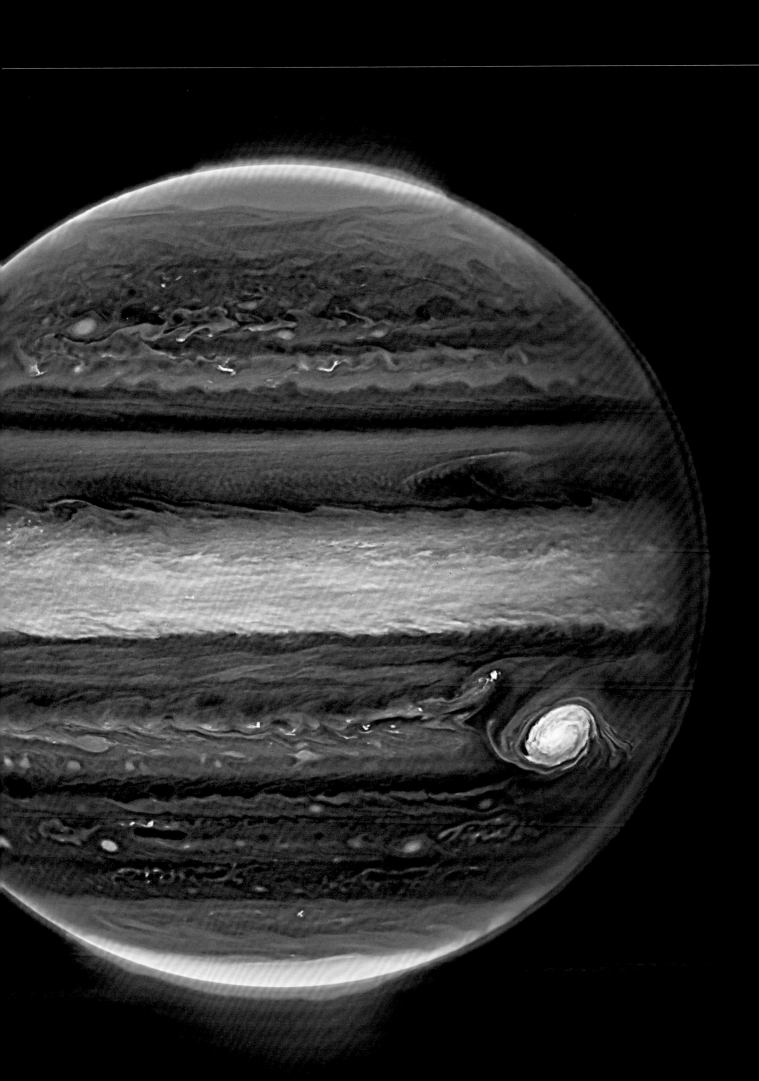

Hubble's Jupiter

This more familiar visible-light image of Jupiter comes from the Hubble Space Telescope, viewed in 2021, showcasing many turbulent storms across the planet's face. The Great Red Spot, significantly larger than Earth, looms in Jupiter's southern hemisphere, while several smaller, temporary storms appear to the north. The equator is unusually devoid of clouds, revealing the deeper, orange-colored gases beneath them. Jupiter's atmosphere clearly circulates in latitude-dependent fashions, with significant differences between its northern and southern hemispheres.

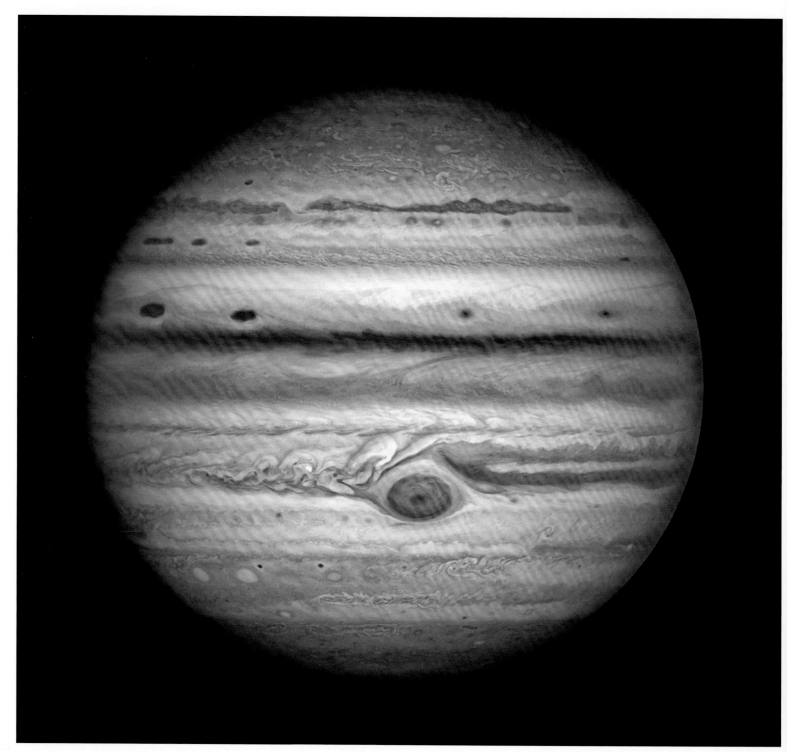

JWST's Jupiter

Taken just 10 months after the Hubble photo opposite, this infrared
view of Jupiter comes courtesy of NIRCam. The red ribbons at
Jupiter's poles are auroras, which shine only in ultraviolet and
infrared wavelengths. The dark ribbons at slightly lower latitudes
show regions with very little cloud cover. Highly reflective features,
like high-altitude clouds, appear white to JWST's instruments. The
pink dots, lining the interface between the various circulating
bands of Jupiter, represent enormous storms occurring on this
giant planet.

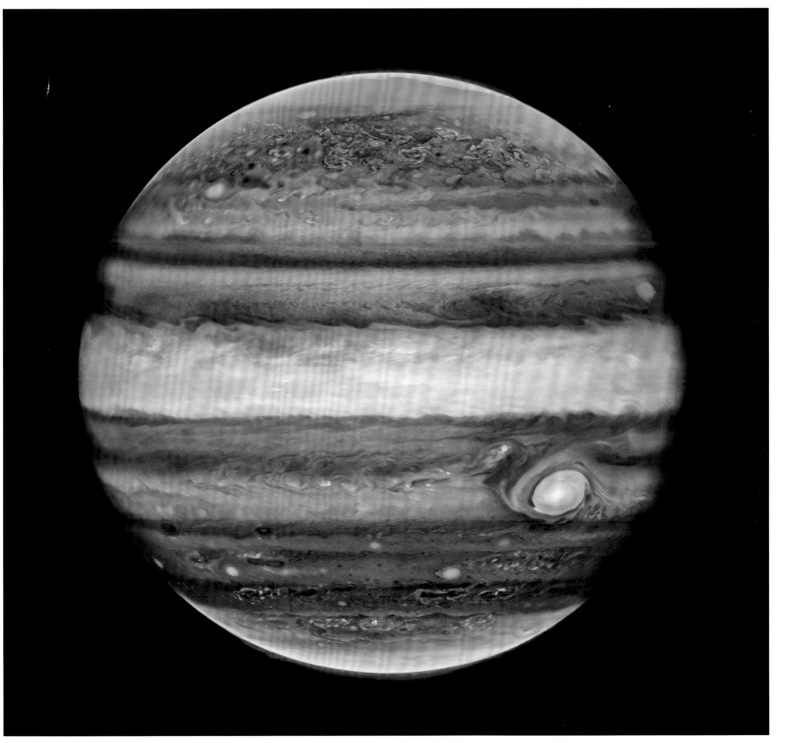

Neptune close up and from afar

When JWST targeted the most distant planet in our solar system, astronomers were in awe of what they were able to see. Neptune's atmosphere is rich in methane, but it also contains high-altitude clouds, which explains why the planet is dark, with only a few bright spots. Four of Neptune's rings are visible, along with all seven of the planet's innermost moons. In the wider view opposite, the bright bluish object is Neptune's giant moon, Triton, which appears much brighter than Neptune in this NIRCam view, despite its smaller size. The reason? Triton is an ice-rich, solid-surface world, and ices are incredibly reflective, especially in infrared light. Neptune, by comparison, is covered in methane, which reflects only a tiny fraction of infrared light. Hundreds of background galaxies appear beyond the Neptune-Triton system in this image as well, varying in shape, size, and distance.

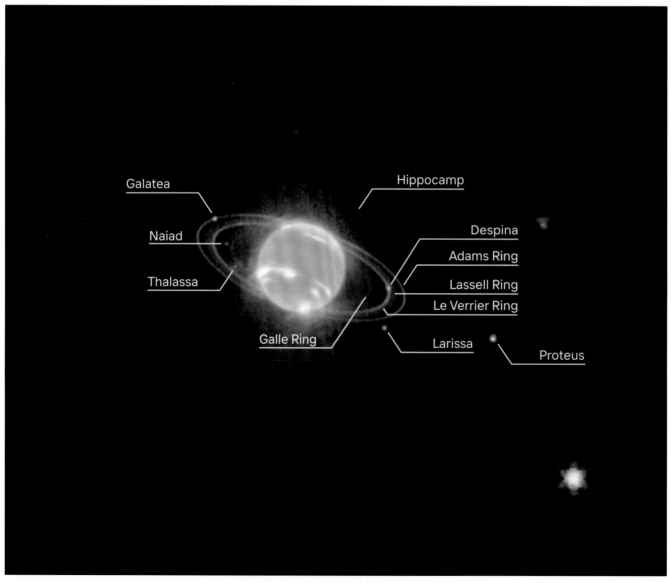

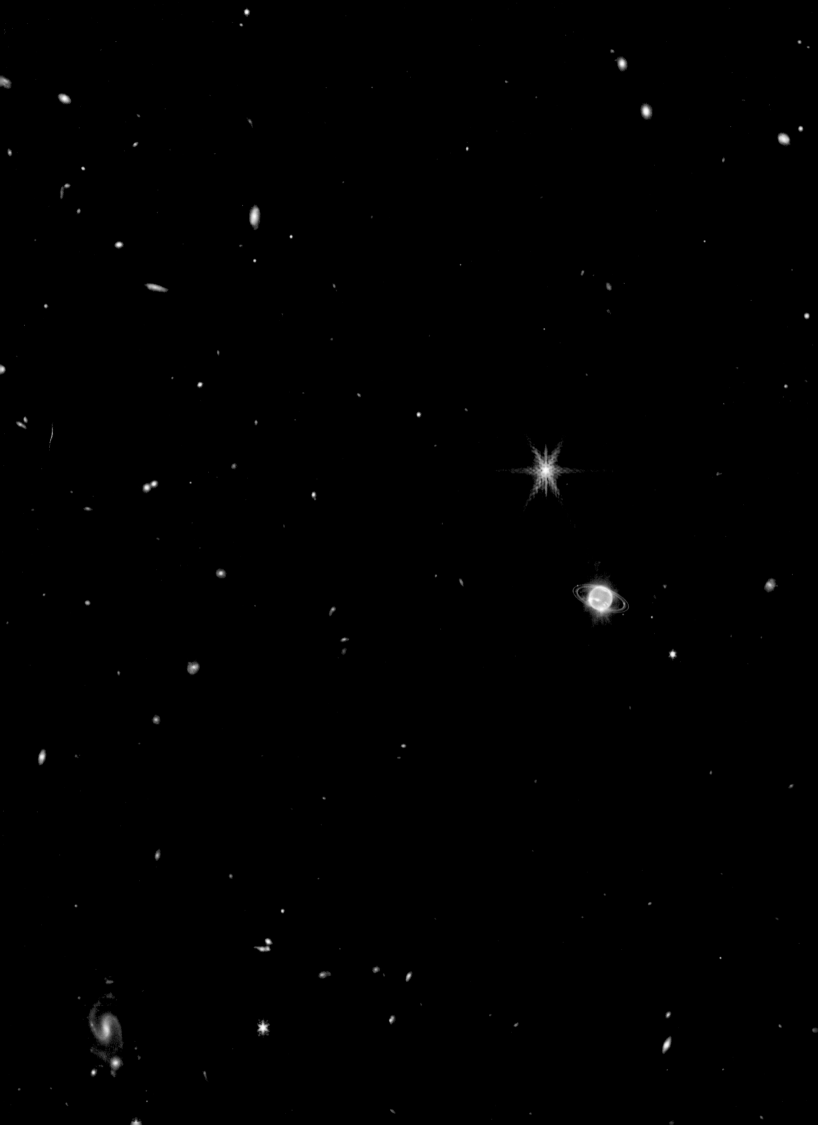

Oberon

Titania

Umbriel

Perdita

Rosalind

Juliet

Puck

Portia

Belinda

Desdemona

Bianca

Cressida

Ariel

Miranda

Uranus from afar and up close

On September 4, 2023, JWST snapped this image of Uranus, its rings, and a whopping 14 of its moons. Uranus appears almost monochrome and featureless, since it—unique among the planets in our solar system—rotates on its side and is here approaching its solstice, when one pole faces the sun. The bright blue points are Uranus's largest moons, named for characters in Shakespeare's *The Tempest* and Alexander Pope's *The Rape of the Lock.*

This view of Uranus and its rings is the best one we've acquired of our solar system's seventh planet since those sent back by Voyager 2 in 1986. We can see several concentric rings surrounding the planet. Uranus appears largely blue with a highly reflective polar cap that will disappear over the next four to six years as the pole keeps turning to face the sun. At the edge of that cap, a highly reflective cloud appears; just above and on the left, outside the cap, a bright, cloudy feature most likely represents a storm.

Saturn's shining rings

In visible light, Saturn's most striking feature is its enormous, impressive rings: brighter, larger, and more reflective than those of any other planet in our solar system. With NIRCam, however, Saturn appears extremely dark, as its methane-rich atmosphere absorbs nearly all the sunlight that strikes it at infrared wavelengths. The rings, on the other hand, are made almost entirely of water-ice, which is highly reflective. As a result, as seen by JWST, Saturn's rings outshine the planet. Three of Saturn's moons—Dione, Enceladus, and Tethys—hover nearby.

C3.4

◐ **Planet-forming surprises**

Since the Hubble era, we've seen that newly forming stars typically are surrounded by disks of matter: regions where planets, moons, and smaller bodies form. These protoplanetary disks, or proplyds, are likely responsible for the majority of planets that form in the universe, including, some 4.5 billion years ago, the planets in our own solar system.

But with JWST, we're seeing new features within these disks, providing information that showcases the many ways in which solar systems form. Data from JWST is uncovering how water arrives on the rocky planets that take shape within these disks: via ice pebbles that migrate inward. JWST is measuring the presence and abundance of various molecules and chemical compounds—including benzene and other organic molecules—that are found at various distances from a newly formed planet's central star, providing new details that inform our understanding of how planets form. It's unveiling more about debris disks, some of which persist for hundreds of millions of years, well after planets finish forming, and how

they originate and are replenished through cosmic collisions.

Perhaps most spectacularly, around the nearby young star Fomalhaut, JWST observations have revealed three dusty areas:

- an inner disk, whose edge corresponds to our solar system's asteroid belt;
- an outer, extended ring, corresponding to our own Kuiper belt; and
- a mysterious, unexpected intermediate belt, with no known analogue.

For a long time, we assumed our own solar system would serve as a prototypical template for other stellar and planetary systems. With JWST's observations, we've already learned that our cosmic backyard is not the only option, and indeed that it may not even be a typical example of what's out there in the universe.

These surprises, found in young planetary systems, are merely the first hints of all the new knowledge that will continue to arrive throughout the JWST era.

A stellar surprise

This image shows the young, nearby star Fomalhaut, one of the 20 brightest stars in Earth's night sky, as observed with JWST's coronagraphic capabilities. A coronagraph is a special instrument that blocks the light from the main star, allowing astronomers to measure faint details around them: in this case, a dusty debris disk. Around the star, JWST data confirmed three independent regions: an inner disk, corresponding to our asteroid belt and inner planets; an outer belt, corresponding to our Kuiper belt; and an intermediate belt, newly discovered, with no analogue within our solar system. Is this configuration common? New discoveries often lead to unexpected, deeper questions.

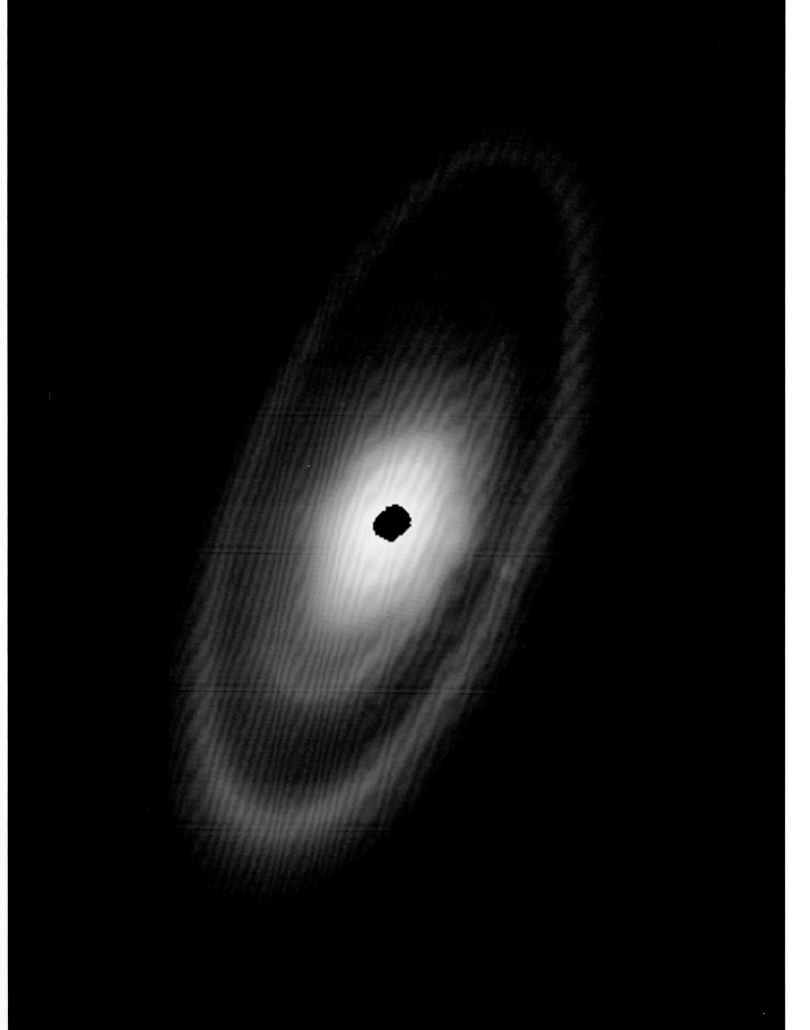

C3.4

Sparklers and snakes

At the center of the image opposite lies the massive galaxy cluster SDSS J1226+2149, located an impressive 6.3 billion light-years away. The cluster itself isn't the main target of JWST, however; the more distant galaxies in the background, made visible by gravitational lensing, are. Below, a diagram shows how gravitational lensing works. Without gravitational lensing, only nearby galaxies (in blue) and bright, distant galaxies (in red) would be visible. But around each massive foreground galaxy, light from background sources gets focused, stretched, and magnified by the force of gravity. When those lenses happen to enhance a more distant galaxy (in orange), they can be observed by telescopes like JWST, leading to powerful, novel discoveries of even faint, ultradistant objects.

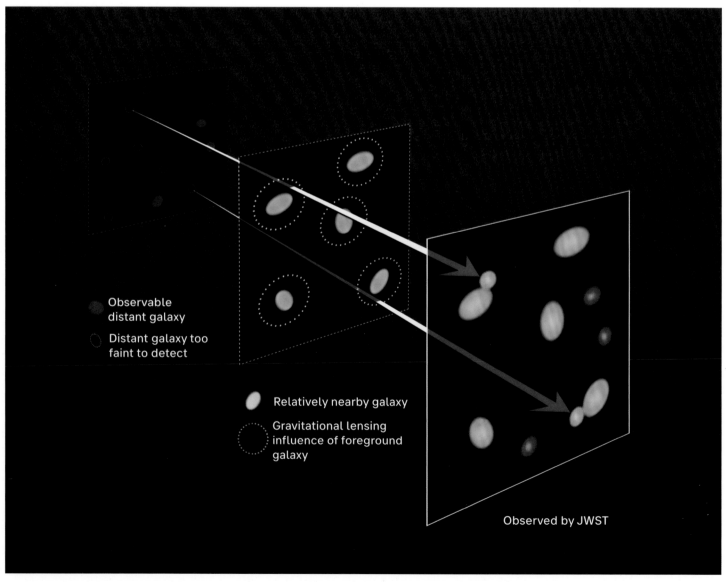

Observable distant galaxy

Distant galaxy too faint to detect

Relatively nearby galaxy

Gravitational lensing influence of foreground galaxy

Observed by JWST

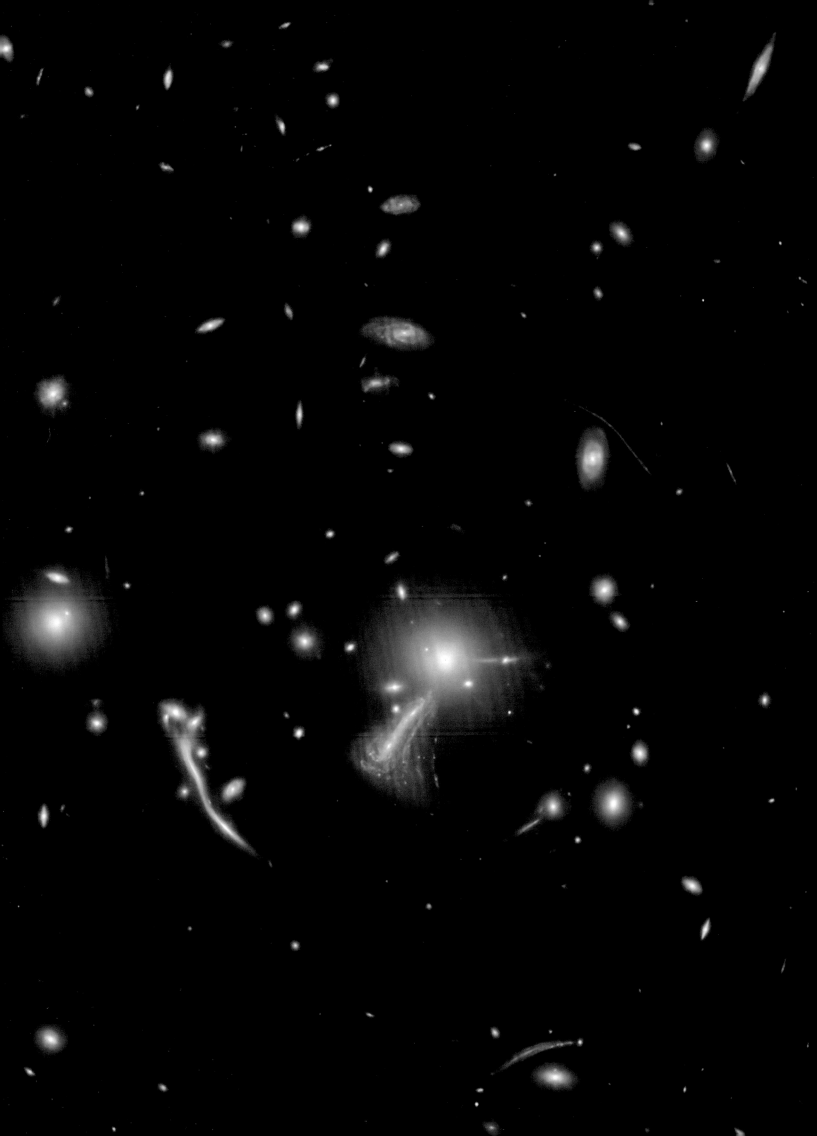

Eye of the storm

This isn't a ghostly view of a hurricane, but rather the heart of a nearby spiral galaxy discovered way back in 1780: the Phantom Galaxy, M74. Seen with MIRI, the dust distribution within the galaxy is mapped out, heavily lining its spiral arms. Great apparent holes in the dust correspond to regions where new stars have recently formed, with their ultraviolet light carving deep cavities as the dust evaporates nearby. In the center of the galaxy, a lack of gas allows JWST to capture an exquisite view of the stars clustered deep inside.

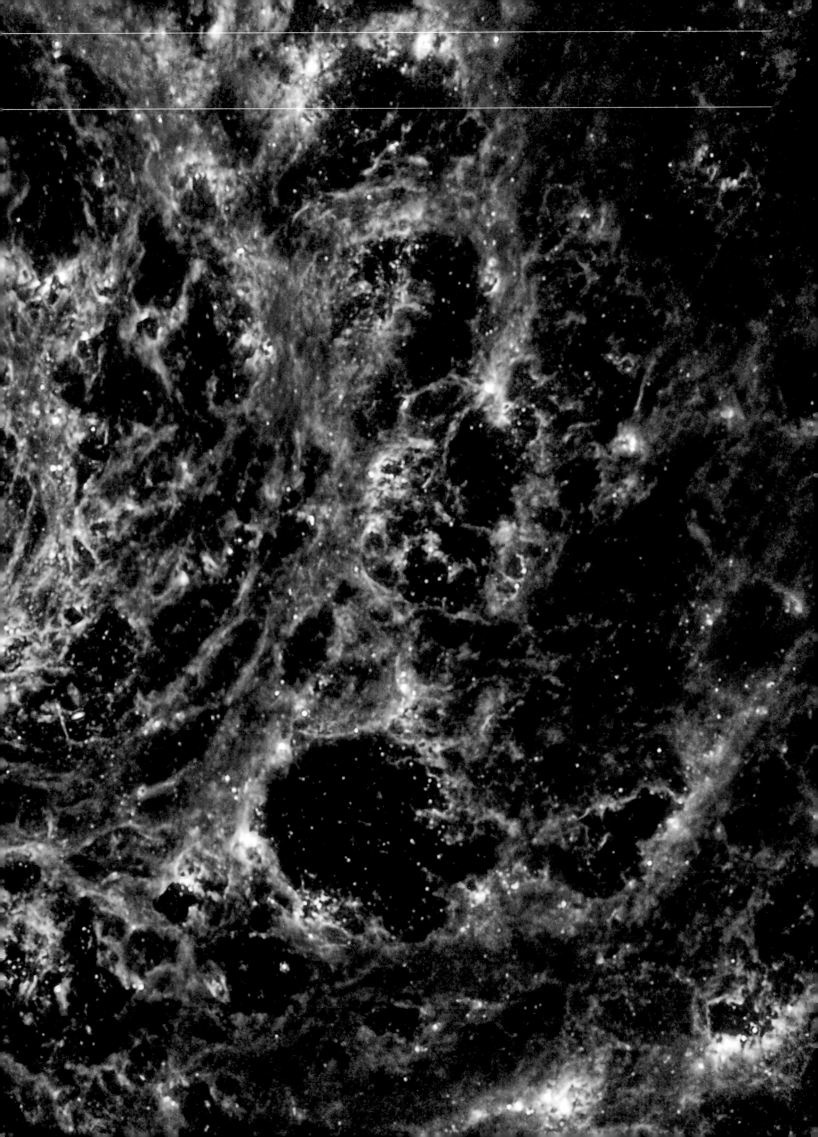

Hubble and JWST together

There's an old saying in astronomy: "One astronomer's noise is another astronomer's data." To Hubble, the bright optical sources—the stars, star-forming regions, and bright emission features from energized atoms—are the data, whereas light-blocking material, like dust, is noise. To MIRI, however, dust is the main target, and it is brilliantly illuminated in mid-infrared light. The combination of both Hubble (left) and JWST (center) data provides a unique view of the Phantom Galaxy (right), allowing us to see how dust, stars, and star-forming regions relate to one another.

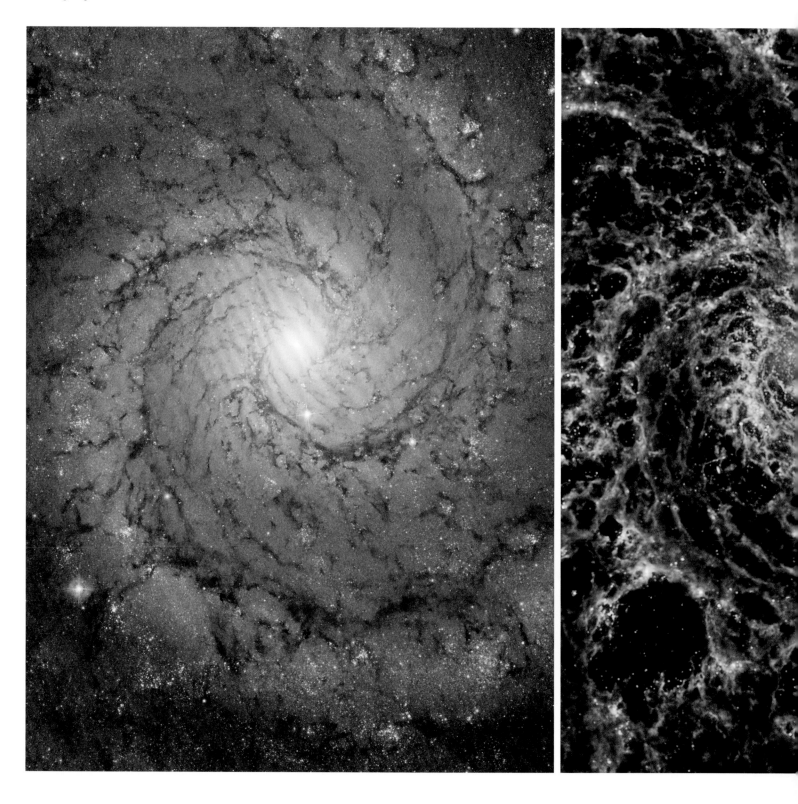

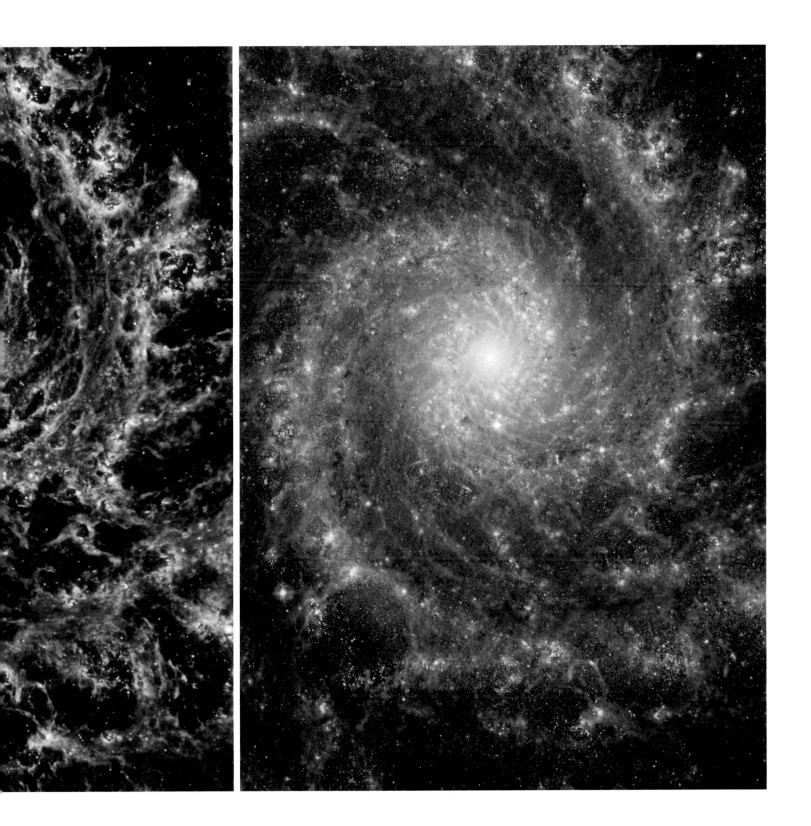

The largest of them all

As the universe ages, galaxies and galaxy clusters grow and increase in mass. For its age and distance in the universe, the largest galaxy cluster ever discovered is this one: El Gordo, or "the fat one" in Spanish. As viewed by JWST in near-infrared light, nearly every point of light seen here is its own galaxy, with only a few foreground stars from our home galaxy in the way. Behind El Gordo, located more than seven billion light-years from Earth and weighing more than two quadrillion suns, many gravitationally lensed galaxies can be spotted.

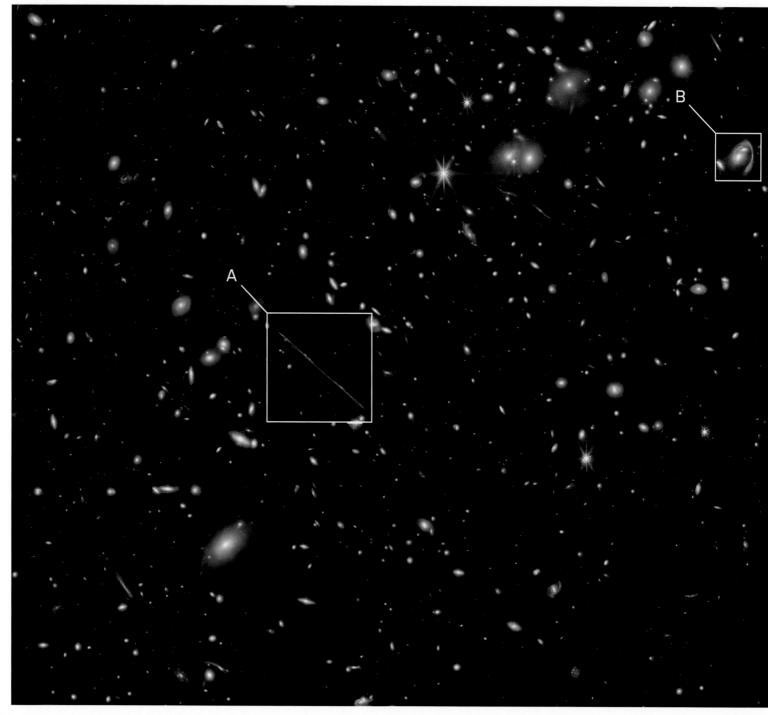

The thin one

What do you call a galaxy stretched into a long, narrow line by the El Gordo galaxy cluster? La Flaca—"the thin one," of course! Even though El Gordo's light comes from when the universe was only 6.2 billion years old, La Flaca is even younger: less than three billion years old. The physical extent of La Flaca is actually quite modest; gravitational lensing stretches it out to appear some 50 times longer than its actual size. What appear to be parallel streaks near La Flaca are also ultradistant galaxies, magnified and distorted by El Gordo's gravity.

A galactic fishhook

What has two thumbs and pulled up the sky? It sounds like a legend, but it's actually a heavily distorted galaxy known as El Anzuelo, "the fishhook." The galaxy looks red for two reasons: first, because its light gets stretched (redshifted) by the expanding universe; and second, because this is an incredibly dusty galaxy, with cosmic dust blocking blue light better than red light. This galaxy is only about 26,000 light-years across—one-fourth the diameter of the Milky Way—but massive foreground galaxies along our line of sight stretch it into this large, looping shape.

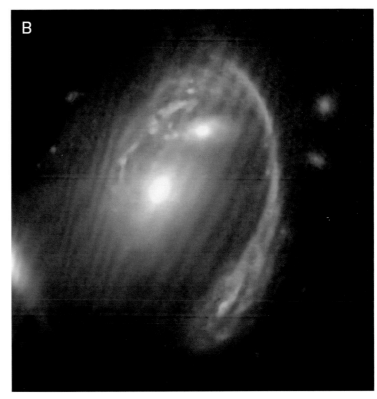

C3.4

A dying star, filtered

Human eyes typically possess only three types of color receptors, or cones, and so only three separate filters are needed to create a full-color image for our perception. But JWST has more than 20 filters between MIRI and NIRCam. The choice of which filter(s) to highlight can dramatically change what our eyes perceive. In this image of the Southern Ring, the cool gas expelled by the dying star is highlighted, emphasizing the dying star (in red) and its brighter, still living companion (in blue) alongside it.

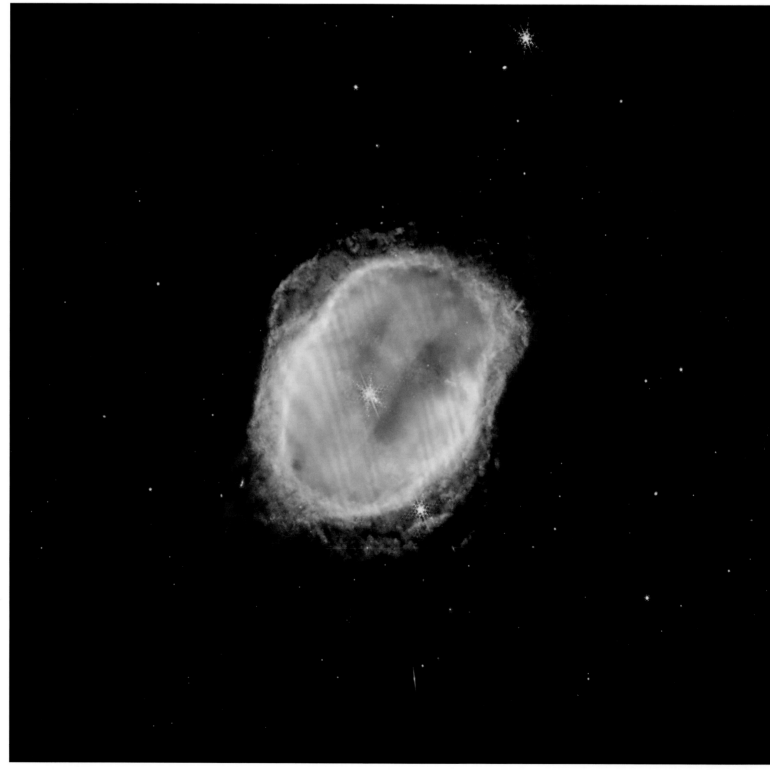

Same star, different filter

This combined MIRI and NIRCam view highlights what different
filters of light see when they observe the same object. Instead
of showing the cold gas in a shell around the dying star, this
view highlights the knotted ejecta, showcasing the emptiness
of the cavity as well as concentric streams of gas blown off
in prior centuries and millennia. The spoke-like features
accentuate where light streams through holes within the
gaseous nebula.

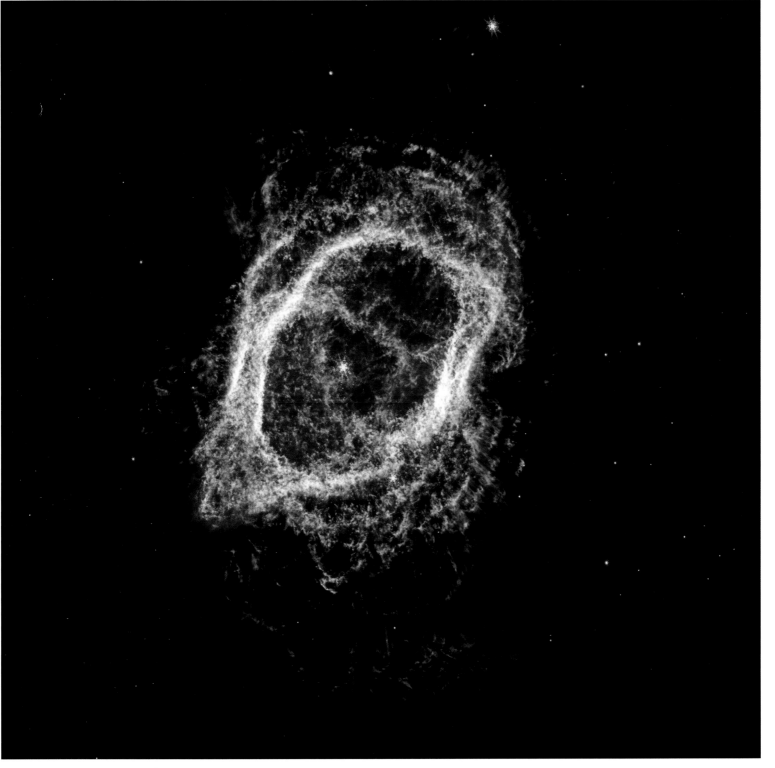

Focus on
Coloring the universe

One of the most striking features of JWST images is their unique coloration. Because JWST is an infrared telescope, the light it receives is inherently invisible to human eyes; we would perceive it only thermally, as heat. In order to visualize its observations, astronomers translate its data into a format we can view, accomplished by judiciously assigning colors to the data JWST provides.

Whereas human eyes typically possess three different types of color receptors—cones—for interpreting the universe visually, JWST's near-infrared and mid-infrared imagers observe in between seven and 12 separate wavelengths, depending on which observing mode is chosen. Across all modes, up to 29 different types of image can be produced. The images that JWST takes begin as monochrome and gray-scale, but by assigning various colors to components of each image representing different wavelengths, astronomers artificially "shift" those infrared images into visible-light colors that our eyes can perceive.

Higher-energy, shorter-wavelength light is interpreted by the human brain as blue in color, while lower-energy, longer-

Assigning color

By assigning green and yellow to intermediate-wavelength light ①, orange and red to long-wavelength light ②, and violet and blue to short-wavelength light ③, a JWST image can present a wealth of details together in a single visual display. The final result (opposite) is a breathtaking, assigned-color view that displays a wide variety of physical features all at once.

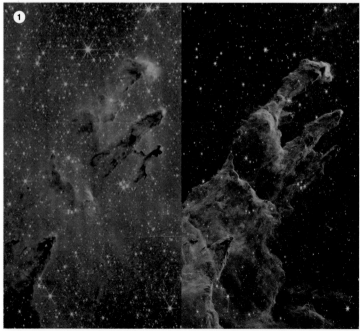

wavelength light appears red to us, and that's typically how JWST image colors are assigned: with short-wavelength light assigned blue colors, medium-wavelength light assigned greens and/or yellows, and long-wavelength light assigned red. Because different targets are observed with different sets of filters and sometimes by wholly different instruments (such as NIRCam for near-infrared imaging and MIRI for mid-infrared imaging), the resulting color scheme is often unique to the particular object and data set being viewed at any given time.

Just as old cathode-ray-tube televisions and projectors would project three images at once—one with a red color, one with a green color, and one with a blue color—to create a full-color image that our eyes could digest, JWST data gets stitched together into a single, visible portrayal. By observing the same object across various wavelength ranges, where different individual filters are assigned as various colors, human eyes can feast on the end result. Color images remain the simplest way to communicate the greatest amount of information to the viewer all at once, even when the raw data itself would otherwise be entirely invisible to our eyes.

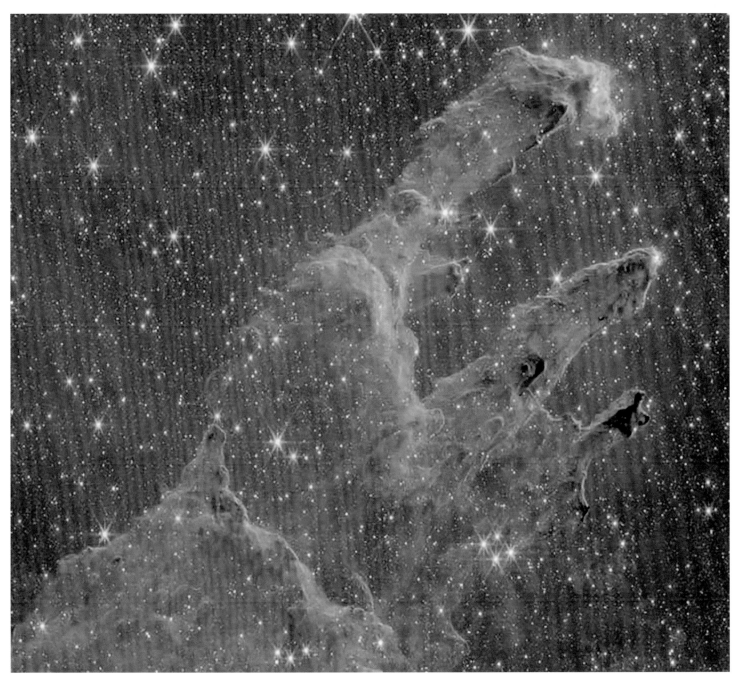

C3.5

● Gravitational lensing

Even with its unprecedented capabilities, JWST's views of the universe are still finite and limited. The faintest, most distant objects in the cosmos—including the very first stars of all—remain invisible even in the longest-exposure JWST images acquired to date. The universe itself offers a natural enhancement, however, that can reveal features that would otherwise remain unobservable: gravitational lensing.

Whenever a large amount of mass gathers together in one location, it bends and distorts the fabric of the surrounding space-time, just as the theory of general relativity dictates. As light from background objects even farther away passes close to or through that region of the universe, it not only gets distorted but also gets magnified and potentially bent, either into multiple images or into a complete or partial ring. The foreground mass behaves as a gravitational lens. The amount of mass and how it's distributed affect the light passing through it, amplifying the light coming from those background sources.

Gravitational lensing has brought a tremendous set of brilliant features into JWST's view, including
- the most distant single star ever viewed, Earendel;
- a triply imaged supernova in a galaxy 16 billion light-years away;
- star formation occurring in distant globular clusters; and
- the tiniest early galaxy ever discovered, forming stars just 500 million years after the big bang.

With such an enhancement, thanks to gravity, extraordinarily distant objects have a chance of being captured by JWST's eyes.

Better together

When both JWST and Hubble take a look at the same object—in this case, a small region within the galaxy cluster MACS 0416—the combined data present a spectacular array of features and colors. Here, while the yellowish galaxies are members of the cluster, located about 4.3 billion light-years away, the background galaxies are stretched into extreme, slender arcs via gravitational lensing. The bluest galaxies are actively forming stars and are best seen by Hubble in visible light, while the reddest galaxies are full of dust and best revealed by JWST's infrared eyes.

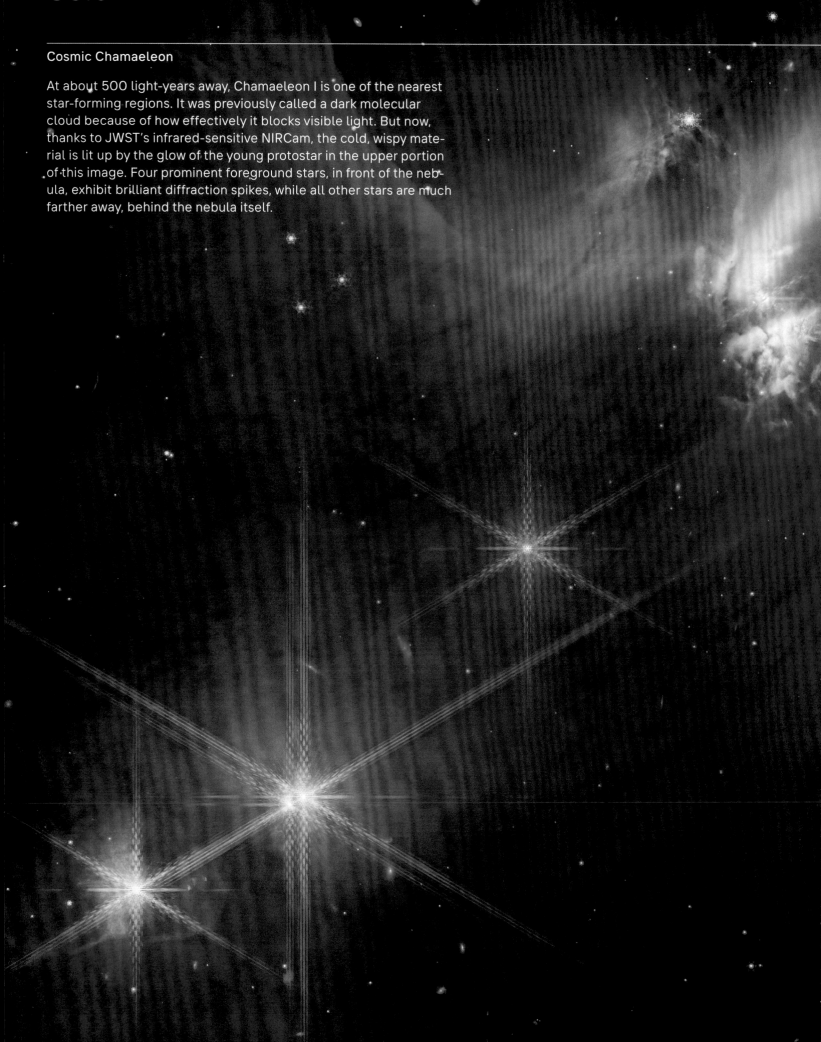

Cosmic Chamaeleon

At about 500 light-years away, Chamaeleon I is one of the nearest star-forming regions. It was previously called a dark molecular cloud because of how effectively it blocks visible light. But now, thanks to JWST's infrared-sensitive NIRCam, the cold, wispy material is lit up by the glow of the young protostar in the upper portion of this image. Four prominent foreground stars, in front of the nebula, exhibit brilliant diffraction spikes, while all other stars are much farther away, behind the nebula itself.

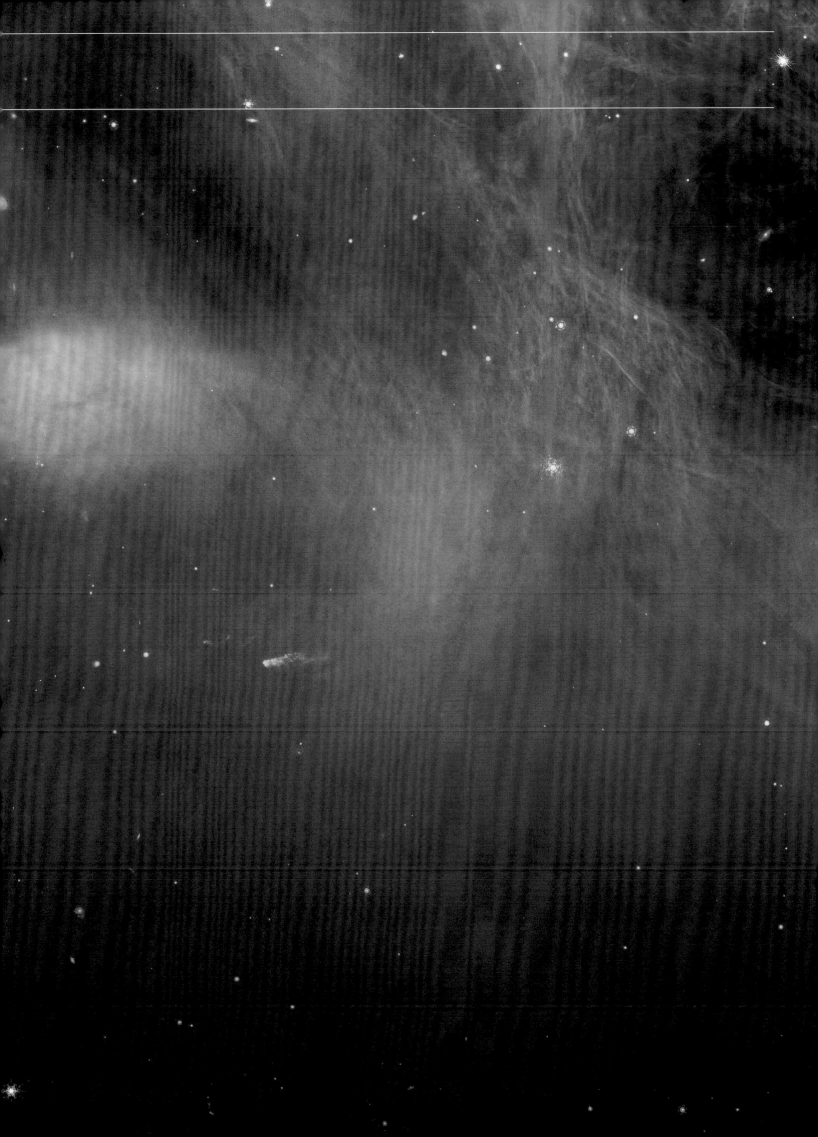

C3.5

Cosmic fireworks explode

Since the dawn of the 21st century, more than 100,000 supernovae have been detected, including two in a relatively nearby spiral galaxy: the Fireworks galaxy, NGC 6946, located only 25 million light-years away. Because it's so close by, NGC 6946 appears rather large on the sky, and would require dozens of JWST observations stitched together to view in one image. From the ground, however, a single image from Kitt Peak National Observatory in Arizona can capture the entire galaxy. The locations of its two most recent supernovae are marked in this picture.

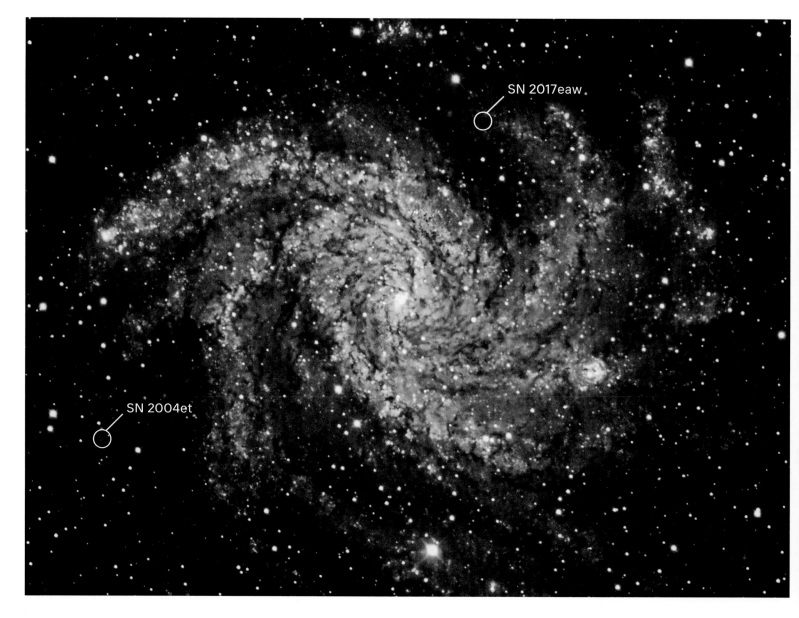

Dusty afterglows

JWST's MIRI images of the locations of the two supernovae within
NGC 6946 look vastly different from the Kitt Peak National
Observatory's visible-light image opposite, yet these are indeed the
same regions of space. While the Kitt Peak observatory sees visible-
light features, including the pink-appearing regions that are a
telltale sign of where new stars are forming, MIRI is primarily
sensitive to dust, highlighted here.

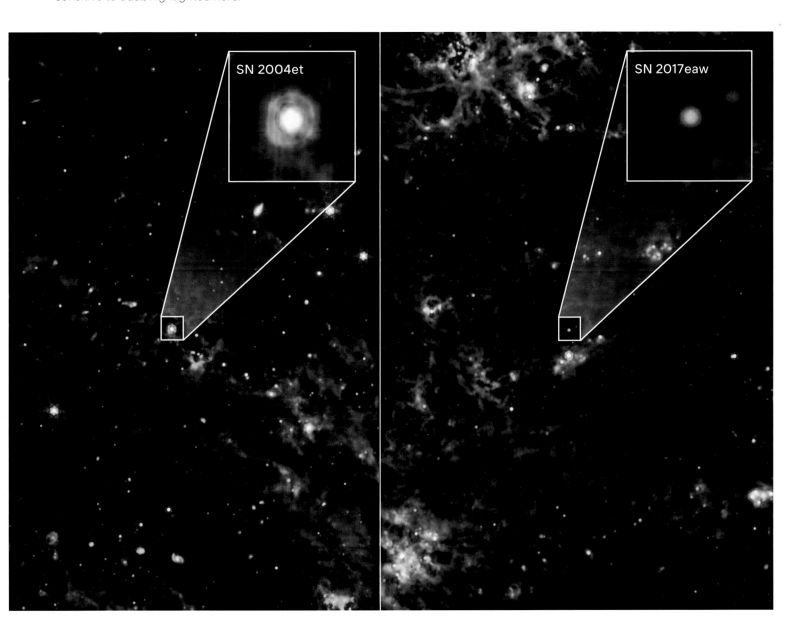

Cartwheel galaxy

Nearly all galaxies in the universe are either spiral or elliptical in shape, but very rarely one appears in the shape of a ring. How does it form? In this composite view of the Cartwheel galaxy, data from NIRCam and MIRI hint at an answer. The galaxy at the upper left has passed through the disk of the Cartwheel galaxy, and shock waves have rippled outward, sending gas and newly forming stars out with them. Over time, these new stars will stabilize around the central gas-rich spiral structure, creating a permanent ring.

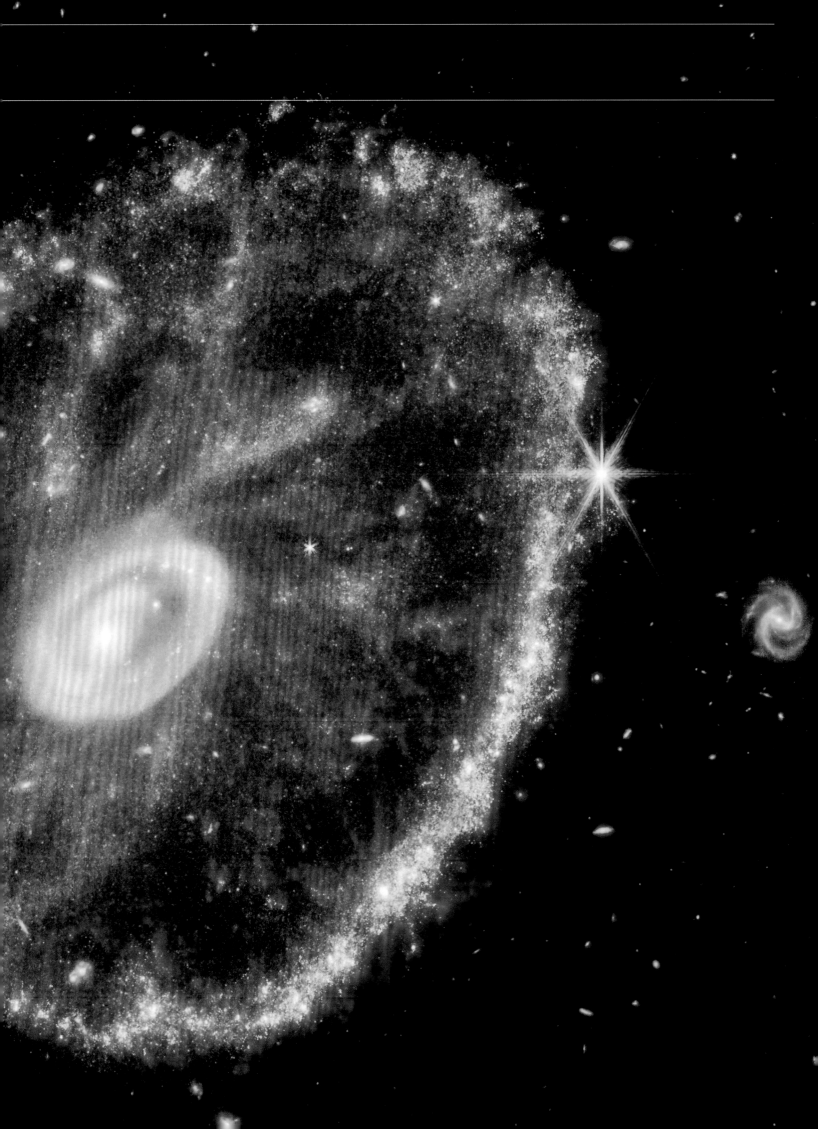

Tarantula Nebula

The Tarantula Nebula is the largest star-forming region in our Local Group—a group of more than 100 galaxies, including the Milky Way. It's found in one of our satellite galaxies located about 165,000 light-years away: the Large Magellanic Cloud. As our galaxy gravitationally tugs on this smaller companion, gas collapses to form new stars. Within the Tarantula Nebula, hundreds of thousands of new stars actively form, including the most massive known star at the center of the blue-colored cluster: R136a1, 260 times the mass of the sun. Where dusty features revealed by JWST still remain, new stars are continuing to form.

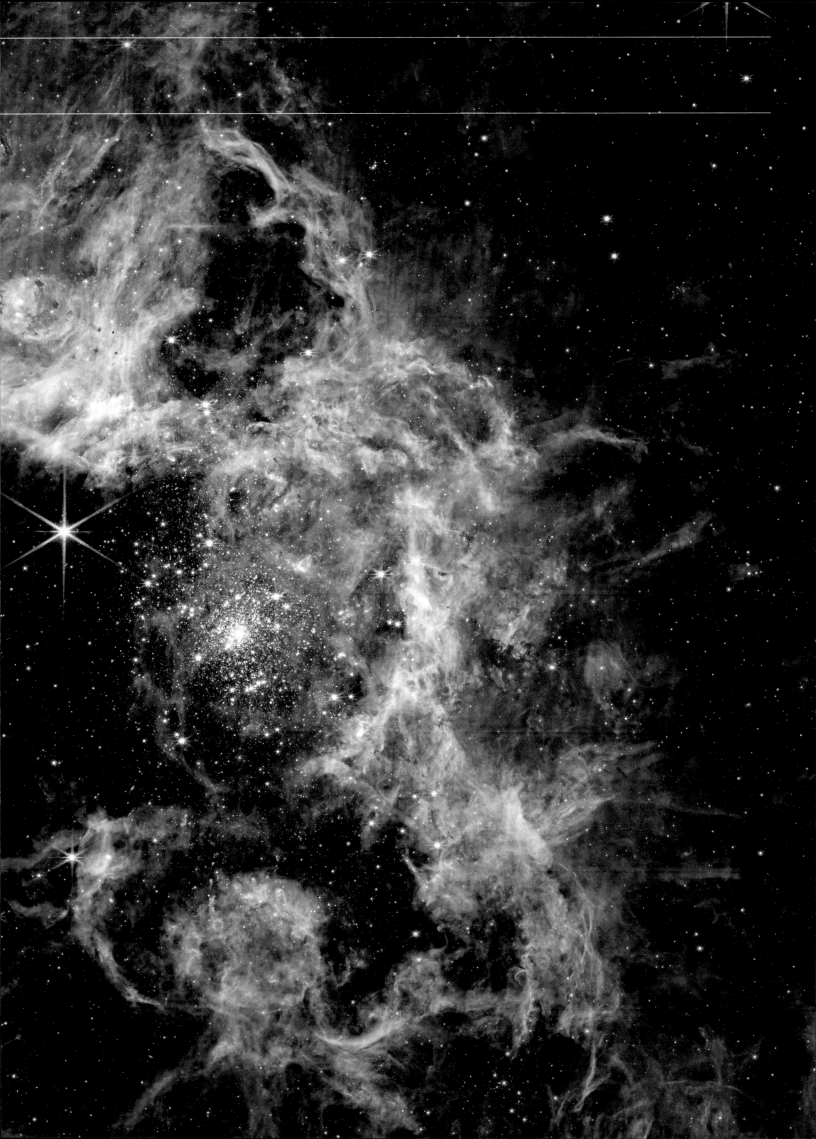

Orion Nebula

Just 1,300 light-years away, in our own galaxy, the Orion Nebula was one of the first objects discovered with the invention of the telescope, in 1610. Today, more than 400 years later, we can now see its insides in unprecedented detail, thanks to JWST's infrared eyes. Inside the nebula, more than a thousand newborn stars can be found, while collapsing clouds of gas and dust continue the process of stellar birth. Surprisingly, a large number of substellar objects have also been found, both isolated and in pairs. These Jupiter-mass binary objects, or JuMBOs, are one of the unexpected mysteries discovered by JWST.

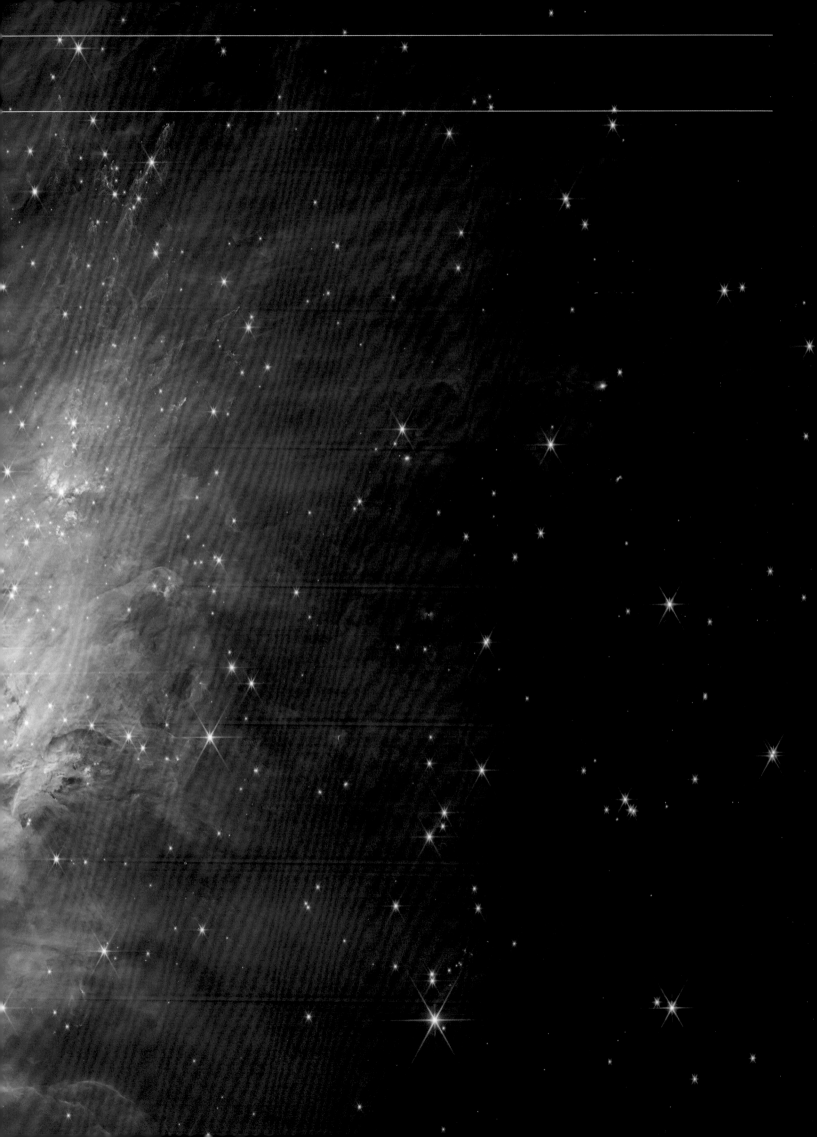

C3.5

The CEERS survey

This patchwork view of galaxies from the distant universe comes courtesy of the Cosmic Evolution Early Release Science (CEERS) survey: one of the very first deep glimpses of the early universe with JWST. The gaps, or black areas, in the survey exist because it was designed to take advantage of JWST's parallel mode observing capabilities, stitching together data from multiple disconnected pointings. For each image taken, a second, nearly adjacent image of a parallel field can also be acquired, practically doubling the amount of data that can be collected with each observation. Within this field lie some 100,000 galaxies, including the one called Maisie's galaxy—the seventh most distant galaxy ever discovered.

An airless world

Just 40 light-years away from Earth lives a faint red dwarf star, TRAPPIST-1, with seven planets orbiting it, all rocky and between 78 and 113 percent the size of Earth. Could any of them support life? Using JWST observations with data from NIRISS and MIRI, scientists were able to determine that the two innermost worlds, TRAPPIST-1 b and TRAPPIST-1 c (shown here in an artist's illustration), possess either bare rocky surfaces or only thin atmospheres devoid of light molecules, such as hydrogen and helium. Future observations may yet detect atmospheres around the other five exoplanets in this system.

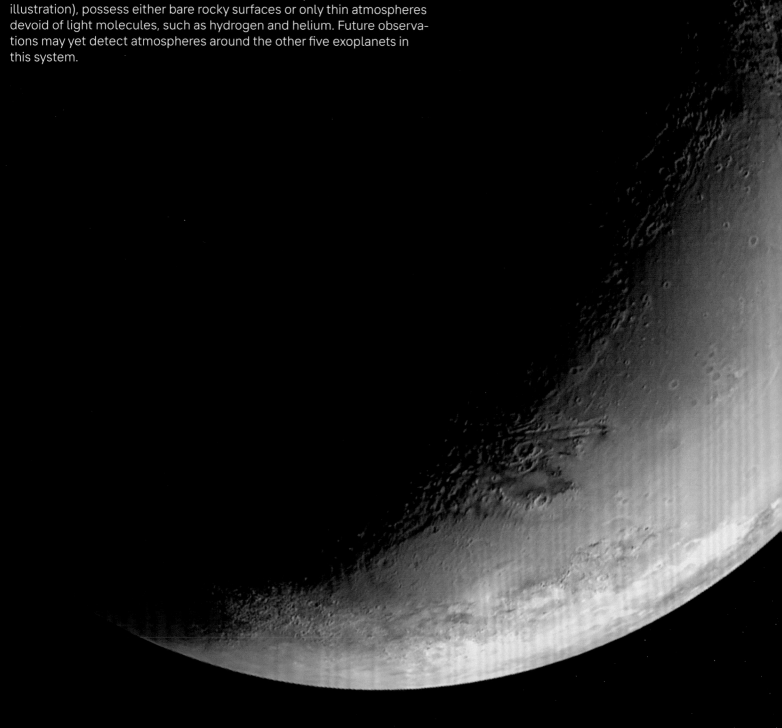

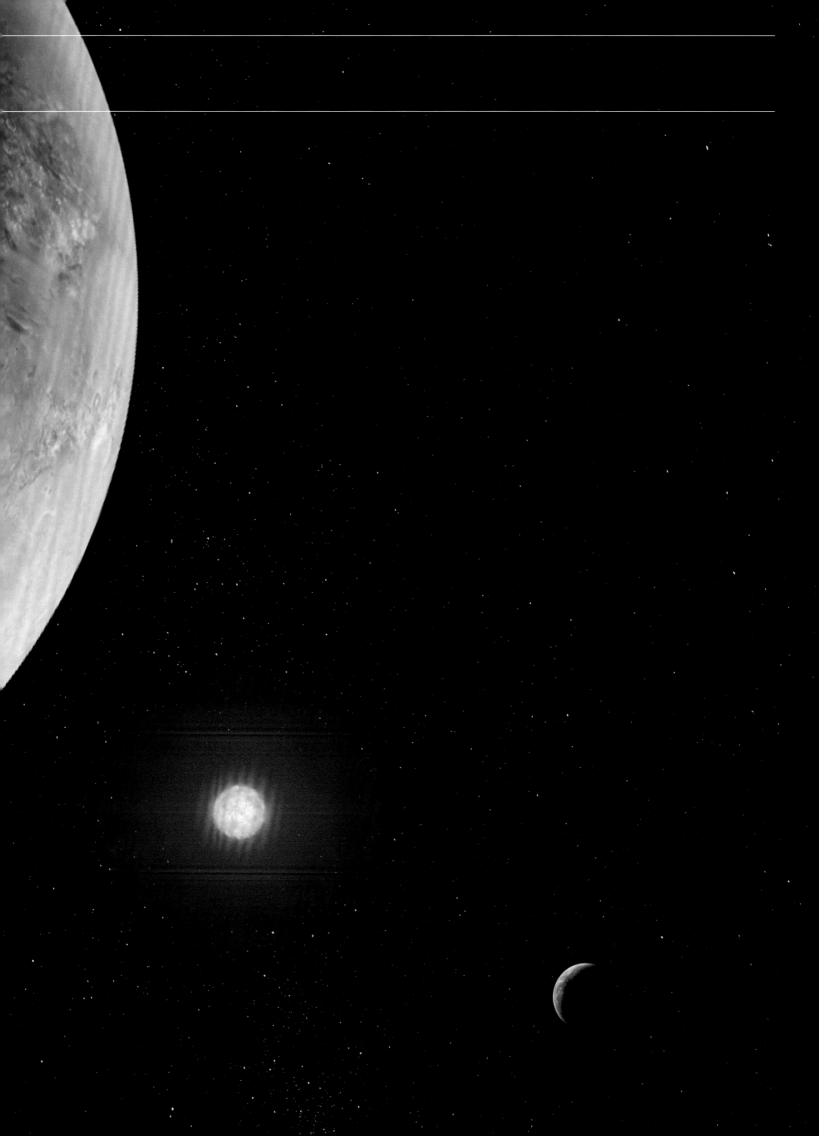

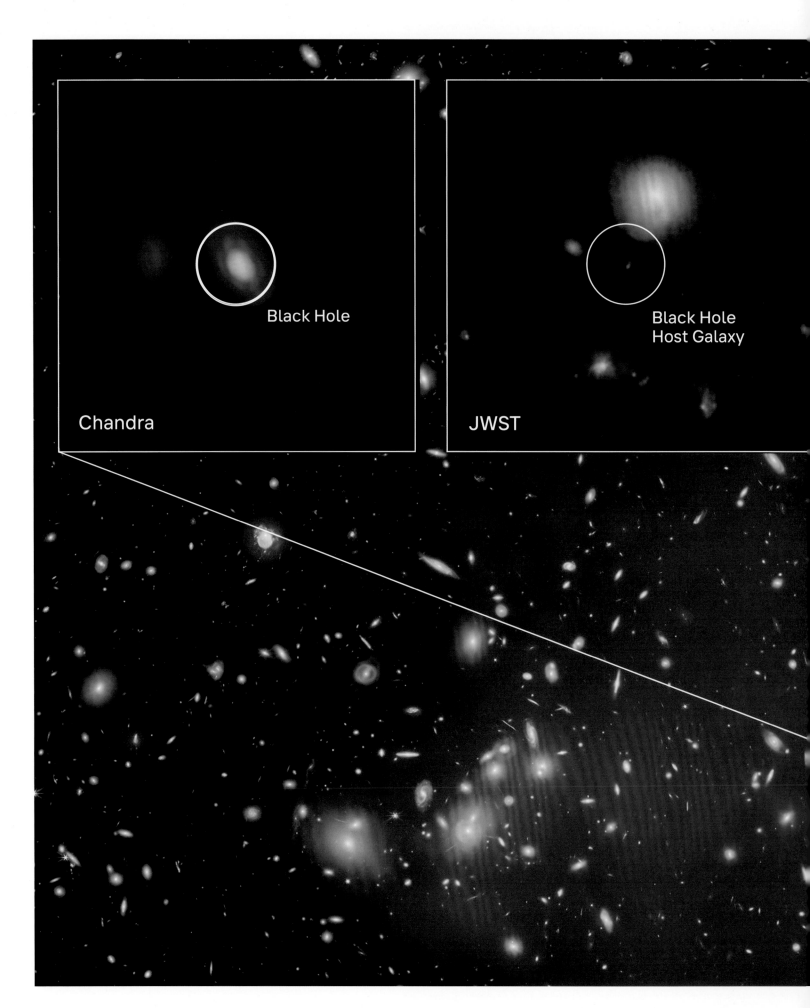

Black Hole

Chandra

Black Hole
Host Galaxy

JWST

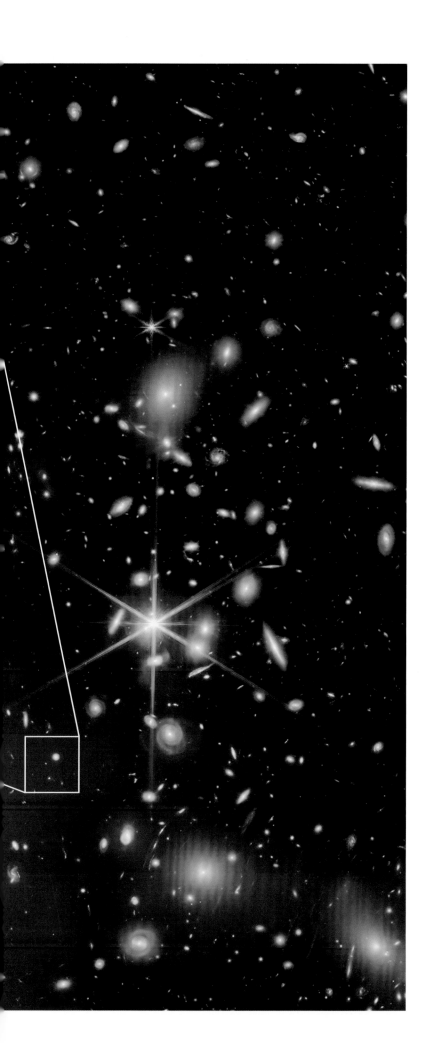

Teaming up to find black holes

The gravity from Pandora's cluster (Abell 2744) distorts and magnifies the light from distant objects across all wavelengths, including x-ray and infrared light. Spotted by JWST, the inset region at right shows a tiny, ultradistant galaxy with no more than 100 million stars inside, its light coming to us from when the universe was just 470 million years old—3 percent of its current age. But NASA's Chandra found evidence, shown at left, for a black hole of at least 10 million solar masses inside, heavier than the one at the Milky Way's center. Named UHZ1, it is the most massive black hole, relative to the cumulative mass of the stars inside the galaxy, ever discovered.

T+347.0

1.27.36

C3.5

(previous) **Hot and cold**

When peering into NGC 346, a star-forming nebula 200,000 light-years away in the Small Magellanic Cloud, JWST reveals not only thousands upon thousands of new stars glittering in this young cluster, but also plumes and arcs of gas and dust. Some of this material is intensely cold molecular hydrogen (H_2 molecules), while some is incredibly hot ionized hydrogen. The cold gas exists along the ridges of the cloudy features, where new stars are still actively forming.

A spiky surprise

This composite view of spiral galaxy NGC 1365 uses data from both NIRCam and MIRI, exposing features that would be obscure in visible light alone. The orange lanes highlight galactic dust and include cavities where bursts of star formation have evaporated it away. Bright background stars and newly forming protostars shine where the dust is sparse or even absent, while the galactic center provides a hotbed for new star formation. At the galaxy's very center, a bright set of spikes suggests an active supermassive black hole: a new discovery thanks to JWST.

Dance of death

How is the dust in the universe produced? One prominent way is shown here: from massive, evolved, binary star systems with strong stellar winds. Here a hot, blue, dying star orbits a slightly less evolved companion star every eight years. The dying star—known as a Wolf-Rayet star (WR 140)—used to be even more massive, but it has already shed its outer hydrogen layers and is now blowing off material enriched in heavy elements: carbon, nitrogen, oxygen, and silicon. More dust is continuously expelled outward, with the two stars' orbits creating a spectacular spiral shape carved into the dust pattern.

C3.5

Catch a runaway star

At the center of this image, a bright star 20 times as massive as our sun shines brilliantly while expelling large amounts of matter because of its strong stellar winds. Although the star is losing mass alarmingly fast, it does so irregularly, through random, asymmetric ejections rather than in smooth, concentric shells. Unlike most stars in the Milky Way, this one moves exceptionally quickly: hundreds of kilometers per second faster than stars like the sun. Although someday it may escape from the Milky Way, it's still within reach of JWST.

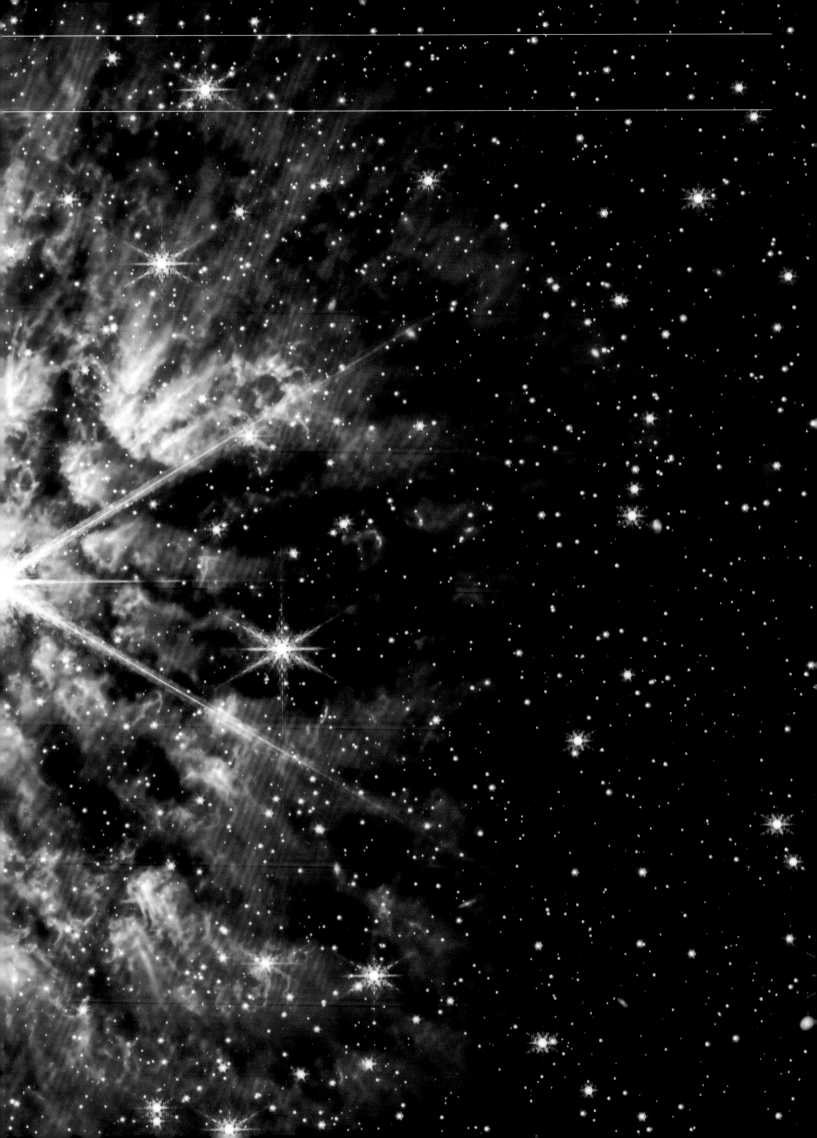

With its large primary mirror, incredible resolution, and infrared reach, JWST has the capacity to see back farther into the early universe than any telescope before it—a key aspect of the remarkable new scientific knowledge this observatory offers to the world. As it detects the most distant galaxies of all, it is perceiving celestial phenomena that formed shortly after the big bang—an accomplishment that is difficult not only because those galaxies are faint and distant, but also on account of the effects of two other essential physical phenomena.

First, as light travels through the expanding universe, its wavelength gets stretched, or "redshifted," to progressively longer wavelengths. Light that was initially emitted in the visible (or even ultraviolet) parts of the spectrum becomes impossible to observe at optical (or visible light) wavelengths; to see it, we must now look in the infrared. And second, if we observe galaxies from the earliest times in the universe, we see that few stars have cumulatively formed, meaning there are still many neutral atoms that effectively block any existing starlight. These two facts combined have set the limits for all ground-based and space-based observatories, including Hubble, that have tried to look back toward cosmic dawn.

But in December 2022, JWST smashed the cosmic record

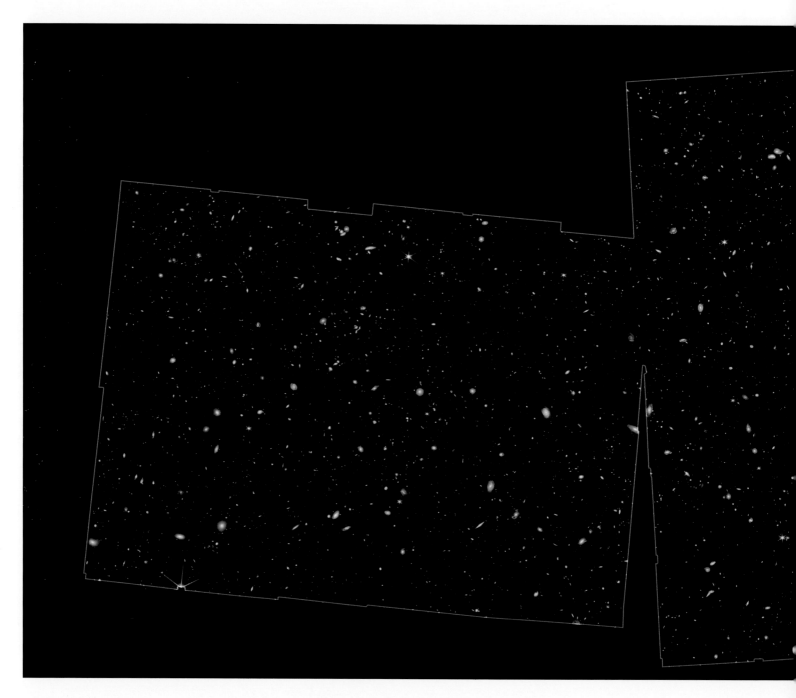

for the most distant galaxy ever observed with the announcement of JADES-GS-z13-0, whose light was emitted just 320 million years after the big bang, when the universe was merely 2.3 percent of its current age of 13.8 billion years. To make those cosmic numbers a bit easier to understand, here's an analogy. If our universe today were a 70-year-old adult, JWST has shown us a galaxy representing the time when it was a 19-month-old toddler. Presently located 33 billion light-years away, this galaxy emits ultraviolet light that was redshifted all the way into the infrared by the time it arrived at JWST's eyes, with much of it being blocked—or, as

astronomers say, extincted—by the intervening matter along our line of sight to it.

By not only detecting that ultradistant light but also analyzing it spectroscopically—that is, by breaking it up into its individual wavelength components—astronomers were able to identify the key imprint of hydrogen atoms, allowing them to precisely determine the cosmic distance to this object.

With its unique cosmic capabilities and instrument suite, JWST has now measured the eight most distant galaxies ever seen, with more cosmic records certain to fall in the near future.

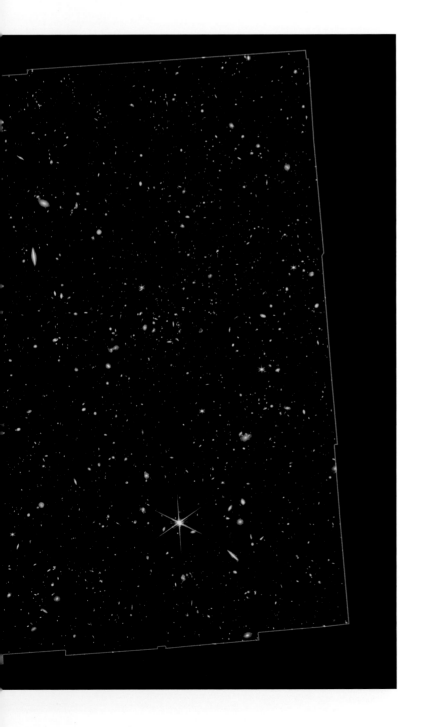

Deeper than ever

Prior to the launch of JWST, our deepest view of the universe came from Hubble. Called the eXtreme Deep Field (XDF), it combined the results of 23 days of observations, all focusing on a single small region of the sky. Here, the project known as JADES—standing for JWST Advanced Deep Extragalactic Survey—has viewed that same region and much more, finding galaxies fainter, redder, and more distant than Hubble was capable of seeing. Many of the most distant galaxies ever discovered are located in this field, making this JWST image the deepest view of the universe thus far.

Cosmic record-breakers

Until 2022, Hubble repeatedly broke its own all-time record for observing galaxies at the greatest distances. Those most distant appear very red, possessing only long-wavelength light, but the only way to know a galaxy's distance for sure is to take its spectrum—to break its light up into constituent components. Within JWST's JADES deep field, an enormous number of candidate ultradistant galaxies were discovered. These images represent two of the 10 most distant galaxies found by JWST: Below is a galaxy whose light emanated just 450 million years after the big bang; and at right is the most distant one found so far, JADES-GS-z13-0, whose light comes from when the universe was just 320 million years old.

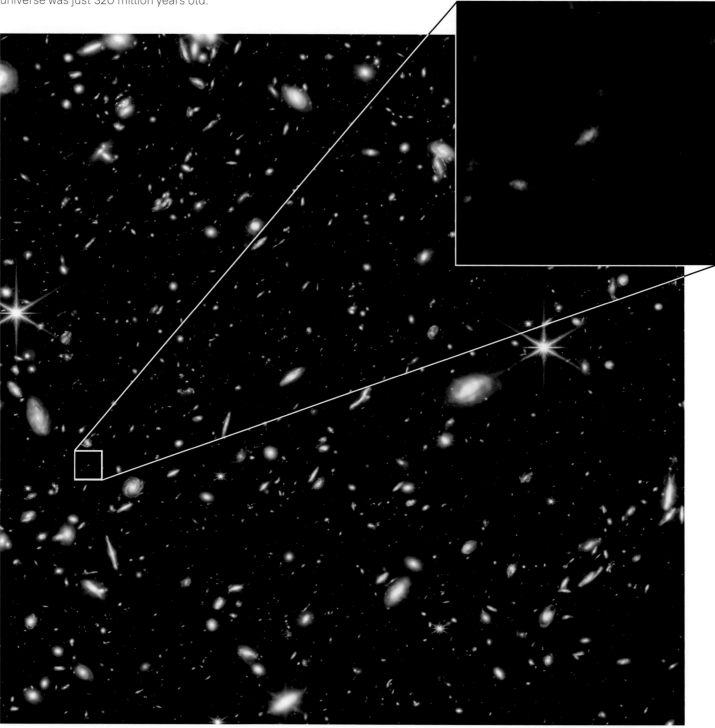

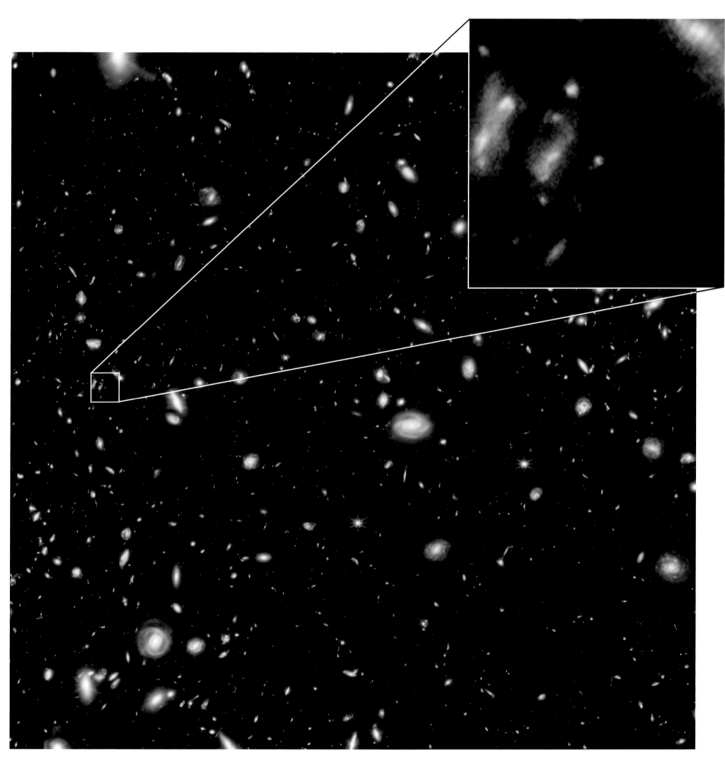

C3.5

An unceremonious demotion

Found within the Hubble eXtreme Deep Field and announced in 2016, galaxy GN-z11 represented the most distant object ever discovered— until that record was broken by JWST in December 2022, With both light-blocking dust and the wavelength-stretching effects of the expanding universe to contend with, the light from GN-z11 was barely perceptible to Hubble, right at the observatory's limits. As of December 2023, GN-z11 now holds the position of the ninth most distant galaxy known; the eight more distant are galaxies either discovered or spectro-scopically measured by JWST since mid-2022.

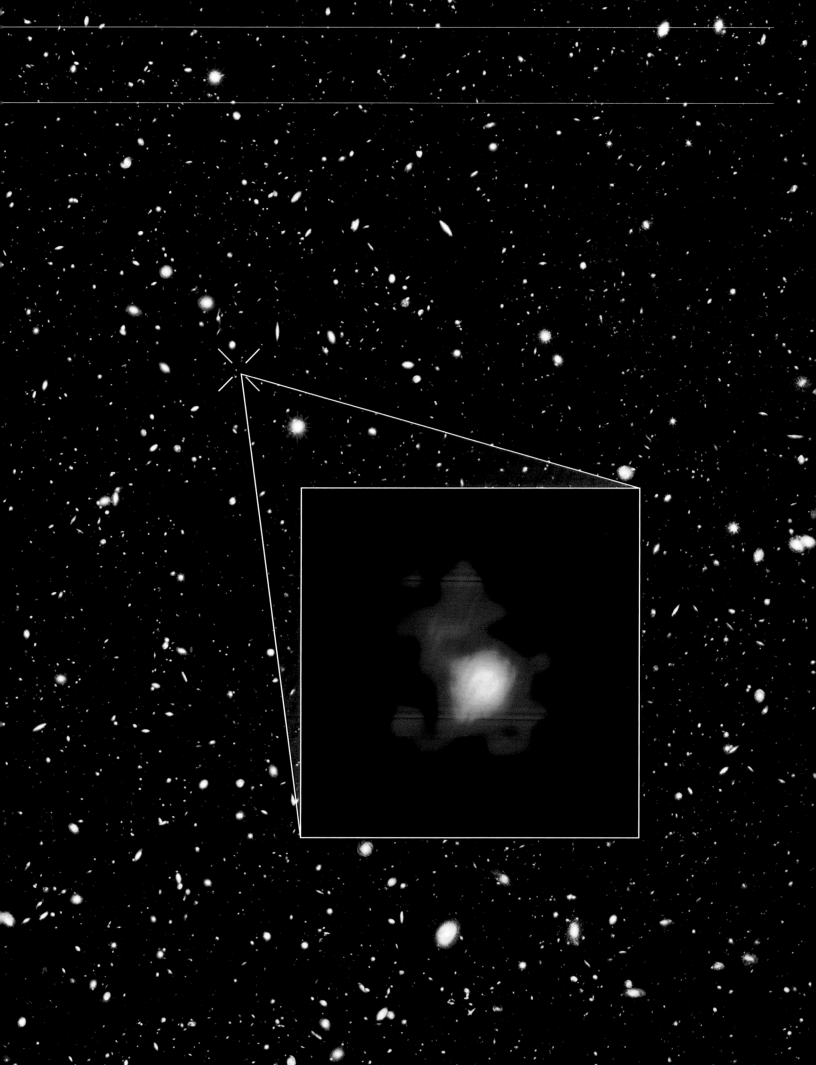

● **The cosmic horizons recede**

Although JWST has now taken us deeper into the universe than ever before—to greater distances, earlier times, and fainter objects, all at superior resolution—it's still fundamentally limited in its scope and capabilities.

The very first stars, made of pristine material left over from the big bang, still remain out of reach of JWST's eyes, at least so far. The dustiest regions of all, such as the heart of the closest recent supernova seen by humanity (SN 1987A), remain obscure: impenetrable to even JWST's infrared views. And despite its spectacularly deep views of space, JWST's narrow field of view ensures that, even two decades from now, some 99 percent or more of the sky will still remain unobserved by it. After all, it would take more than 16 million independent JWST observations to cover the entire sky!

In 1936, Edwin Hubble wrote:

With increasing distance, our knowledge fades, and fades rapidly. Eventually, we reach the dim boundary—the utmost limits of our telescopes. There, we measure shadows, and we search among ghostly errors of measurement for landmarks that are scarcely more substantial. The search will continue. Not until the empirical resources are exhausted, need we pass on to the dreamy realms of speculation.

With JWST in action, the horizons of the unknown are receding. With each new answer provided by its data, new questions arise. The wonder inherent in scientific endeavors, and our joy at finding things out, will always be part of the journey.

A hidden supernova

More than 300 years ago, a supernova went off in the Milky Way's galactic plane: Cassiopeia A, named for the constellation within which it is located in our night sky. Discovered only in 1947, it's the brightest radio source beyond our own solar system, but JWST sees it in a whole new light. Dense gaseous filaments extend out 10 light-years, teaching us that this supernova remnant is expanding at 1.5 percent the speed of light. Different colors highlight an extreme range of temperatures, while small bubbles found throughout the interior of this remnant—newly discovered with JWST—show the shape of the internal gas.

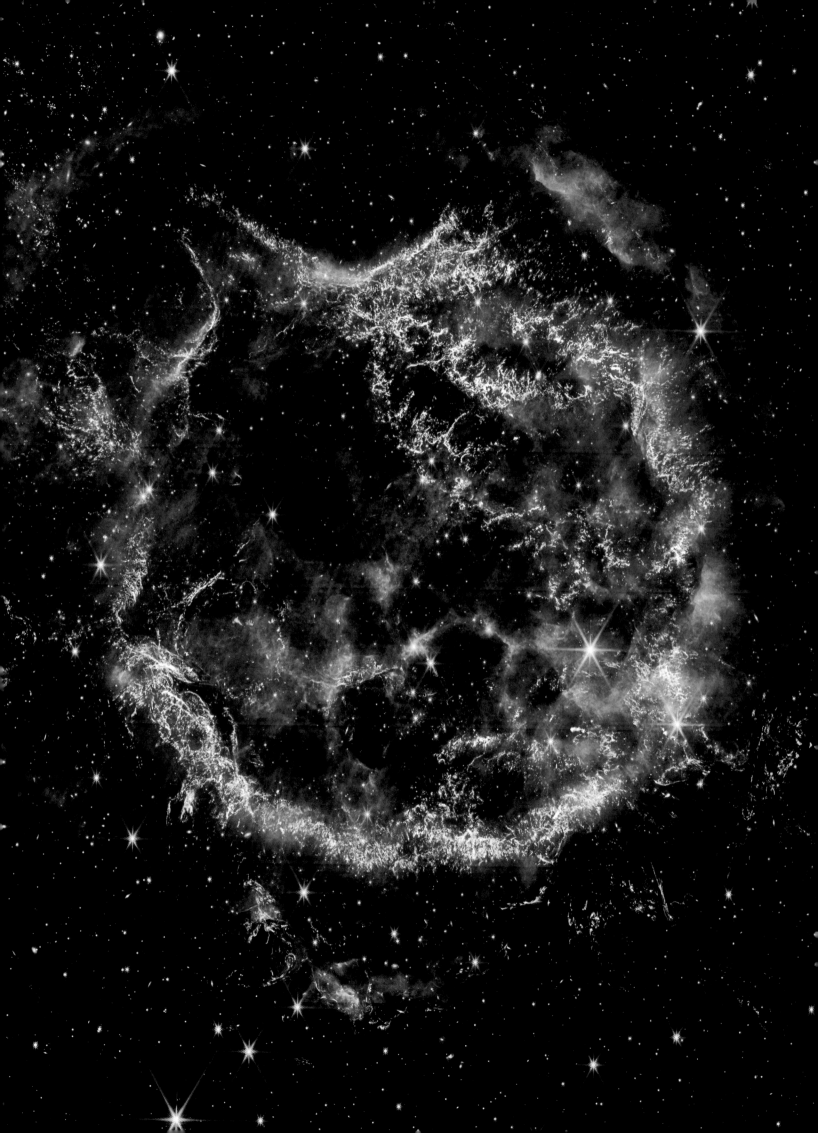

C3.6

Spiral galaxies in a new light

The Milky Way galaxy is our cosmic home: a multiarmed spiral galaxy, filled with luminous stars and light-blocking dust. Our location inside it makes getting a face-on view impossible, but viewing other nearby spirals can teach us incredible amounts about our own galaxy. Here, these 19 nearby face-on spirals— seen with both NIRCam and MIRI aboard JWST—reveal stars, gas, dust, central bulges and bars, and thousands upon thousands of newborn star clusters. As gas collapses and new stars form, dusty material is heated and evaporated, continuing the great stellar life cycle within Milky Way–like galaxies. In these and so many other images coming to us from the James Webb Space Telescope, we witness the wonders of our universe anew.

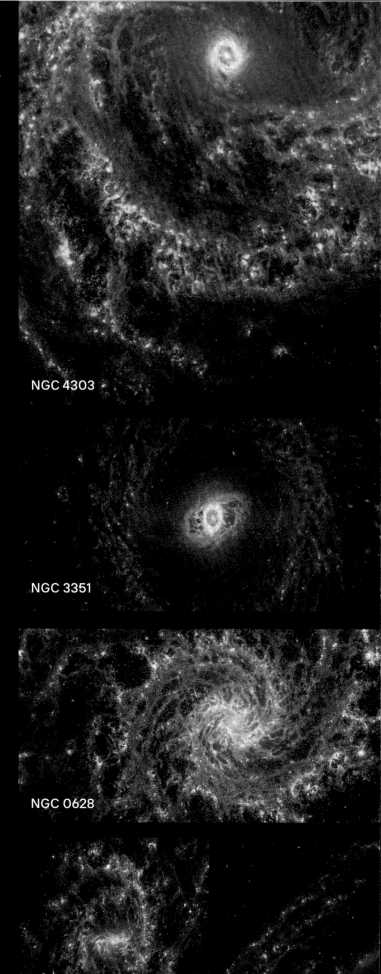

NGC 4303

NGC 1385

NGC 1087

NGC 3351

NGC 1672

NGC 0628

NGC 3627

NGC 2835

NGC 1300

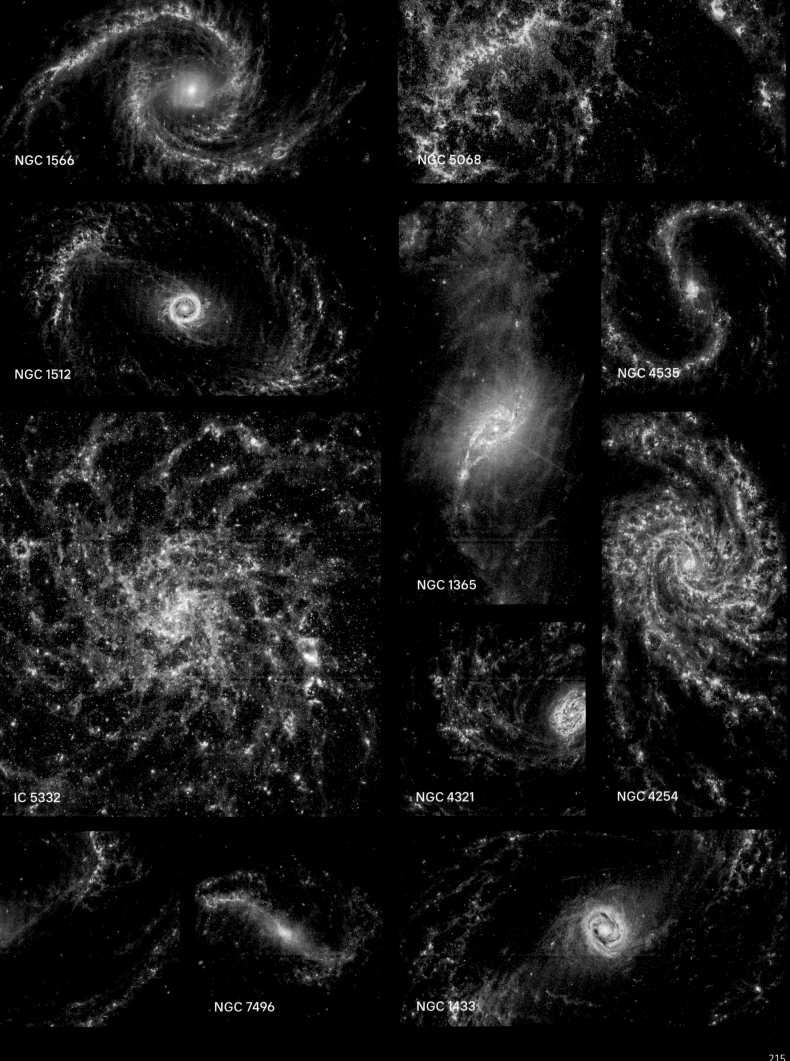

NGC 1566

NGC 5068

NGC 1512

NGC 4535

NGC 1365

IC 5332

NGC 4321

NGC 4254

NGC 7496

NGC 1433

ILLUSTRATIONS CREDITS

Case cover, NASA, ESA, CSA, STScI; 2-3, NASA, ESA, CSA; image processing: Joseph DePasquale (STScI), Anton M. Koekemoer (STScI); 4-5, NASA/MSFC/David Higginbotham; 6-7, NASA, ESA, CSA, STScI, Samuel Crowe (UVA); 8-9, NASA, ESA, CSA, STScI; image processing: Joseph DePasquale (STScI), Alyssa Pagan (STScI), Anton M. Koekemoer (STScI); 10-1, NASA, ESA, CSA, STScI; 12, portrait by Katja Heinemann/Cavan Images with JWST image superimposed; 17, NASA-GSFC, Adriana M. Gutierrez (CI Lab); 20, ESA/Webb, NASA, CSA, M. Zamani (ESA/Webb), PDRs4ALL ERS Team; 24, NASA, ESA, CSA, STScI, Klaus Pontoppidan (STScI); image processing: Alyssa Pagan (STScI); 28-9, NASA/MSFC/David Higginbotham/Emmett Given; 31, NASA/MSFC/David Higginbotham; 32-7, NASA/Chris Gunn; 40-1, Adapted from a graphic in the October 2023 issue of *National Geographic* magazine: Diana Marques, NGM staff; Kelsey Nowakowski. Art: Mark Garlick. Sources: Enrico Garaldi, Max Planck Institute for Astrophysics; Kevin Hainline, University of Arizona; Erica Nelson, University of Colorado Boulder; 42, ESA/Webb, NASA, CSA, M. Barlow, N. Cox, R. Wesson; 43, NASA, ESA, and C. Robert O'Dell (Vanderbilt University); 44-51, NASA/Chris Gunn; 52, Science and Technology Facilities Council (STFC); 53-61, NASA/Chris Gunn; 62-3, Northrop Grumman/Alex Evers; 64-5, David Higginbotham; 67, NASA/Chris Gunn; 68(1), Northrop Grumman; 68(3)-75, NASA/Chris Gunn; 76-7, NASA/Desiree Stover; 78-85, NASA/Chris Gunn; 86-7, NASA; 88-9, 2021 ESA-CNES-Arianespace/Optique vidéo du CSG - JM Guillon; 90-1, ESA/CNES/Arianespace; 92-3, NASA/Chris Gunn; 94-5, NASA/Bill Ingalls; 97, NASA/Chris Gunn; 98-9, CNES/ESA/Arianespace/Optique vidéo CSG/JM Guillon, 2021; 100-1, NASA/Bill Ingalls; 102-3, ESA/D. Ducros; 105, Arianespace, ESA, NASA, CSA, CNES; 106, NASA Goddard Space Flight Center; 108-9, NASA/Bill Ingalls; 111, NASA GSFC/CIL/Adriana Manrique Gutierrez; 112(1), NASA; 112(2), NASA/STScI/J. DePasquale; 112(3) and (4), NASA/STScI; 113, NASA; 115, NASA/STScI; 116, NASA, ESA, HEIC, and The Hubble Heritage Team (STScI/AURA); 117, Team MIRI; 118, NASA/ESA/CSA/STScI ; 119, NASA/STScI; 120-1, NASA/ESA/CSA; 124-5, NASA/Bill Ingalls; 127-132, NASA, ESA, CSA, STScI; 133, NASA, ESA, and The Hubble Heritage Team (STScI/AURA); 134-5, NASA, ESA, CSA, STScI; 136-7, NASA, ESA, CSA, Joseph Olmsted (STScI); 139, NASA, ESA, CSA, STScI; 140-1, NASA, ESA, CSA, Takahiro Morishita (IPAC); image processing by Alyssa Pagan (STScI); 142-3, NASA, ESA, CSA, STScI, T. Temim (Princeton University); 144(1), NASA, ESA, ESO, CXC, and D. Coe (STScI)/J. Merten (Heidelberg/Bologna); 144(2-4), X-ray: NASA/CXC/ITA/INAF/J.Merten et al, Lensing: NASA/STScI; NAOJ/Subaru; ESO/VLT, Optical: NASA/STScI/R.Dupke; 145, NASA, ESA, CSA, Ivo Labbe (Swinburne), Rachel Bezanson (University of Pittsburgh); image processing by Alyssa Pagan (STScI); 146, NASA, ESA and the Hubble Heritage Team (STScI/AURA); 147, NASA, ESA/Hubble and the Hubble Heritage Team; 148, NASA, ESA, CSA, STScI; image processing by Joseph DePasquale (STScI), Alyssa Pagan (STScI); 149, NASA, ESA, CSA, STScI; image processing by Joseph DePasquale (STScI), Anton M. Koekemoer (STScI), Alyssa Pagan (STScI); 150-1, ESA/Webb, NASA, CSA, T. Ray (Dublin); 152-3, NASA, ESA, CSA; 155, NASA, ESA, and J. Olmsted and F. Summers (STScI); 156-7, NASA, ESA, Jupiter ERS Team; image processing by Ricardo Hueso (UPV/EHU) and Judy Schmidt; 158, NASA, ESA, A. Simon (Goddard Space Flight Center), and M.H. Wong (University of California, Berkeley) and the OPAL team; 159, NASA, ESA, CSA, STScI, R. Hueso (University of the Basque Country), I. de Pater (University of California, Berkeley), T. Fouchet (Observatory of Paris), L. Fletcher (University of Leicester), M. Wong (University of California, Berkeley), J. DePasquale (STScI); 160-1, NASA, ESA, CSA, STScI; image processing: Joseph DePasquale (STScI), Naomi Rowe-Gurney (NASA-GSFC); 162-3, NASA, ESA, CSA, STScI; 164-5, NASA, ESA, CSA, STScI, Matt Tiscareno (SETI Institute), Matt Hedman (University of Idaho), Maryame El Moutamid (Cornell University), Mark Showalter (SETI Institute), Leigh Fletcher (University of Leicester), Heidi Hammel (AURA). Image processing: J. DePasquale (STScI); 167, NASA, ESA, CSA, András Gáspár (University of Arizona), Alyssa Pagan (STScI); 168, NASA, ESA, Zolt G. Levay (STScI), Ann Feild (STScI); 169, ESA/Webb, NASA & CSA, J. Rigby; 170-1, ESA/Webb, NASA & CSA, J. Lee and the PHANGS-JWST Team; 172, ESA/Hubble & NASA, R. Chandar; 172-3, ESA/Webb, NASA & CSA, J. Lee and the PHANGS-JWST Team; 173, ESA/Webb, NASA & CSA, J. Lee and the PHANGS-JWST Team; ESA/Hubble & NASA, R. Chandar Acknowledgement: J. Schmidt; 174-5, NASA, ESA, CSA; 176-7, NASA, ESA, CSA, STScI, Orsola De Marco (Macquarie University); Image Processing: Joseph DePasquale (STScI); 178-9, NASA; 181, NASA, ESA, CSA, STScI, Jose M. Diego (IFCA), Jordan C. J. D'Silva (UWA), Anton M. Koekemoer (STScI), Jake Summers (ASU), Rogier Windhorst (ASU), Haojing Yan (University of Missouri); 182-3, NASA, ESA, CSA, and M. Zamani (ESA); 184, KPNO, NSF's NOIRLab, AURA; Image Processing: Alyssa Pagan (STScI); 185, NASA, ESA, CSA, Ori Fox (STScI), Melissa Shahbandeh (STScI); 186-9, NASA, ESA, CSA, STScI, Webb ERO Production Team; 190-1, NASA, ESA, CSA/Science leads and image processing: M. McCaughrean, S. Pearson; 192-3, NASA, ESA, CSA, Steven Finkelstein (University of Texas at Austin), Micaela Bagley (University of Texas at Austin); Image Processing: NASA, ESA, CSA, Alyssa Pagan (STScI); 194-5, NASA, ESA, CSA, Joseph Olmsted (STScI); Science Sebastian Zieba (MPI-A), Laura Kreidberg (MPI-A); 196-7, X-ray: NASA/CXC/SAO/Ákos Bogdán; Infrared: NASA/ESA/CSA/STScI; Image Processing: NASA/CXC/SAO/L. Frattare & K. Arcand; 198-9, NASA, ESA, CSA, O. Jones (UK ATC), G. De Marchi (ESTEC), and M. Meixner (USRA), with image processing by A. Pagan (STScI), N. Habel (USRA), L. Lenkic (USRA) and L. Chu (NASA/Ames); 200-1, NASA, ESA, CSA, STScI, J. Lee (STScI), T. Williams (Oxford), PHANGS Team; 202-3, NASA/ESA/CSA/STScI/JPL-Caltech; 204-5, NASA, ESA, CSA, STScI, Webb ERO Production Team; 206-7, NASA, ESA, CSA, M. Zamani (ESA/Webb); Image Processing: Zolt G. Levay (STScI); 209, NASA, ESA, CSA, Tommaso Treu (UCLA); Image Processing: Zolt G. Levay (STScI); 210-1, NASA, ESA, and P. Oesch (Yale University); 213, NASA, ESA, CSA, STScI, Danny Milisavljevic (Purdue University), Ilse De Looze (UGent), Tea Temim (Princeton University); 214-5 (unless otherwise noted), NASA, ESA, CSA, STScI, Janice Lee (STScI), Thomas Williams (Oxford), PHANGS Team; 214(NGC 1087) and 215(NGC 5332), NASA, ESA, CSA, STScI, Janice Lee (STScI), Thomas Williams (Oxford), Rupali Chandar (UToledo), PHANGS Team; 215(NGC 1566), NASA, ESA, CSA, STScI, Janice Lee (STScI), Thomas Williams (Oxford), Rupali Chandar (UToledo), Daniela Calzetti (UMass), PHANGS Team; 223 (UP), Elena Seibert; 223 (LO), Ethan Siegel.

INDEX

ACKNOWLEDGMENTS

Ethan Siegel acknowledges a great number of JWST scientists and engineers for fascinating and informative discussions about the observatory over the years, including Andras Gaspar, Kevin Hainline, Stacey Alberts, Christina Williams, Heidi Hammel, Dan Coe, Rebecca Larson, Jon Arenberg, Alberto Conti, and Scott Willoughby. He also sends great thanks to the people at the Space Telescope Science Institute, including Christine Pulliam and Alyssa Pagan, as well as to John Mather, the JWST senior project scientist. He especially acknowledges his spouse, Jamie Cummings, for being the absolute best thing in the entire observable universe.

The editors also thank Peter R. Sooy of NASA's Goddard Space Flight Center and Christine Pulliam of the Space Telescope Science Institute for initial conversations about this book idea; Brian Greene for his illuminating introduction, along with Zianne Cuff, Criss Moon, and Eric Simonoff for facilitating our work together; and our National Geographic Books team on this title: Neal Ashby for the striking design, Katie Dance for tireless photo research, Greg Ugiansky for work on maps and graphics, Elisa Gibson for creative input and support, Maureen Klier for copyediting, Mary Stephanos for proofreading, Connie Binder for indexing, and Becca Saltzman for editorial precision.

ABOUT THE AUTHORS

BRIAN GREENE

Brian Greene is a theoretical physicist and the best-selling author of books including *The Fabric of the Cosmos, The Elegant Universe,* and, most recently, *Until the End of Time.* He is a professor of physics and mathematics at Columbia University and a co-founder of the World Science Festival. He lives in New York City. *briangreene.org*

ETHAN SIEGEL

Ethan Siegel is a theoretical astrophysicist, science writer, and the author of the blog Starts With a Bang! His previous books are *Beyond the Galaxy, Treknology,* and, for children, *The Littlest Girl Goes Inside an Atom.* He lives in the U.S. Pacific Northwest. *@startswithabang*

INFINITE **COSMOS**

Since 1888, the National Geographic Society has funded more than 14,000 research, conservation, education, and storytelling projects around the world. National Geographic Partners distributes a portion of the funds it receives from your purchase to National Geographic Society to support programs including the conservation of animals and their habitats.

National Geographic Partners, LLC
1145 17th Street NW
Washington, DC 20036-4688 USA

Get closer to National Geographic Explorers and photographers, and connect with our global community. Join us today at nationalgeographic.org/joinus

For rights or permissions inquiries, please contact National Geographic Books Subsidiary Rights: bookrights@natgeo.com

ISBN: 978-1-4262-2382-2

Printed in China

24/RRDH/1